Queen Elizabeth II

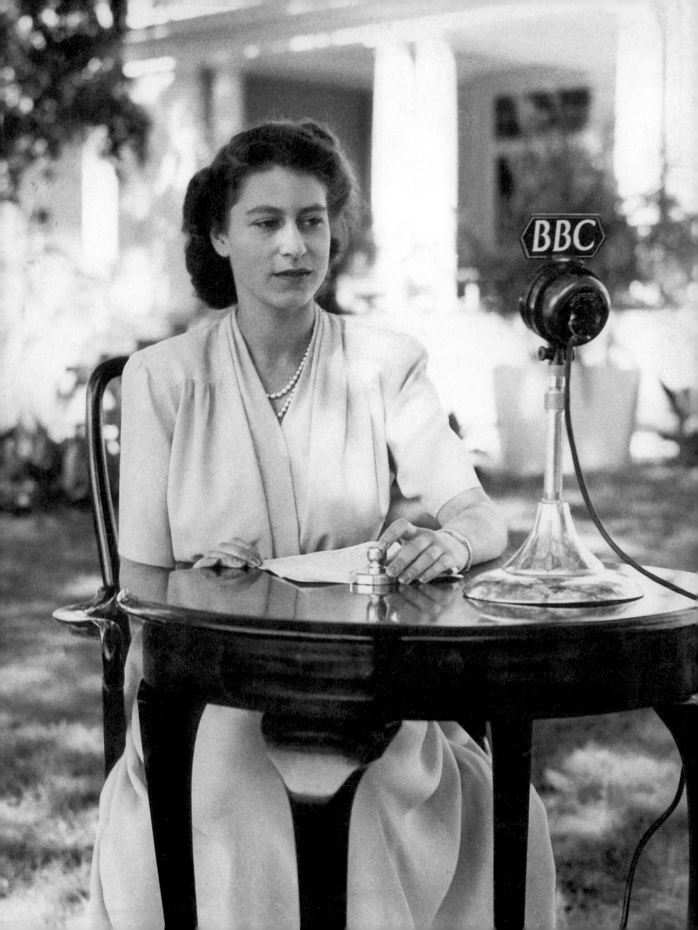

Queen Elizabeth II

A celebration of her life and reign in pictures

David Souden

BBC
BOOKS

3 5 7 9 10 8 6 4 2

BBC Books, an imprint of Ebury Publishing
20 Vauxhall Bridge Road,
London SW1V 2SA

BBC Books is part of the Penguin Random House group of companies whose
addresses can be found at global.penguinrandomhouse.com

Penguin
Random House
UK

First published by BBC Books in 2022

www.eburypublishing.co.uk

A CIP catalogue record for this book is available from the British Library

ISBN 9781785943096

Printed and bound by Firmengruppe APPL, aprinta druck, Wemding, Germany

Penguin Random House is committed to a sustainable future for our business,
our readers and our planet. This book is made from Forest Stewardship
Council® certified paper.

BBC Books would like to thank the following sources for providing photos.
While every effort has been made to trace and acknowledge all photographers,
we should like to apologise should there be any errors or omissions.

Image credits: BBC 16, 20, 22, 23, 26b, 41, 42, 43, 46, 53, 54, 56, 57, 59,
66–67, 73, 74, 75, 76–7, 78, 79, 82, 83, 84b, 87, 90, 96, 103, 104, 105, 107,
108, 110b, 111t, 112, 113t, 115b, 118, 119, 120, 121, 122, 123, 124, 128–129,
130, 131, 132, 133, 134, 135, 136, 143, 165, 174–175, 178, 179, 180, 181, 182,
183, 184, 185, 187, 190, 191, 193, 194, 195, 196, 202, 204–205, 206, 208b,
210t, 212, 214–215, 216, 222–223, 227; Camera Press/Cecil Beaton 176; Crux
Productions, from the documentary Elizabeth at 90 – A Family Tribute 203;
Getty Images 2, 15, 20, 26t, 28–29, 30–31, 33t, 34–35, 36–37, 41, 44, 48–49,
50–511, 57, 65, 111b, 113b, 126, 137, 139, 140, 141, 144, 145, 149, 150–151,
168, 169, 170–171, 172–173, 198, 200, 201, 207, 217, 224, 225, 226, 227, 228,
229, 230–1, 232, 233, 235, 236–7, 238–239; International Olympic Committee
220–221; Library & Archives of Canada 71; PA Images 10–11,13, 14, 17, 18,
19, 21, 25, 32, 33b, 38, 39, 40, 47, 52, 55, 58, 60, 61, 62–63, 64b, 68–69, 70,
72, 80–81, 84t, 85, 86, 88–89, 91–92, 93, 94, 95, 97, 98, 99, 100, 101, 102, 106,
109, 110t, 114, 115t, 116 –117, 125, 127, 138, 142, 146–147, 148, 152–153,
154, 155, 156–157, 158, 160–161, 162–163, 164, 166–167, 177, 188–189, 192,
197, 199, 211t, 213, 218–219, 234, 240; Rex/Shutterstock 64t, 208t, 209, 210b,
211b; Royal Collection Trust/ Her Majesty Queen Elizabeth II 2017 12, 14, 159.
Picture research completed by Victoria Hall.

CONTENTS

INTRODUCTION

In 1922 the British Broadcasting Company was born, and in 1926 Princess Elizabeth Alexandra Mary was born. One grew up to be the British Broadcasting Corporation, the BBC, established by royal charter in 1927. The other grew up to be Elizabeth II, in 1952: Queen of the United Kingdom of Great Britain and Northern Ireland and of her territories beyond the seas, Queen of Australia, Queen of Canada, Head of the Commonwealth, Defender of the Faith, Duke of Lancaster, and with many other grand titles besides. Nobody in the 1920s could have imagined what would become of these two newly-borns.

Now, nearly a century on, we do not need to imagine. The BBC marks its centenary, and Queen Elizabeth II has gone. Hers was a long and fulfilled life, and one of the longest reigns of any monarch anywhere. For the vast majority of people in the United Kingdom, throughout the Commonwealth and in the territories where she was head of state, they have known no other person as their sovereign.

In the early 1950s, after Princess Elizabeth acceded to the throne, there was talk of a New Elizabethan Age, a hope for a national cultural flowering to match that of the later 16th century. That idea was soon rejected, not least by the new Queen herself, but in reality it has been a new Elizabethan

Age. The speed of change in the world at large is unmatched in history. It has been a technological age, the era of mass telecommunications, the computer age. Britain has watched as super-powers have come and sometimes gone, part-remembering, part-forgetting it had been an imperial super-power not long before. We speak of 'Victorian', and in many ways the late Queen took great regard of what her great-great-grandmother had done, and the age that she seemed to embody. Will we now speak in the future of 'Elizabethan'?

That is where this tribute book comes in. The past 90 years and more have seen a revolution in communications. The Victorian age of the steamship, telegraph and rudimentary telephone has become the modern age of mass air travel, satellites, smartphones, internet, computer controls, video and gaming, round the world, round the clock. In Britain, all women over the age of 21 had only finally got the right to vote when Princess Elizabeth was in her pram. The modern monarchy and Royal Family are probably more open and closer to the people than they have ever been.

Yet, at the same time, it has been a time when the past gives greater validity to the present. Heritage is big business. In the face of rapid change there is an urge to preserve. We have a cult of celebrity. As royal political power has waned, so ceremonial has become more public and often more spectacular. Royal weddings, the coronation, parliamentary and funeral rituals, birthdays, jubilees: all have been public elements of the new

Elizabethan age. There is the constant round of openings, performances, speeches, entertaining, investitures, tours, walkabouts and receptions. Almost certainly, more people have seen Queen Elizabeth II in the flesh than any other person in the world.

That is what this book is about. Charting the life of the Queen in its many guises, private as well as public, it uses a very particular lens: the BBC. Not only were the two born together, but also they grew up side by side in a relationship that was often close. Not always too close, and with sometimes particular wariness on the royal side, yet throughout the Queen's life the BBC was there to cover events, produce a new perspective on royal life, and promote the idea of Britishness both at home and abroad partly through the Queen and her family. This happened first on radio, but even from the 1930s on television.

The BBC itself has its own substantial archive of recordings and photographs, and the image archive is at the heart of this book. Extended captions accompanying the images chart the story of the Queen's life and reign: her upbringing, emergence into public life, her husband and their family, the turns of fate that put her on the throne, her travels, her duties, her public self, and her love of horses and dogs. The BBC broadcast at the end of the Second World War, the births and marriages of her children, on her official birthday, from her father's coronation and her own, to cover tours overseas and visits at home, from

racecourses and the Houses of Parliament, her message at Christmas, and now her funeral and the proclamation of her successor.

Although she was the most famous woman in the world and a great public figure, she was also a private person. Everyone seemed to want to know what the Queen was *really* like, but that personal insight was only available to a close and privileged few. As a constitutional monarch who could reign but not rule, her personal opinions would only very occasionally be let slip in public. As the monarch and constitutional head for over six decades, the Queen saw every important document of state and had a weekly audience with a succession of prime ministers from Winston Churchill to Boris Johnson. Her political knowledge was possibly unrivalled, but very few could access that knowledge. Only occasionally, and usually as a stage-managed event, was anyone else permitted to see this aspect of the Queen's life and work.

The Queen commanded great respect, popularity, and very often genuine love and affection. She was glamorous as a younger woman, and a familiar figure from her voice and appearance throughout her life. The images from the BBC move in step with her. Through the years of her emergence into public life and then her many years on the throne, her feelings of duty, compassion, family pride and love for her people shine through the images that document her life.

CHILDHOOD

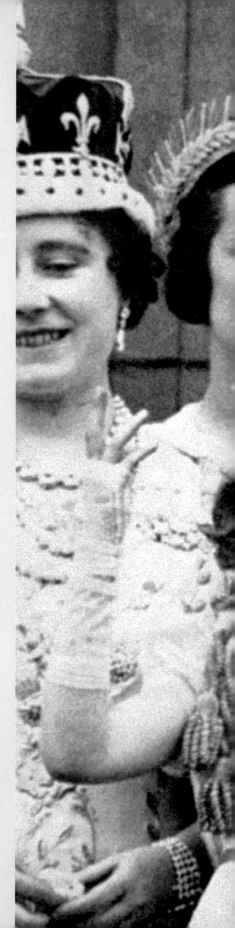

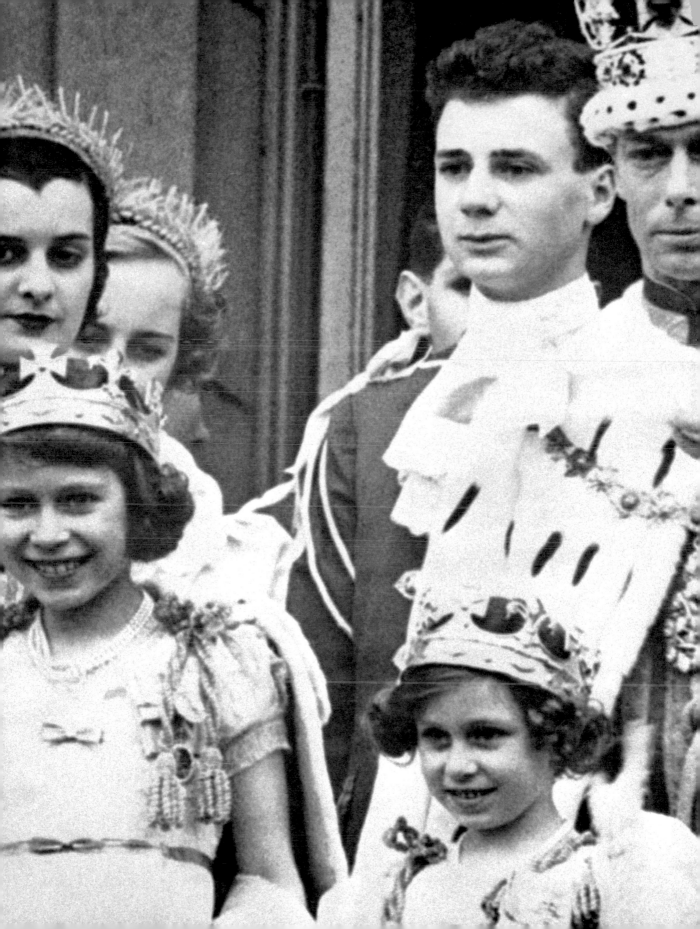

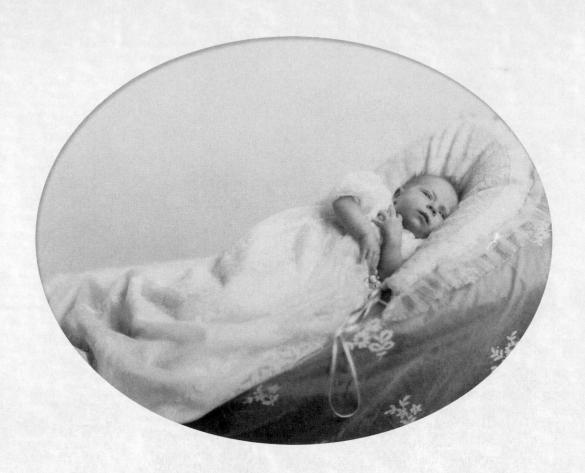

A ROYAL BABY IS BORN

The Duchess of York, wife of the second son of King George V, gave birth to her first child on 21 April 1926, at 17 Bruton Street, London. It was not an easy confinement, and the prospects of the royal couple having many, or any, more children seemed slim. The baby was named Elizabeth Alexandra Mary, after her mother and two queens, her grandmother and great-grandmother. The baby, whose birth was a spark of light in a gloomy period of major national news, just before the General Strike, would become Queen Elizabeth II.

AT THREE YEARS OLD, IN HER PRAM

The baby's grandmother, Queen Mary, called her 'a little darling with lovely complexion & pretty fair hair'. There was considerable public interest in the new Princess, and in the new royal household established at 145 Piccadilly where the family then went to live. Soon Elizabeth became the apple of the eye of her grandfather, the King. A first royal wave, from the infant Princess Elizabeth, showed that she was becoming accustomed to public attention at a very young age. That attention grew when a year later in 1930 her sister was born, Margaret Rose.

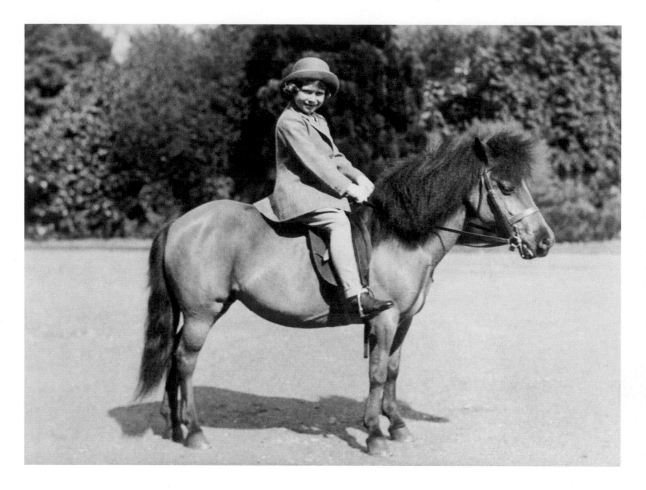

A LIFELONG LOVE

The Queen's love of horses started early, with her first pony, a Shetland called Peggy. By the age of six the Princess was riding with ease.

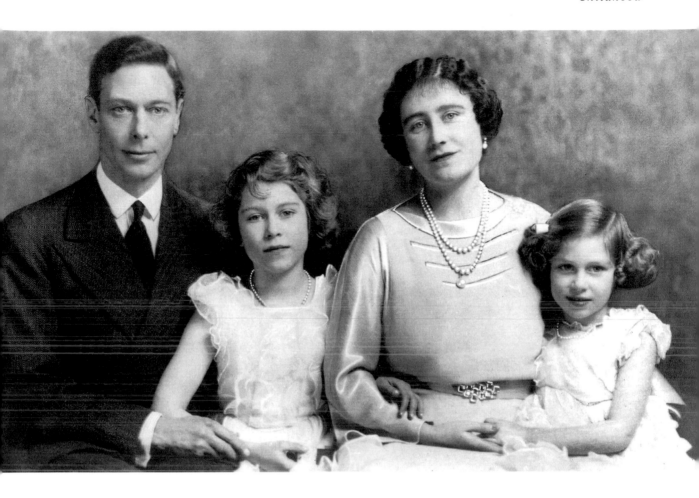

THE YORK FAMILY

The Duke and Duchess of York with their two
daughters, Elizabeth (left) and Margaret
Rose. Royal duties often took the Duke, and
sometimes both parents, away; even as
a small child Princess Elizabeth was left
behind as her parents went on a royal visit
to Australia. Being raised by governesses
was not unusual in royal and aristocratic
households. The family quickly settled into
a happy way of life, living in London and at
Windsor, enjoying country sports, taking part
in occasional ceremonial functions.

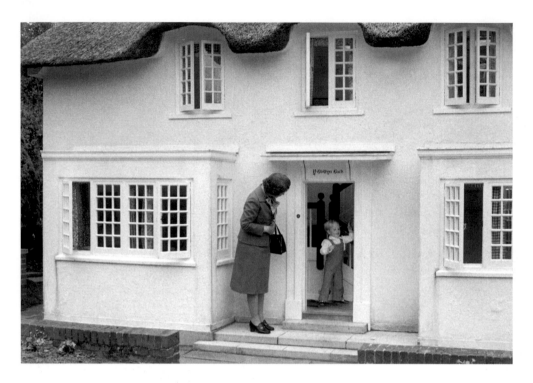

A SPECIAL PRESENT

When she was aged six, Princess Elizabeth received a present from the people of Wales: a two-thirds size cottage of her very own. It was presented to her parents, the Duke and Duchess of York, in 1932, the year after they took over the use of the Royal Lodge in Windsor Park. It was given to the young Princess to enjoy with her baby sister, Princess Margaret Rose. As it was a gift from the people of Wales it correspondingly received a Welsh name, Y Bwthyn Bach, or the 'Little House'. Here the girls would play at keeping house.

LINE OF SUCCESSION

Princess Elizabeth, portrayed by society painter Philip de László in 1933. If the Prince of Wales, who would succeed his father in 1936 as Edward VIII, had had children then Elizabeth would have been pushed down the line of succession. If her parents had had a son she would have been superseded. Neither scenario happened, although after her father ascended to the throne Princess Elizabeth remained heir presumptive rather than heir apparent until he died in 1952.

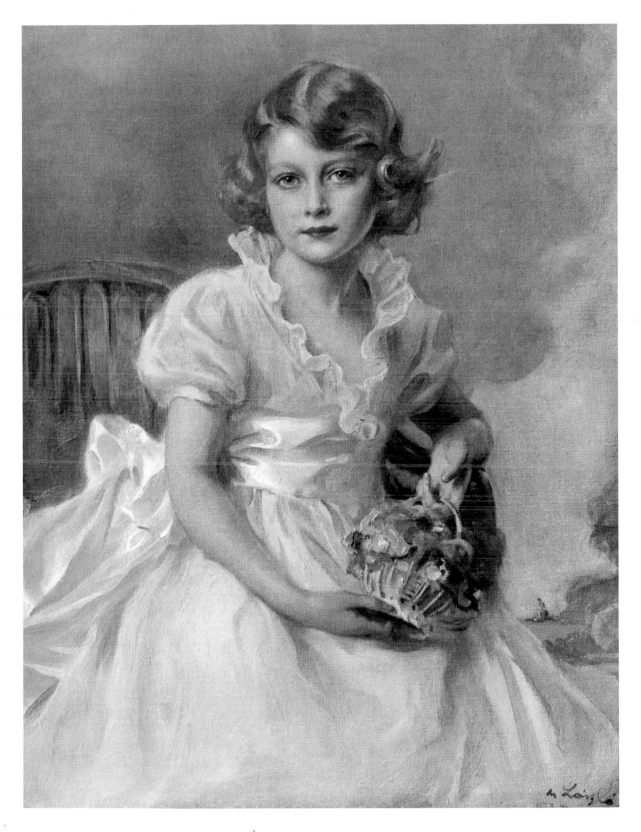

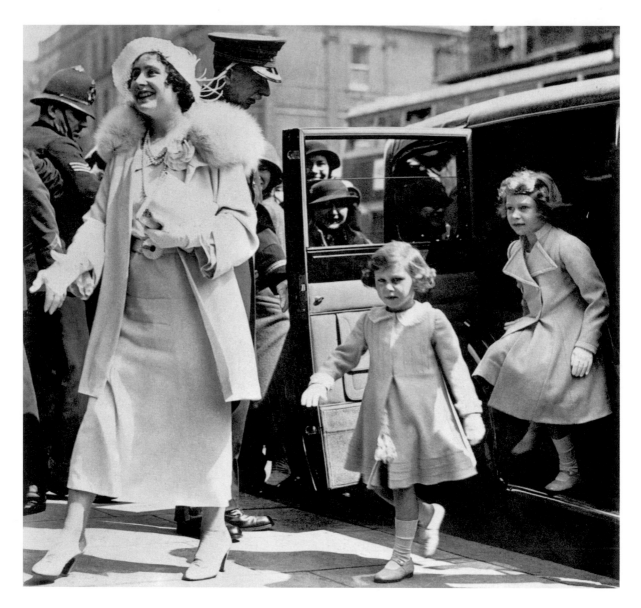

A PUBLIC LIFE BEGINS

Attending public and military events began at an early age for Royal Family members. The Duchess of York brought her two daughters, Margaret Rose (on the pavement) and Elizabeth (alighting from the royal car) to the Royal Tournament in London in the summer of 1935.

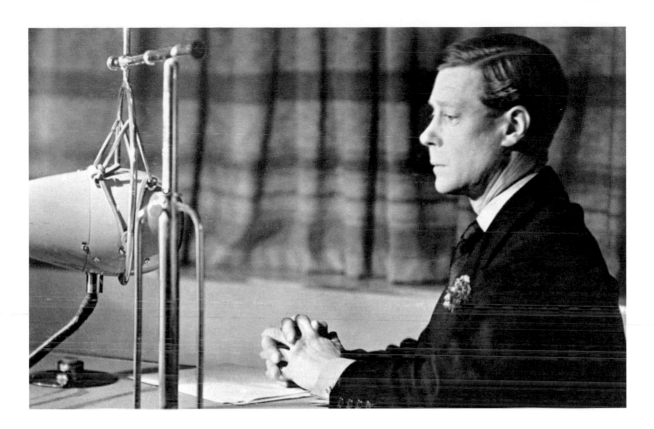

FAMILY AND NATIONAL CRISIS

Towards the close of 1936, the world of the Duke
and Duchess of York was transformed, as were
the prospects of their daughters. The Duke's
elder brother, now King Edward VIII, had come
to the throne on the death of George V on 20
January. However, in 1934 he had fallen in love
with an American woman, twice-married Mrs
Wallis Simpson. No solution could be found
that would allow them to marry and for him to
remain on the throne. By 9 December the King
had decided he must abdicate. Two days later
after the Instrument of Abdication had been
approved by Parliament (and a copy was handed
personally to the Director-General of the BBC
by Prime Minister Stanley Baldwin) he made his
momentous broadcast to the nation.

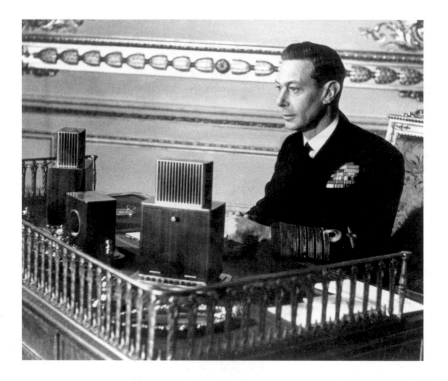

A ROYAL TRADITION

At Christmas 1937, King George VI sat at the microphone giving his first Christmas message, at the same desk as his father had sat, and as his daughter would one day. The annual Christmas message had been introduced in 1932 by George V in the early days of the BBC, as a means of connecting with the people of the nation and the British Empire. The turmoil of the abdication of Edward VIII meant that there was no royal message in 1936, but the run continued almost unbroken thereafter. Nearly a century later, it is as integral a part of monarchy as any of the other ceremonial duties.

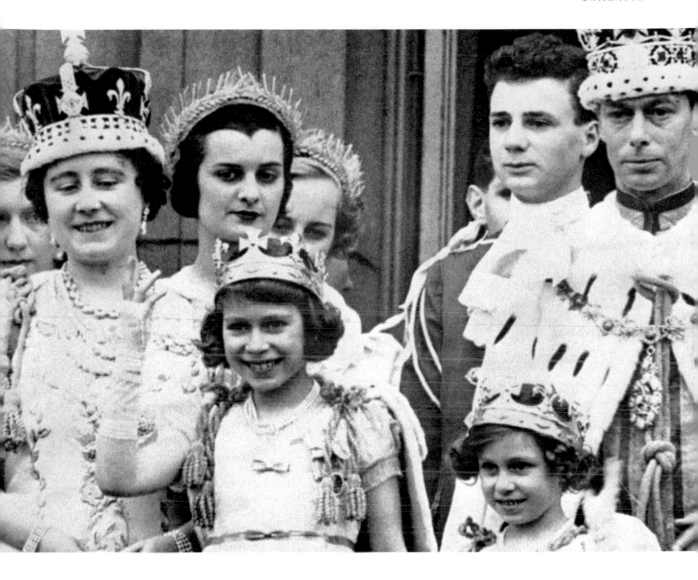

CORONATION 1937

On 12 May 1937, broadcasting history was made when King
George VI and Queen Elizabeth were crowned, and the BBC's
microphones were allowed into Westminster Abbey so that
listeners could hear the coronation service live. This had
been controversial; there was a fear in some quarters that it
would be undignified, but the scruples were overcome. The
young princesses played their part, with little gold coronets
on their heads, and joy on their faces as the Royal Family
took their bows on the balcony of Buckingham Palace.

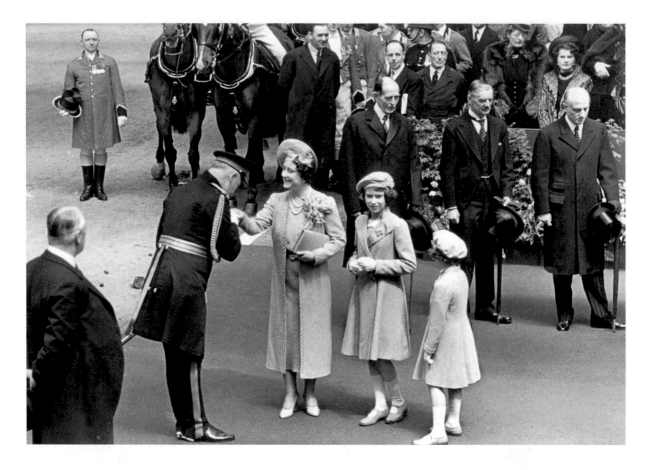

AS WAR APPROACHED

In a television broadcast from Waterloo Station, Princess Elizabeth and Princess Margaret wished their parents King George VI and Queen Elizabeth farewell as they set off for their visit to Canada in May 1939. War with Germany was on the horizon, and although the King had supported Neville Chamberlain's policy of appeasement, reality had now overtaken caution. The royal visit was as much to bolster support in Canada and – in a foray across the border into the USA – to enlist American support if war were to come.

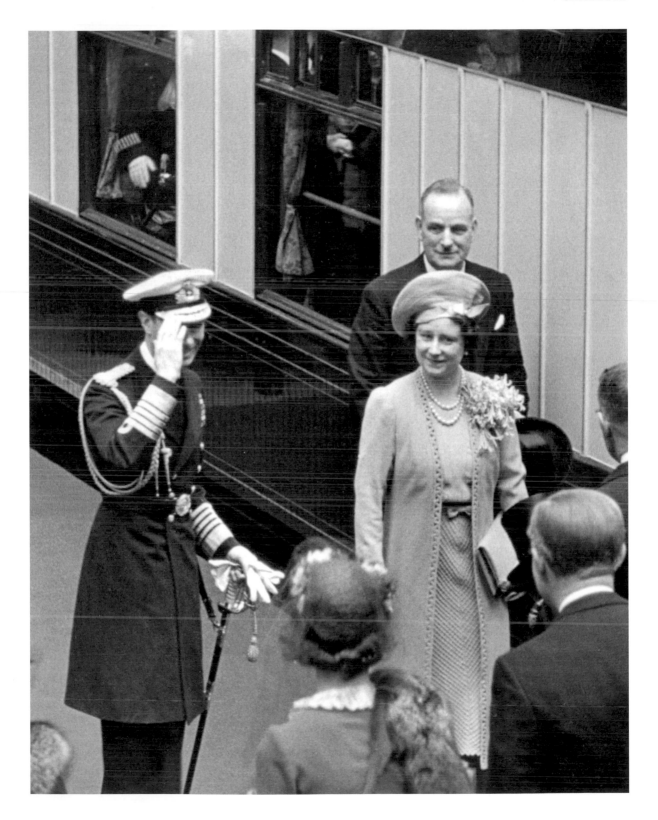

WAR AND AFTER

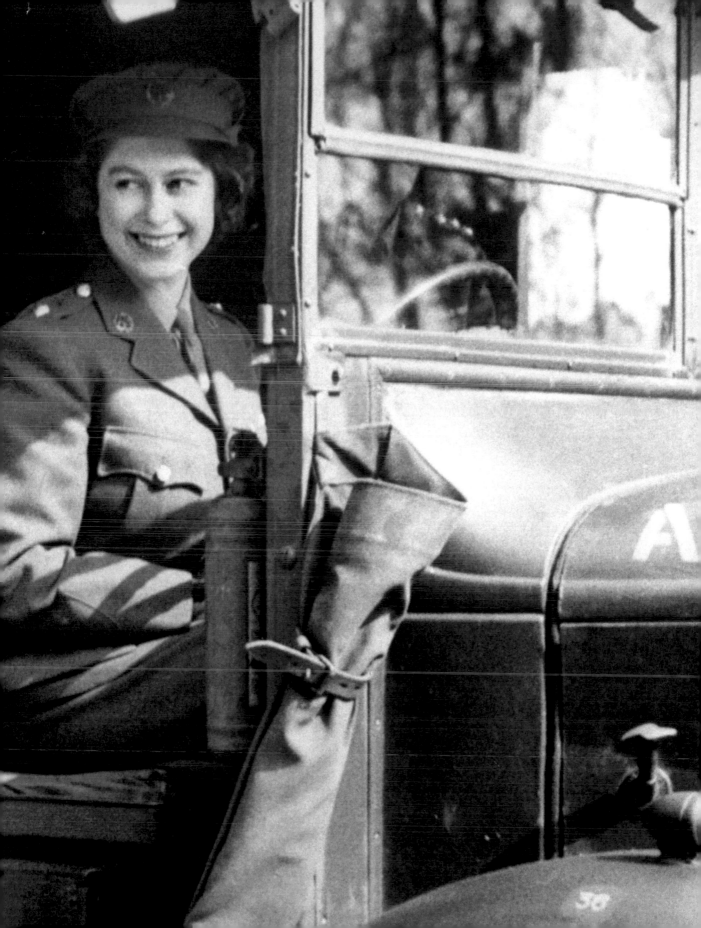

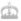

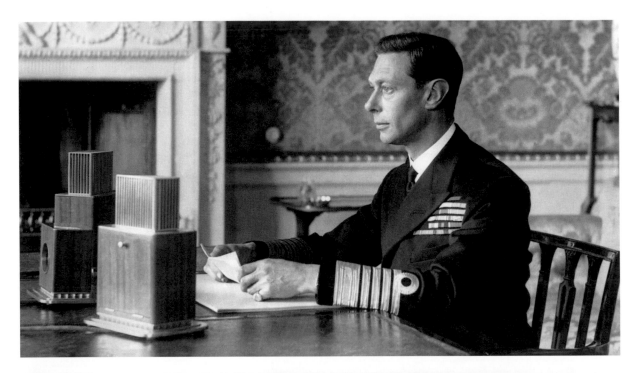

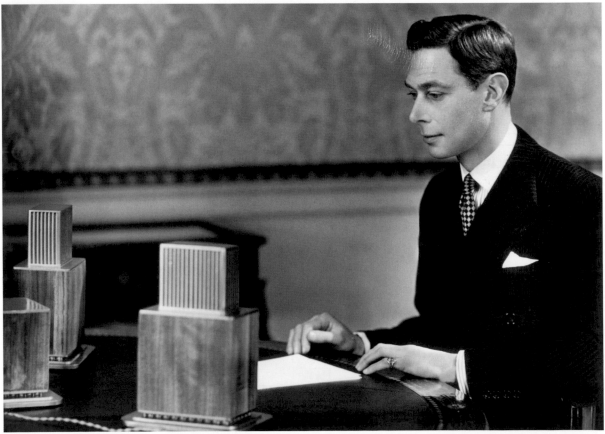

'DO THE RIGHT AS WE SEE THE RIGHT'

War with Germany was declared on 3 September 1939. That night, with the royal children already safely in Windsor, King George VI braced the people of the nation and the Empire for what was to come in wartime. 'The task will be hard. There may be dark days ahead, and war can no longer be confined to the battlefield, but we can only do the right as we see the right, and reverently commit our cause to God. If one and all we keep resolutely faithful to it, ready for whatever service or sacrifice it may demand, then with God's help, we shall prevail.' Eight months later the horror of the evacuation of troops from Dunkirk in the face of the rapid German advance through Belgium into France would bring home the truth of his words.

King George VI was a diffident and uneasy public speaker, hampered by a stammer that was cruelly exposed every Christmas when he addressed the nation and the Empire. The speech for which the King was always remembered was the one he made at Christmas 1939, three months into the Second World War. His words of comfort included lines from a little-known poet, Minnie Louise Haskins, that would stay in people's memories. 'I said to the man, who stood at the gate of the year, "Give me a light, that I may tread safely into the unknown." And he replied, "Go out into the darkness, and put your hand into the hand of God. That shall be to you better than light, and safer than a known way."'

THE PRINCESS'S FIRST RADIO BROADCAST

'Thousands of you in this country have had to leave your homes and be separated from your fathers and mothers. My sister Margaret Rose and I feel so much for you, as we know from experience what it means to be away from those we love most of all.' The two princesses made their first radio broadcast in 1940, at Britain's darkest hour when even children needed to be pulled into the war effort. Before the war, any attempt by the BBC or other media to persuade the Royal Household that Princess Elizabeth might make a radio broadcast had been rebuffed; but now it was different. The princess's words on 13 October opened a radio series on 'Children in wartime' that would be heard at home and abroad. Ten-year-old Margaret Rose had the final words. 'My sister is by my side, and we are both going to say good night to you. Come on, Margaret.' 'Good night. Good night and good luck to you all.'

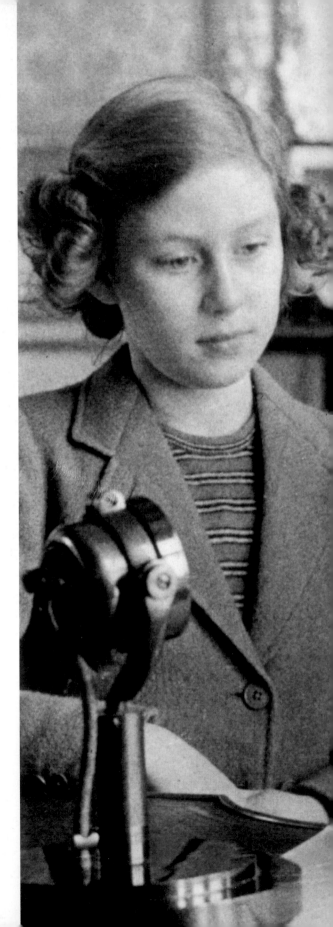

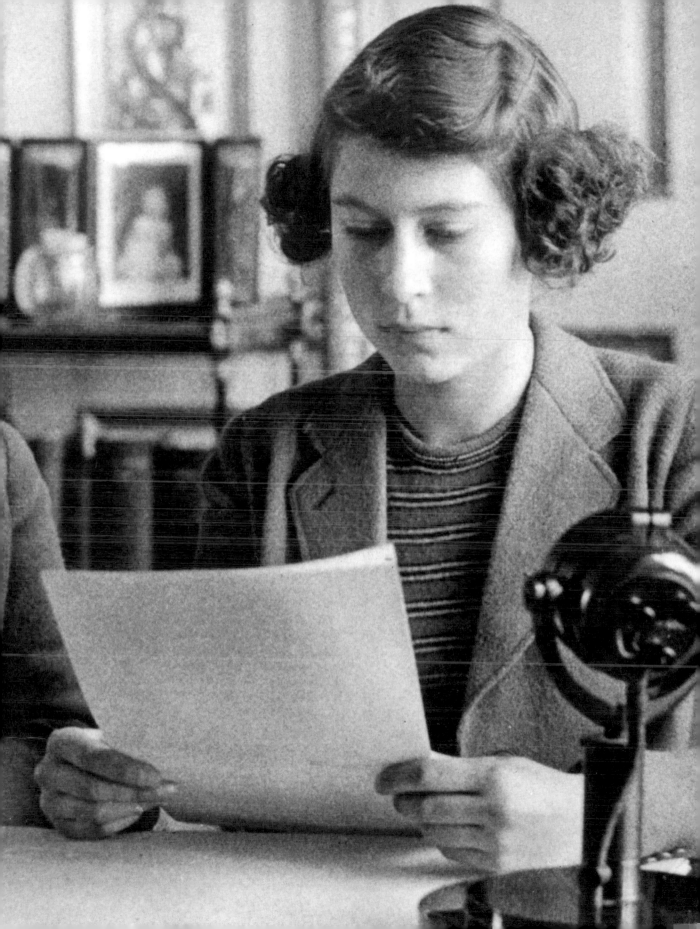

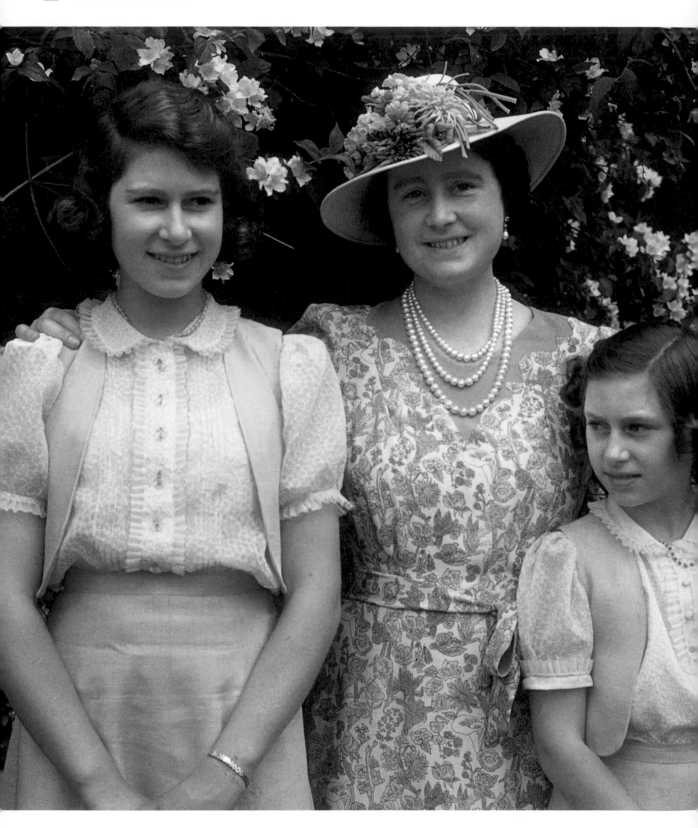

WINDSOR HOME LIFE

Princess Elizabeth and Princess Margaret spent much of the war years at Windsor Castle, with their parents visiting frequently. In 1941, when this photograph of the Queen with the princesses was taken, clothing rationing had been introduced, and the Royal Family were subject to the same restrictions as any other family. Although there had been vocal advice that the Royal Family, and particularly the children, should be sent abroad for safety, they adamantly stayed put.

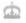

BOMBED

On 13 September 1940, the King and Queen stood amid the
bomb damage at Buckingham Palace. The Palace was
a deliberate target for the Luftwaffe, as its High Command
felt that the destruction of the Royal Palace would demoralise
the nation. It had the opposite effect. The Queen was famously
to say, 'I'm glad we have been bombed. Now I can look the East
End in the face.' The Royal Family mainly lived at Windsor,
and the princesses were kept there away from immediate
harm for much of the war, but their parents felt it was
important to be seen in London and to visit stricken sites.

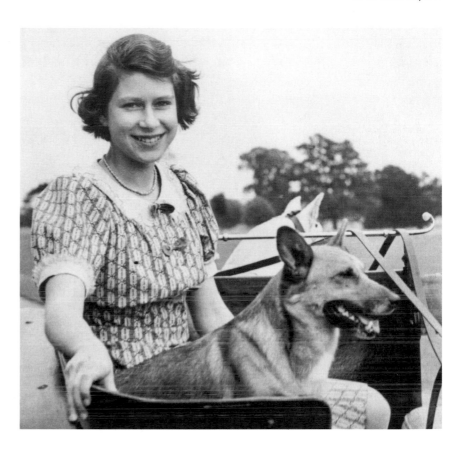

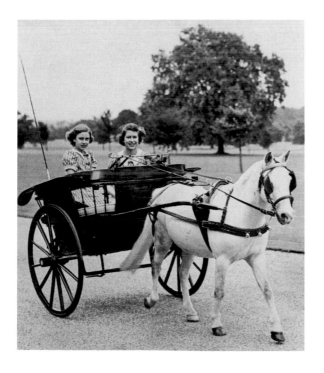

COUNTRY LIFE

The princesses had a simple and often enjoyable life away in Windsor, enjoying themselves in and around the Castle and in the Park with their animals, or driving a pony and cart.

PRACTISING THE PIANO AT WINDSOR

As she was growing up, so Princess Elizabeth expanded her intellectual and political horizons beyond the nursery and her governess, Marion Crawford, the beloved 'Crawfie'. The Vicomtesse de Bellaigue taught her French, the Master of Eton schooled her in constitutional affairs, and she read widely, with a preference for historical fiction. In 1942 she was appointed Colonel-in-Chief of the Grenadier Guards, aged 16, her first proper venture into ceremonial life.

CHRISTMAS PERFORMANCE

At Christmas, the princesses took to the stage at Windsor Castle, with starring roles in pantomimes they also helped devise. These became ever more elaborate as the war continued, and audiences were delighted by the dancing, costumes and bad jokes.

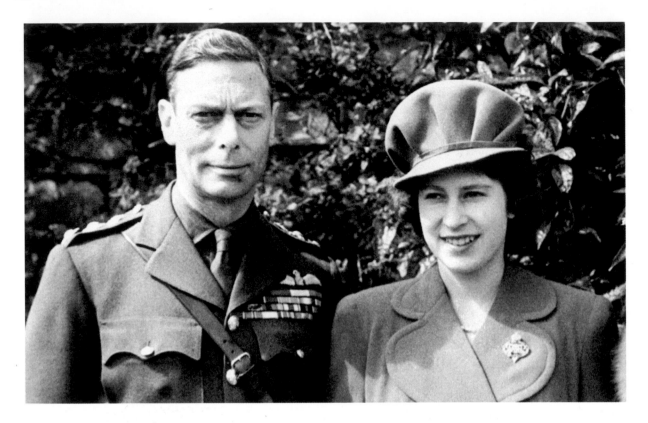

COMING OF AGE

On the Princess's 18th birthday, she was
of age to rule in her own right without
a regent. Yet a legal anomaly meant that
if the King were abroad or incapacitated
Princess Elizabeth could not be a Counsellor
of State and deputise for him until she was
21. With the anomaly corrected by a hastily
passed statute, Princess Elizabeth became
a Counsellor during the King's visit to Italy in
July 1944 when radio listeners followed with
mounting expectancy the Allied advance
through Europe after the D-Day landings.
As Counsellor, the Princess signified the
Royal Assent to Acts passed by Parliament,
her first proper constitutional duty.

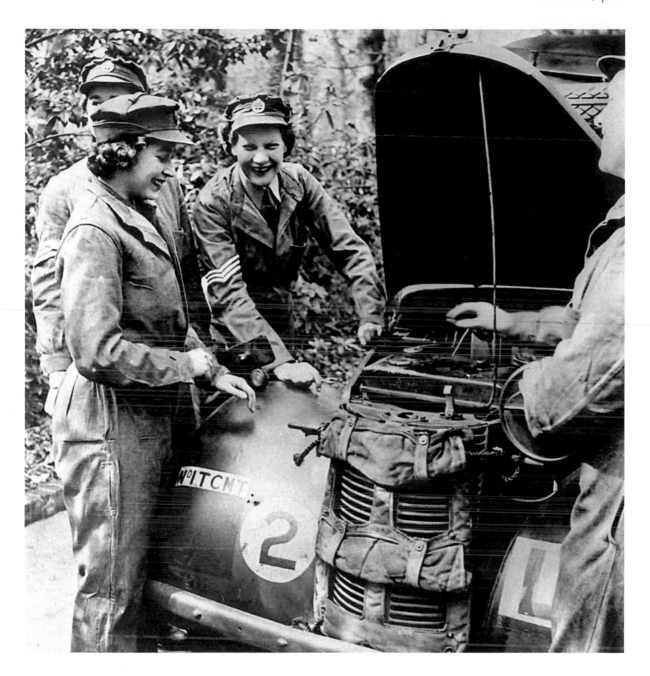

In 1945 the 18-year-old Princess
Elizabeth joined the war effort herself.

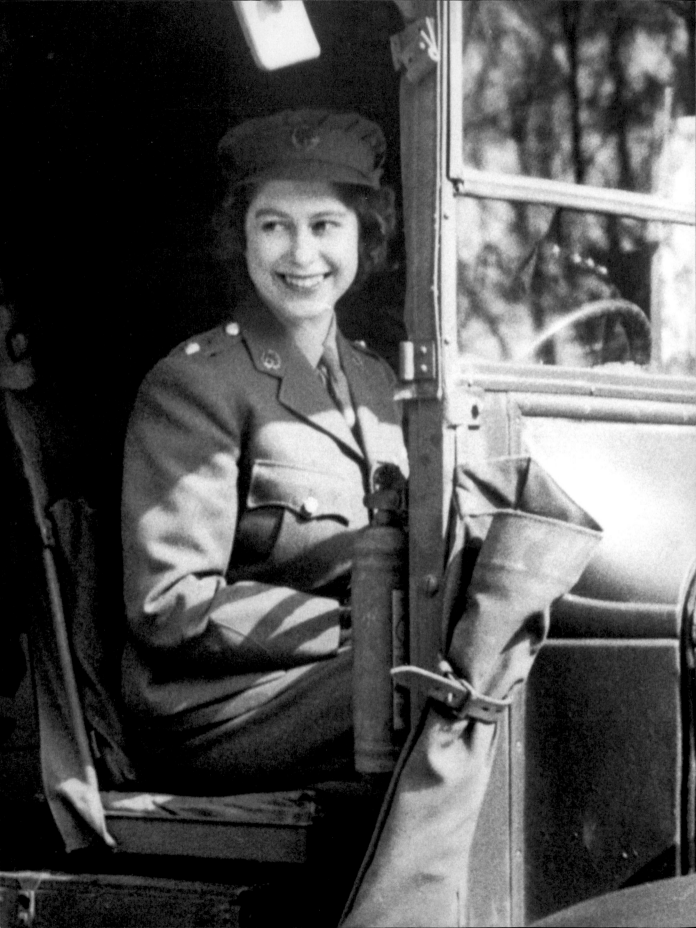

TO BE OF SERVICE

As the Second World War entered its final phase, Princess Elizabeth became a new royal heroine; she was beautiful, she exuded health and vitality, and she embodied the hope that when the war was over a new generation would triumph. Gradually she emerged into public life, and radio listeners and cinema newsreel audiences followed her as she toured parts of the country, launched ships and made her first public speeches. Although her parents were reluctant, Princess Elizabeth overcame their resistance to be allowed to join the Auxiliary Territorial Service, one of the women's forces, in February 1945.

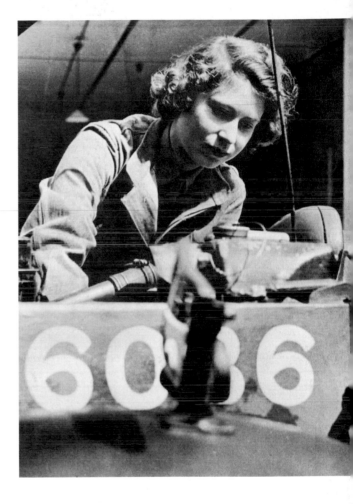

Princess Elizabeth undertook her ATS vehicle maintenance training while serving with No 1 MTTC at Camberley, Surrey, and after six weeks she qualified as a driver. Reportedly, her vehicle training stood her in good stead in later years in difficult circumstances of a breakdown in remote Scotland.

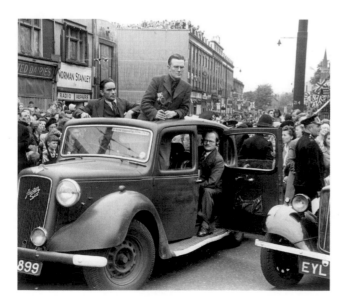

VICTORY

When Victory in Europe came, the two princesses slipped away from Buckingham Palace to join the jubilant crowds in the Mall. The next day, 9 May 1945, the King and Queen toured the East End of London with the two princesses, one of a series of wartime visits the royal party had made to boost morale in the most bombed part of the capital. Following the royal party in a recording car was Stewart MacPherson, who reported on the jubilant scenes.

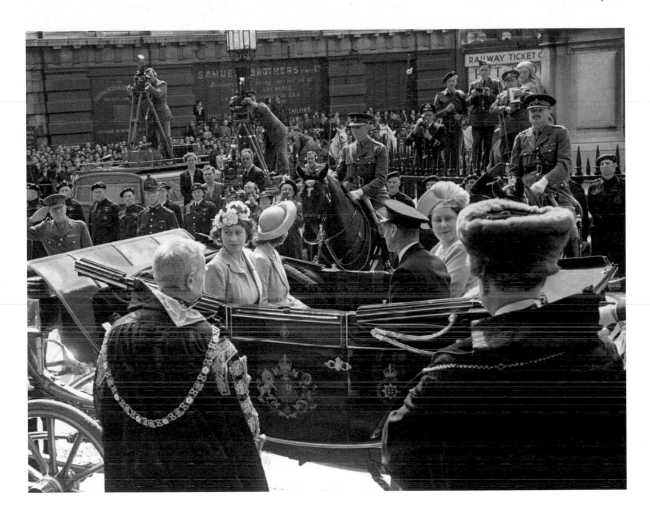

Although the war against Japan
was to continue until August,
May 1945 was the month for
celebrations of Victory in
Europe. On 13 May the King
and Queen attended a national
service of thanksgiving at St
Paul's Cathedral with Princess
Elizabeth and Princess Margaret.
The nations listened to their
wireless sets, as they had listened
attentively for news in the dark
days of war.

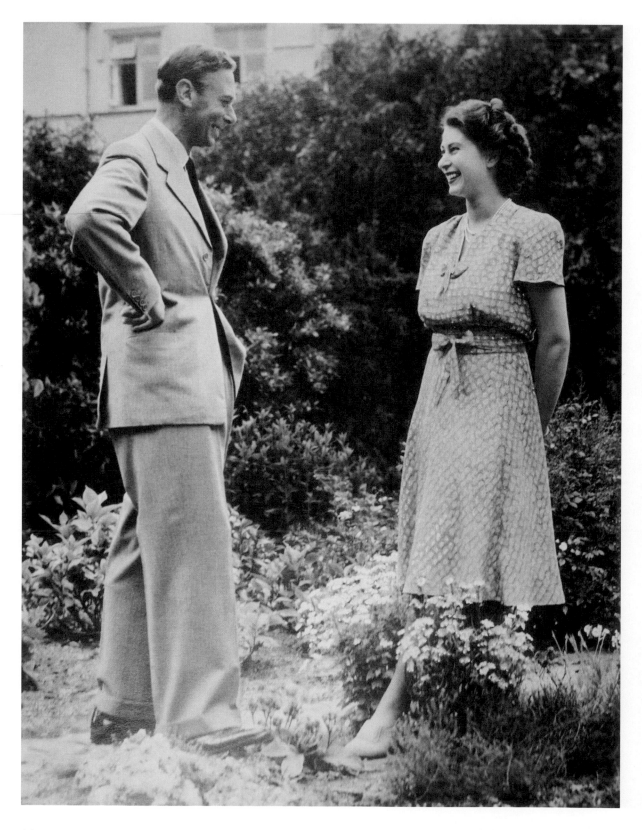

GROWN INTO WOMANHOOD

By the time King George and Princess Elizabeth were pictured enjoying the sunshine in July 1946, the Princess was being courted by dashing young naval lieutenant Philip Mountbatten. He was her distant cousin and a junior member of the Greek royal family. The relationship blossomed, and a year later the couple were engaged.

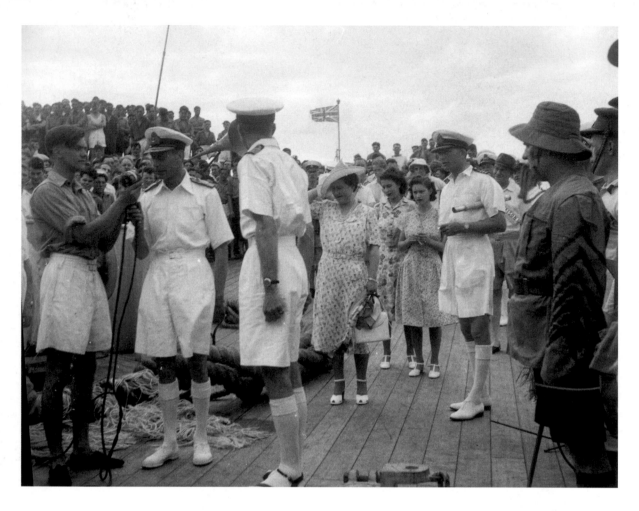

A ROYAL TOUR TO SOUTH AFRICA

In 1947, the Royal Family set sail for South Africa. As with many royal tours, there was a political as well as a social motive, aiming to keep South Africa an integral part of the British Empire in the face of Afrikaans opposition and the imminent introduction of apartheid. Ultimately, the efforts failed, and South Africa became a republic and left the Commonwealth in 1961. Heading south on HMS *Vanguard* at the crossing of the equator, the King – a naval man himself – gave the order to splice the mainbrace.

On the eve of her 21st birthday in 1947, during the royal visit to South Africa, Princess Elizabeth sat for an informal photograph. BBC Television broadcast a series of short films to viewers at home, following the first royal tour since 1939 and the outbreak of war.

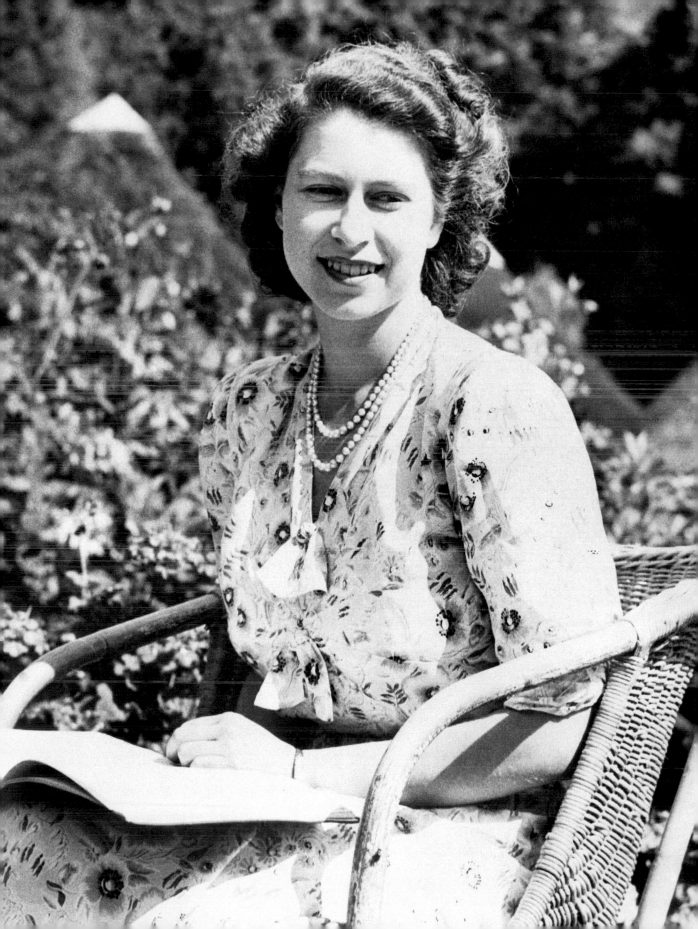

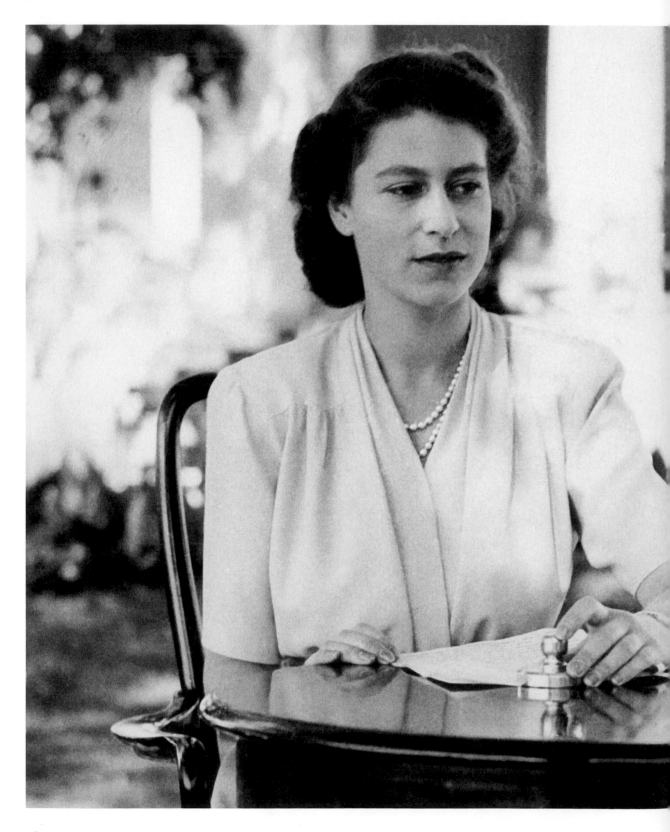

21 APRIL 1947

On Princess Elizabeth's 21st birthday she
reviewed South African troops, attended
a ball in her honour, and made a radio
broadcast to the Empire. In her words,
she dedicated herself and her life ahead.
'I declare before you that my whole life,
whether it shall be long or short, shall be
devoted to your service.' Almost exactly five
years after she set sail, she became Queen,
in succession to her father King George VI.
A long life of service would lie ahead of her.

MARRIAGE
AND FAMILY

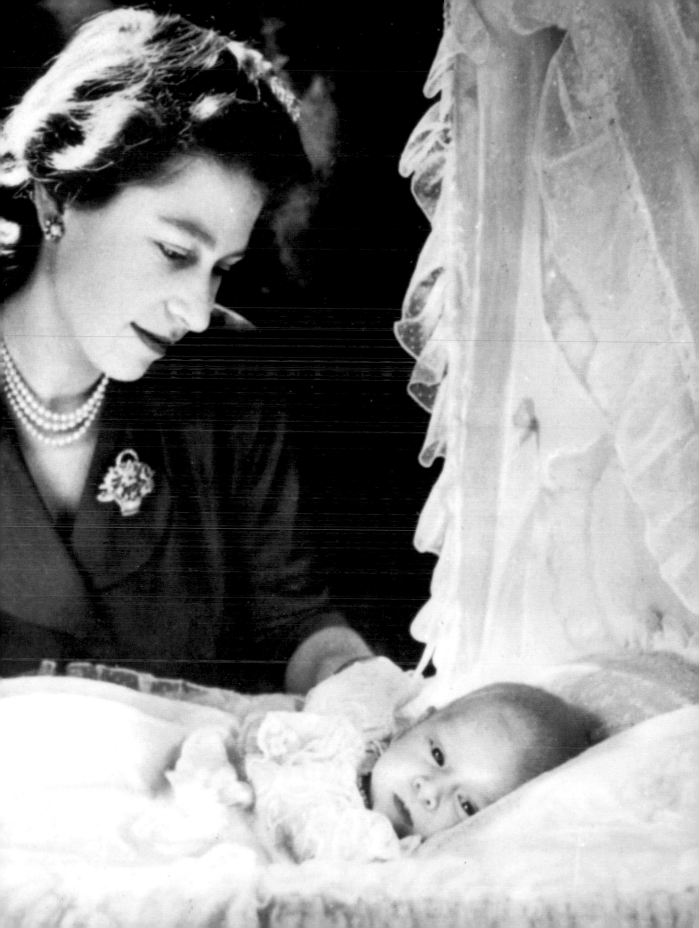

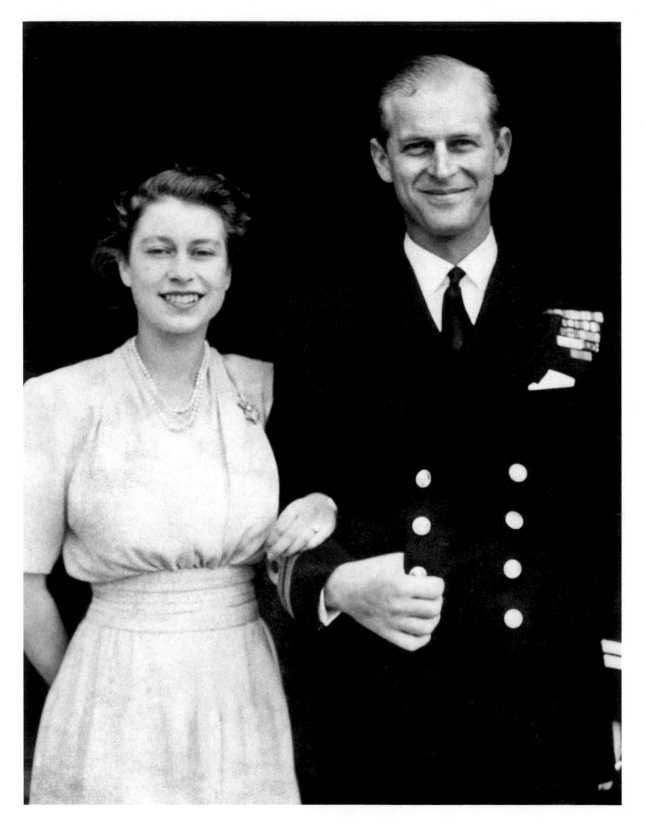

A ROYAL ENGAGEMENT

The BBC had been quick off the mark in planning a series of radio talks to commemorate the Princess's engagement to Philip Mountbatten, assuming it would be announced immediately after the South African tour. Presented as a nephew of Lord Louis Mountbatten, and as a man who had been educated in Scotland and a wartime naval hero, Prince Philip was quickly absorbed into the royal circle. As a minor member of the Greek royal family, and with extensive links with other European royal and aristocratic families, he had pedigree. In the event, the announcement was delayed, and came on 9 July 1947.

Theirs was to be a splendid and public wedding, the first royal wedding to be televised. The television cameras were placed at every vantage point along the processional route to and from Westminster Abbey.

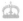

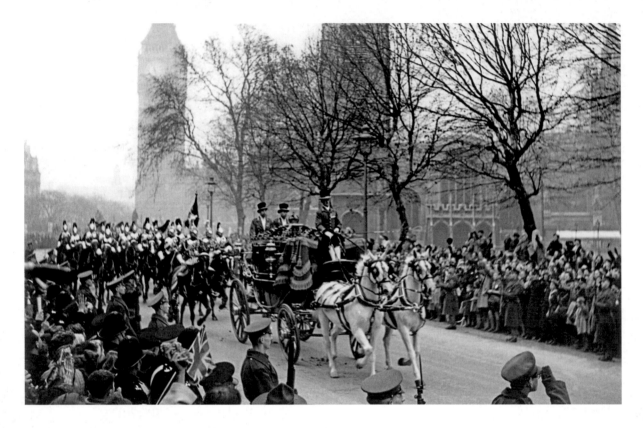

ROYAL WEDDING

The King arrived at Westminster Abbey with his daughter Princess Elizabeth, in the Irish State Coach, for her wedding on 20 November 1947. This had become a major media event, with radio and television commentary, and great crowds lining the processional route from Buckingham Palace eager to catch a glimpse of the royal bride. Probably no previous royal wedding had attracted such eagerness and publicity.

Princess Elizabeth with Prince Philip, created Duke of Edinburgh, left Westminster Abbey after their marriage. The ivory silk wedding dress was designed by Norman Hartnell. Inspired by Botticelli's painting of Primavera, the gown was embroidered with white seed pearls, imported from America, silver thread, sparkling crystals and transparent appliqué tulle embroidery, with a 13-foot train. The dress was a source of considerable public discussion. It was an occasion that was taken up with joy, described by an American commentator as 'a movie premiere, an election, a World Service and Guy Fawkes Night all rolled into one'.

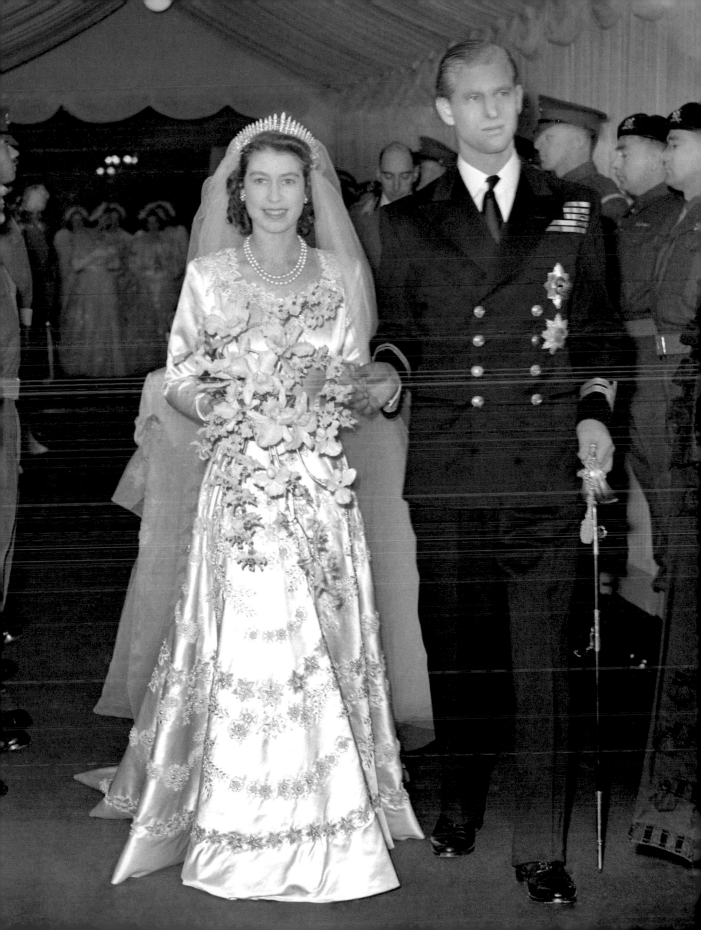

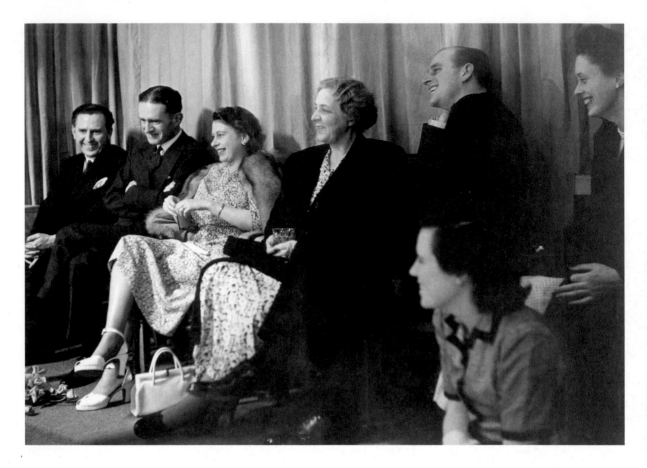

TELEVISION REVIVED

The new medium of television was
suspended during the Second World War,
and transmissions started again once the war
was over and as straitened finances allowed.
In July 1948 Princess Elizabeth and the Duke
of Edinburgh visited Alexandra Palace to see
television in operation for themselves, and
watched a live production of *Hulbert Follies*.
With the royal party were BBC dignitaries
including Lady Reading (centre), a BBC
Trustee who had achieved lasting fame from
her wartime work as founder of the Women's
Voluntary Service.

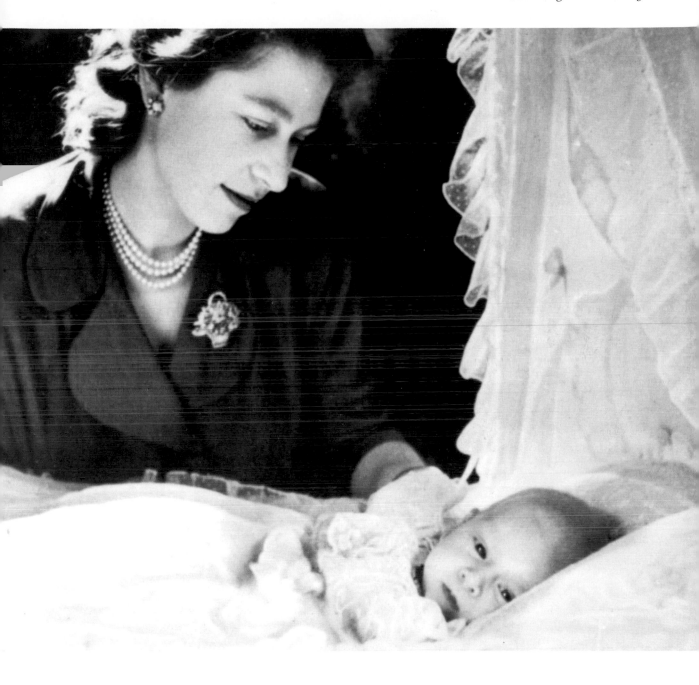

SON AND HEIR

A year after the wedding, a son and heir, Charles
Philip Arthur George, Duke of Cornwall, was born.
The radio proudly announced that the Princess had
been safely delivered of a prince.

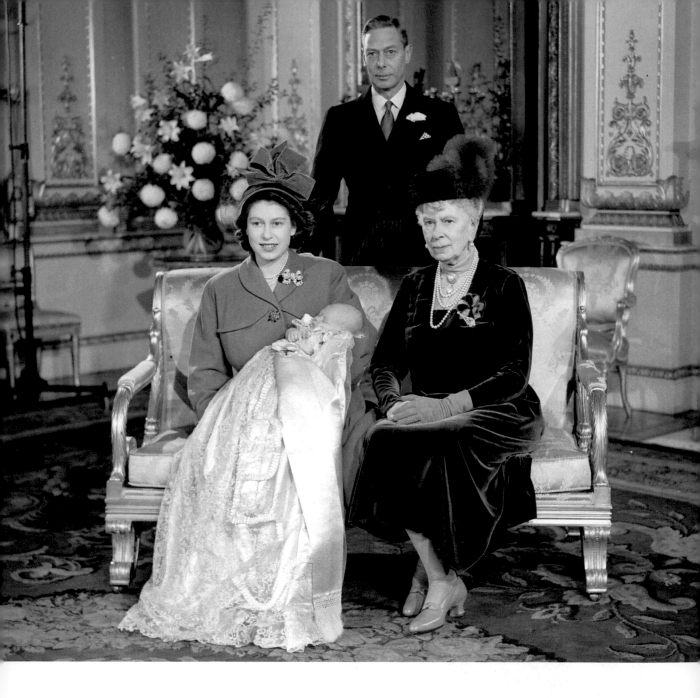

ROYAL BAPTISM

Prince Charles was baptised ten days before Christmas
in 1948, and four royal generations were captured in
the official photograph: Princess Elizabeth and her
son, her father King George VI and his mother Queen
Mary. Two years later, Charles's sister Anne was born,
and for a while the new Royal Family was complete.

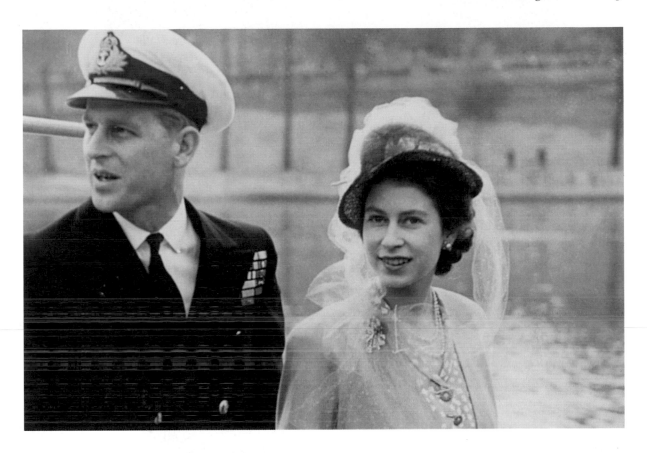

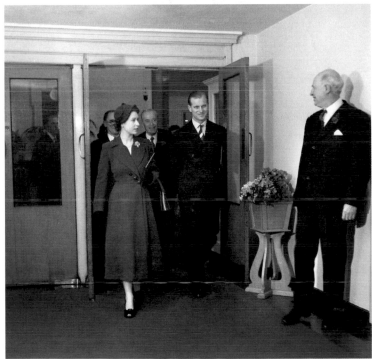

In May 1948 the recently married couple made their first official overseas visit, to Paris. After visiting Versailles, and following the exact route Queen Victoria had taken on her visit, Princess Elizabeth and Prince Philip enjoyed a boat trip on the Seine.

A Royal Family visit to the television studios at Alexandra Palace, revived after closure in the war years, to see the relatively new medium for themselves.

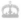

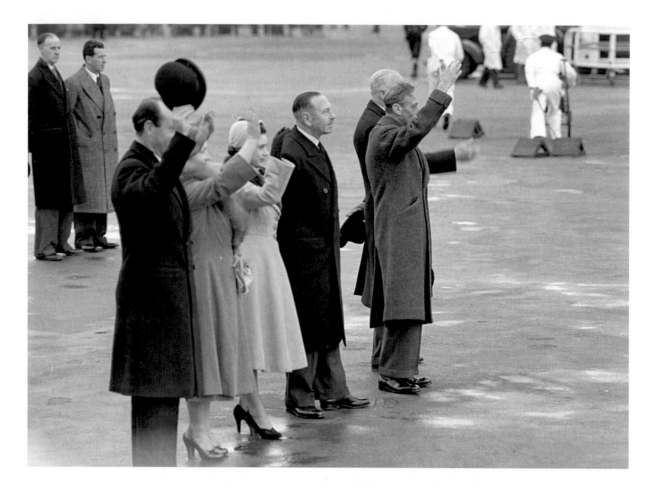

A ROYAL FAREWELL

As the health of the still relatively young King declined,
Princess Elizabeth took over some of the royal duties from
him. On 31 January 1952, Princess Elizabeth and Prince
Philip set off on a Commonwealth tour in place of her
father, who was now too unwell to travel. The King and
Queen, together with Princess Margaret, stood on the
tarmac at London Airport to wave the couple farewell.
This was the last the Princess saw of her father; just
a few days later, on 2 February when she was holidaying
in Kenya ahead of the tour, the news was brought to her
that he had died at his Norfolk home at Sandringham in
the night. When asked what name she would take, she
said her own, of course, and so became Elizabeth II.

THE QUEEN

She had left Britain a princess, and returned a week later a queen. Her prime minister Sir Winston Churchill stood waiting on the tarmac at the airport to greet Elizabeth II.

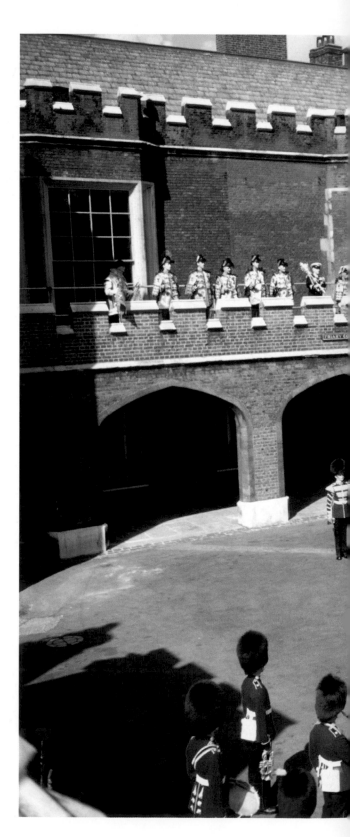

PROCLAMATION

At St James's Palace, Garter King of Arms, Sir George Bellew, flanked by the heralds, proclaimed the new sovereign, before setting off to various traditional locations in London to make the same proclamation. The Accession Council was held in the State Apartments immediately behind where the heralds stood. 'My heart is too full,' the new Queen said, 'for me to say more to you today than that I shall always work as my father did.'

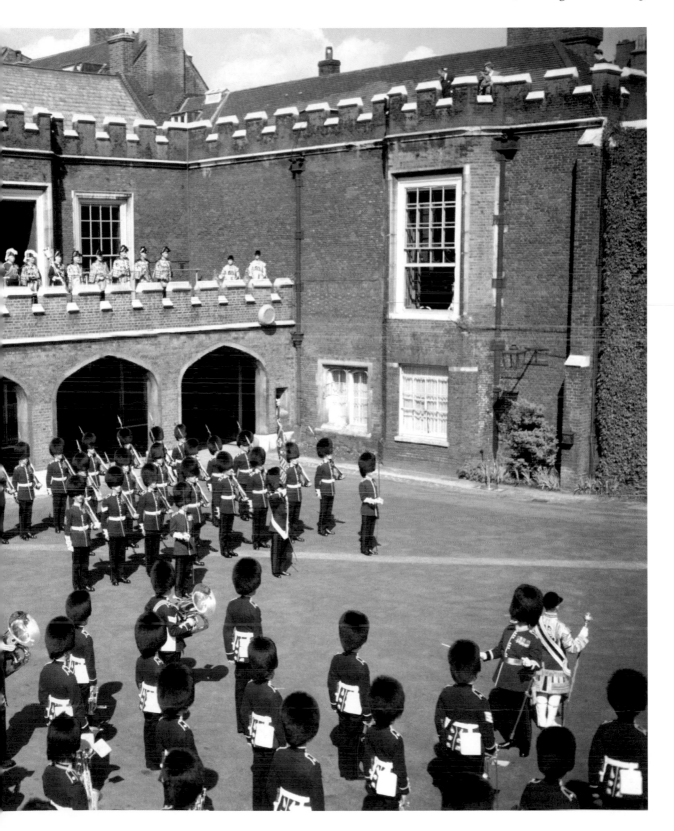

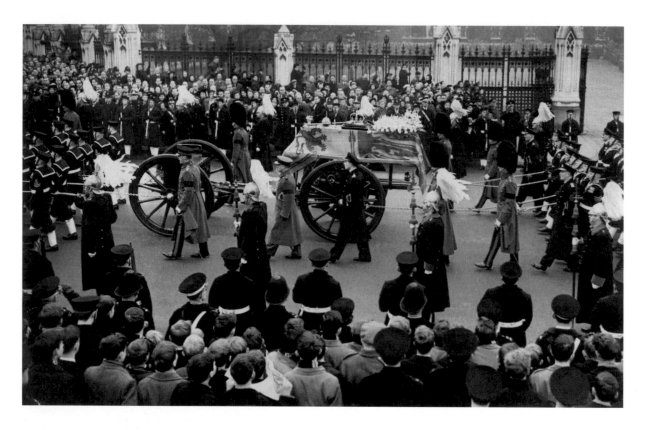

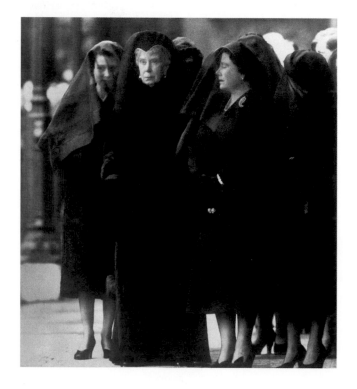

ROYAL FUNERAL

At George VI's funeral, the gun carriage, pulled by sailors, bore his coffin with the royal standard and imperial crown from the funeral at Westminster Abbey, and then to St George's Chapel Windsor for burial.

Three queens stood in mourning for King George VI: his daughter the new Queen Elizabeth II, his mother Queen Mary, and his widow Queen Elizabeth the Queen Mother. They watched as his coffin was brought to Westminster Hall to lie in state, as his father's had been only 16 years before.

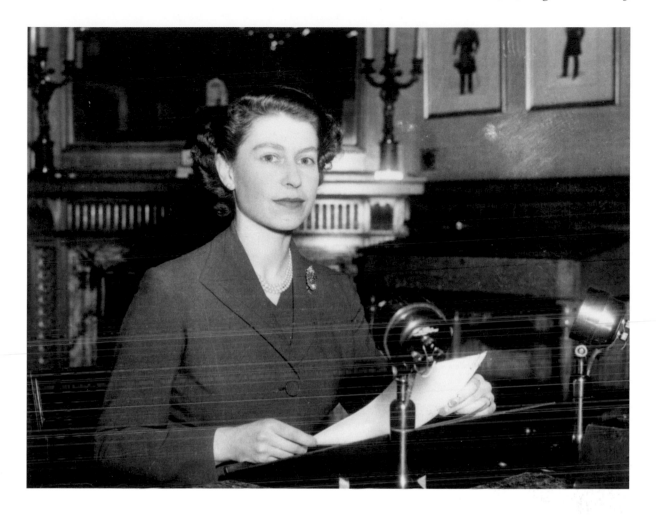

CHRISTMAS MESSAGE

At Christmas 1952, the Queen made her first Christmas broadcast. The radio microphone took her words around the globe. 'Each Christmas, at this time, my beloved father broadcast a message to his people in all parts of the world. Today I am doing this to you, who are now my people ... Most of you to whom I am speaking will be in your own homes, but I have a special thought for those who are serving their country in distant lands far from their families.'

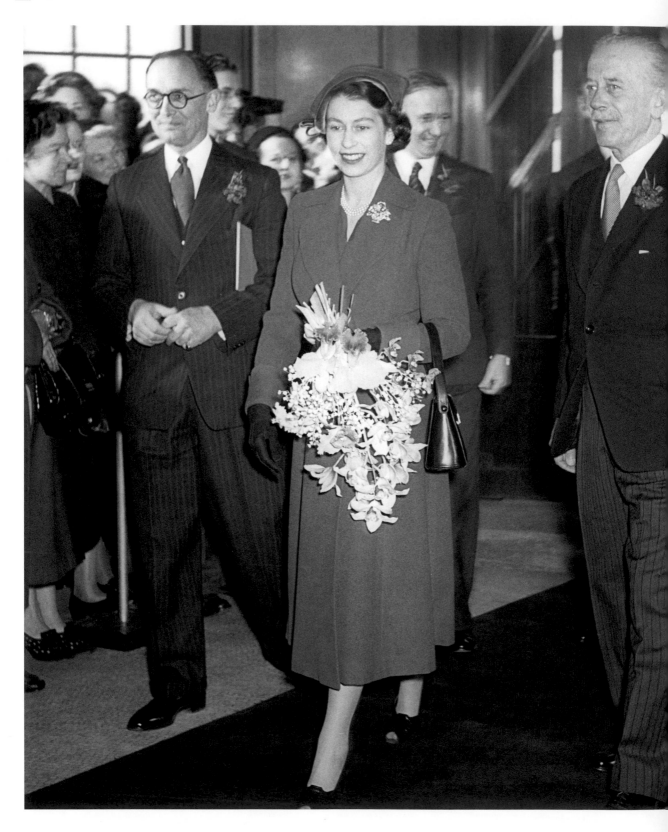

BROADCASTING HOUSE **1953**

As a tribute to the new Queen and her reign, the BBC mounted a special performance by leading artists from radio at Broadcasting House and the Maida Vale Studios on 27 February 1953. The Queen came with the Duke of Edinburgh, to be greeted by the Director-General Sir Ian Jacob (right). There was then much talk of a new Elizabethan Age, and hope for a flowering of talent to match that of the late 16th century. Although reality would soon take over again, the majesty and ceremonial royal life were reinvigorated by the new Queen's coronation.

CORONATION

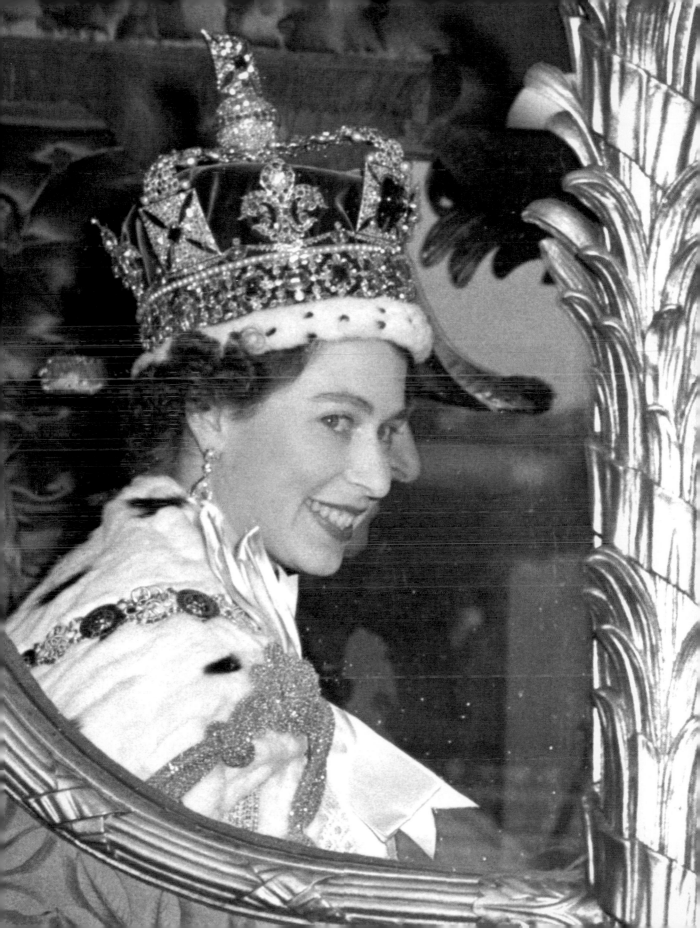

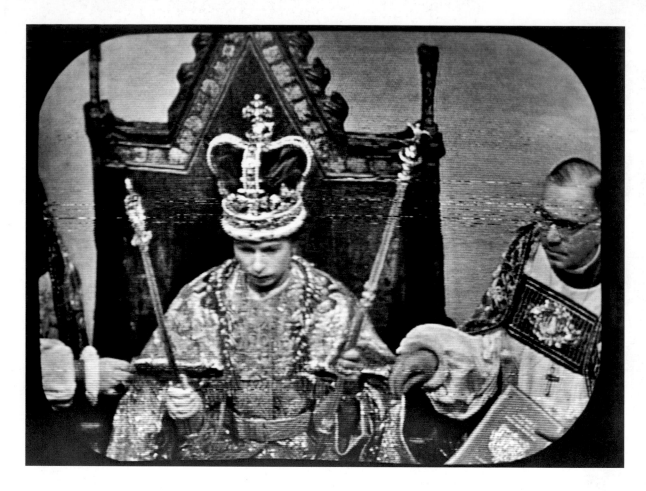

A NEW ERA BEGINS

The Queen enthroned as no one had seen a crowned monarch before, in close-up and on television. The coronation came when post-war austerity was nearing its end, and when millions saw television for the first time. The day's events transformed ownership and the reach of television, and helped usher in a new media age. An audience of 27 million people watched the live transmission.

PAGEANTRY ON TELEVISION

The date of the Queen's coronation was set as 2 June 1953. Prince Philip was put in charge of the preparations committee. He hoped for some more modern elements to be introduced, but this was to be resolutely a historic, pageantry-filled occasion that responded to the past more than the future. What was different was that the television cameras were allowed into Westminster Abbey as well as broadcasting the processions and celebrations in the streets.

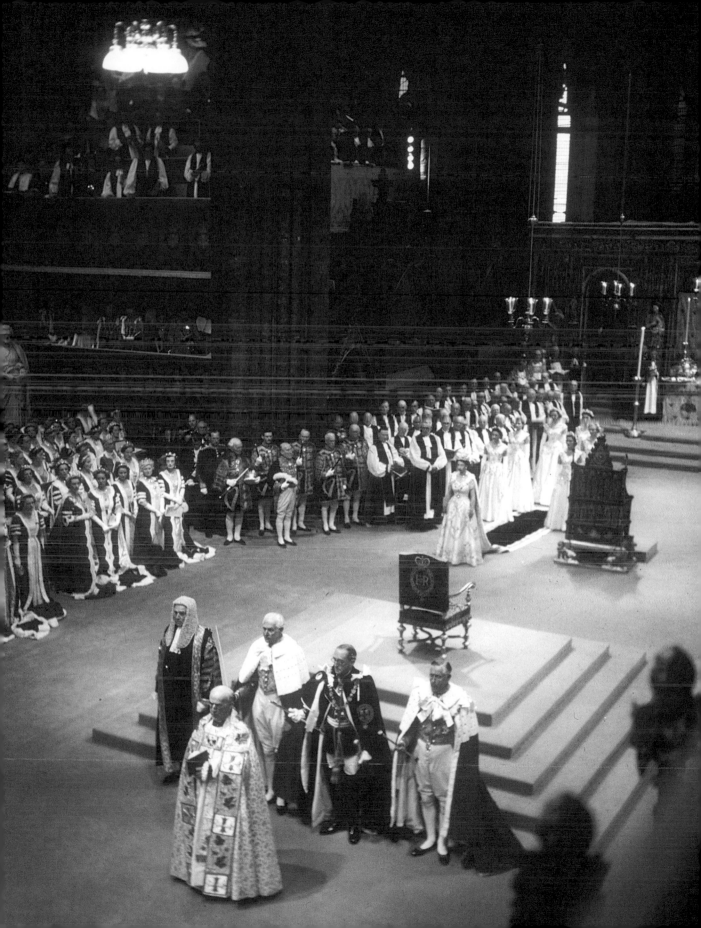

At first, the Queen was thought to be unwilling to have the ceremony televised; a coronation was both sacred and privileged, and there was apprehension that it would be unsuitable for television. After a cascade of popular and media protest, the Queen led the decision to allow the cameras in.

Key to the decision to televise the coronation was the influence of Richard Dimbleby, who was to provide the commentary in his rich voice and stirring prose. Listeners and viewers remembered well his wartime reports from the front line and at the liberation of Belsen. His words became as integral a part of the proceedings as the images: 'Her Majesty returns the orb and the archbishop now places on the fourth finger of her right hand the ring, the ring whereupon is set a sapphire and on it a ruby cross. This is often called the Ring of England.'

Massed troops marched in formation, accompanying the Queen as she travelled from Buckingham Palace to Westminster Abbey.

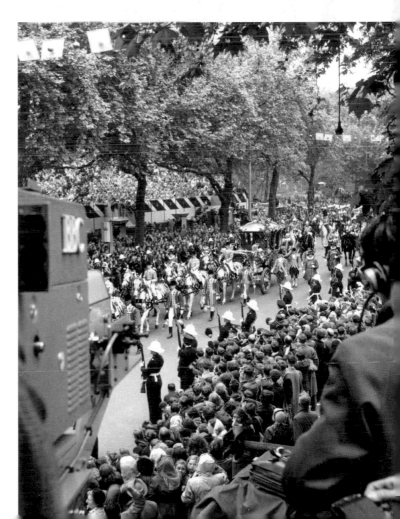

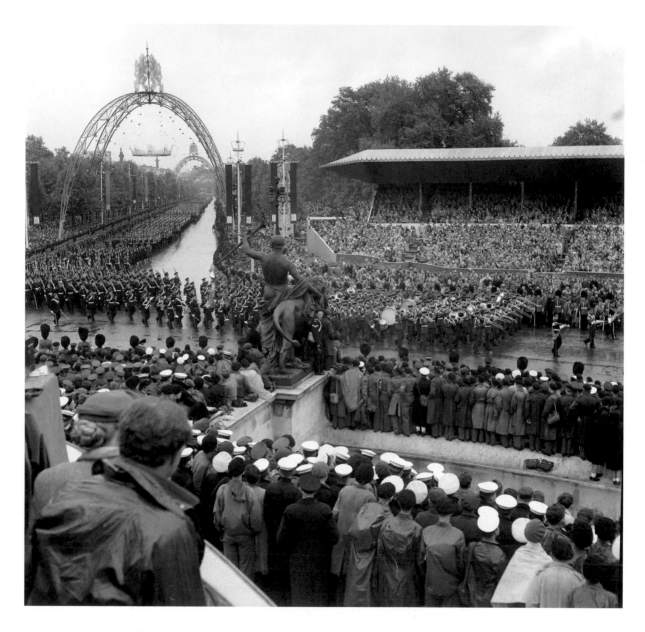

Triumphal arches and stands for spectators
were erected along the processional route,
taking a different way to and from the Abbey.
Seats in the stands were allocated by ballot.
People waited patiently for hours to catch
a glimpse of the procession, their excitement
only partly hindered by the heavy, cold rain
that followed days of good weather.

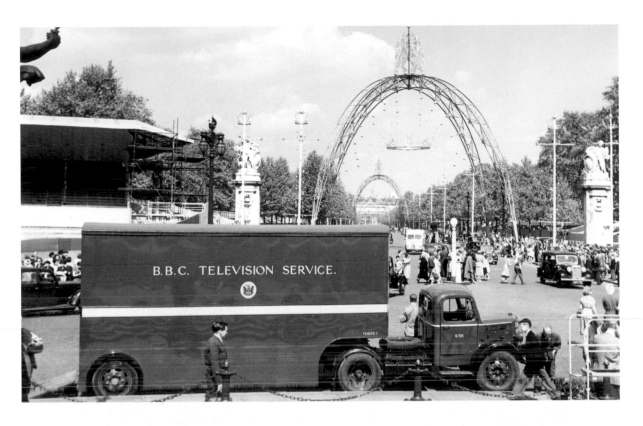

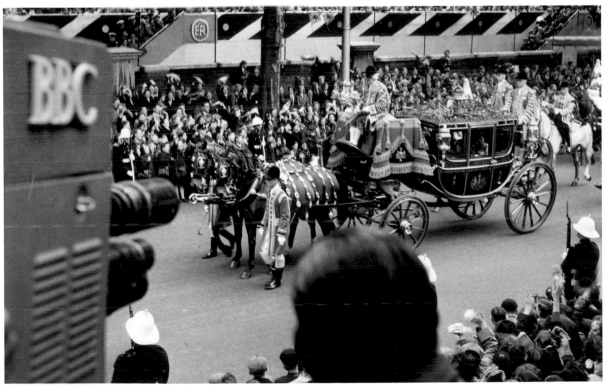

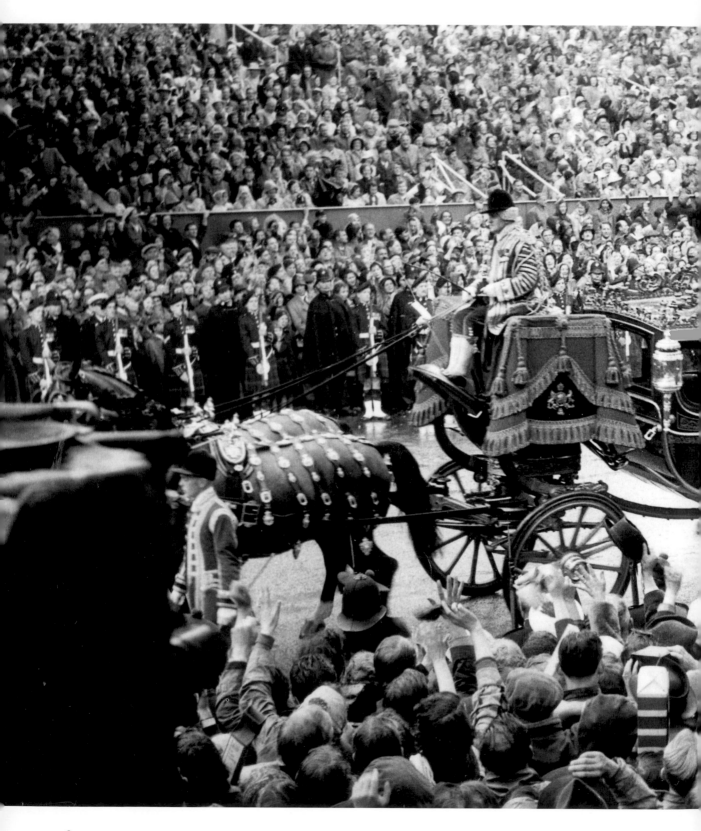

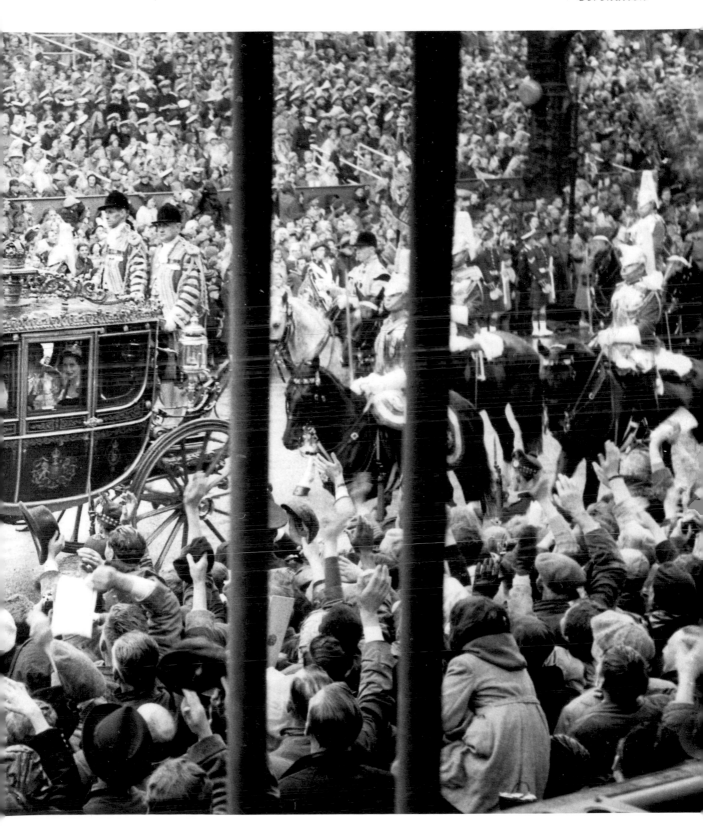

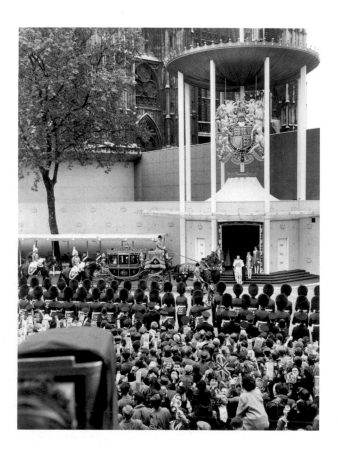

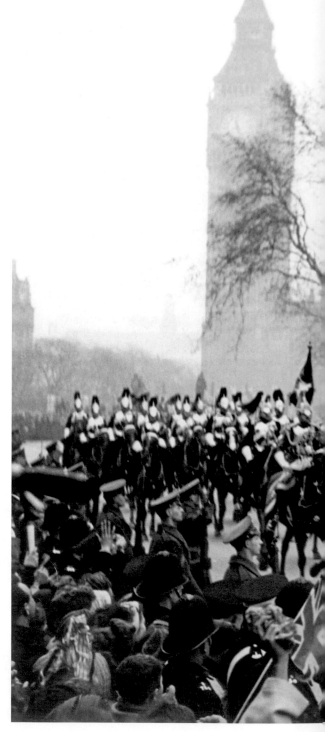

With memories of her own coronation in 1937, the Queen Mother arrived at the west door of Westminster Abbey, accompanied by Princess Margaret, to be greeted by the Earl Marshal, the Duke of Norfolk.

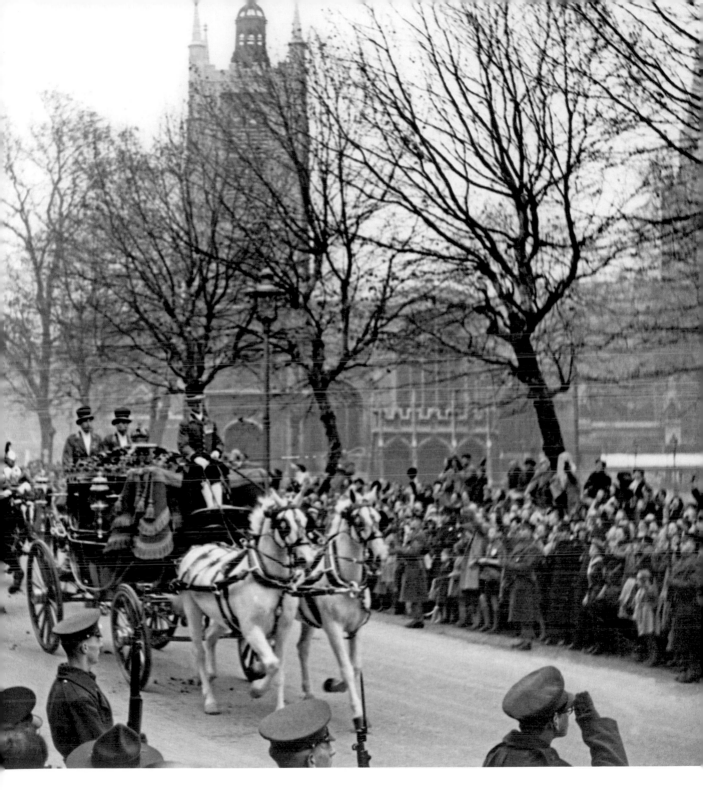

The Gold State Coach passing through
Parliament Square and approaching
Westminster Abbey.

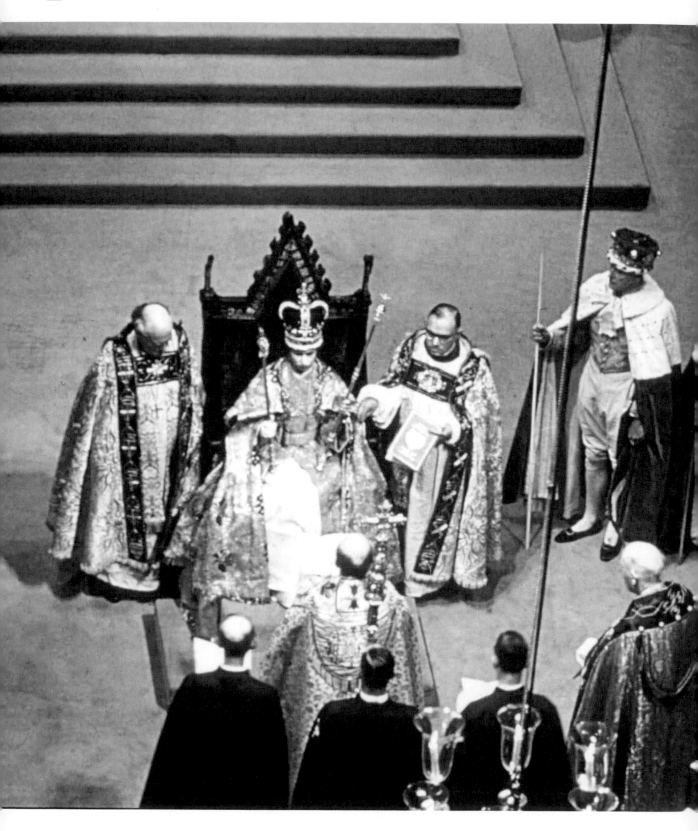

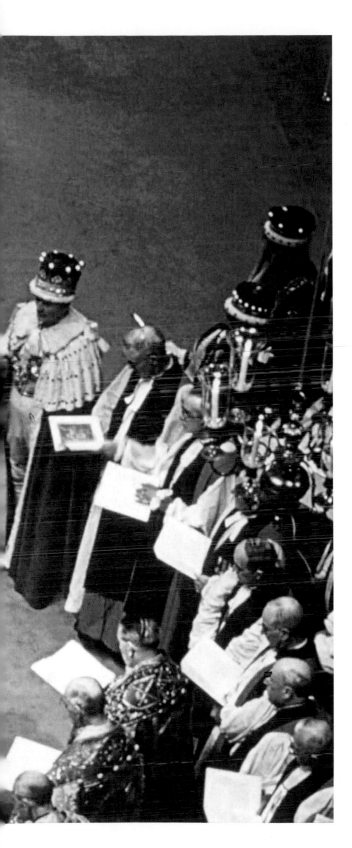

Supported by the bishops of Durham and of Bath & Wells, the Queen sat crowned with St Edward's Crown and enthroned, before she received the homage of the peers of the realm, her husband the first in line to swear allegiance to her.

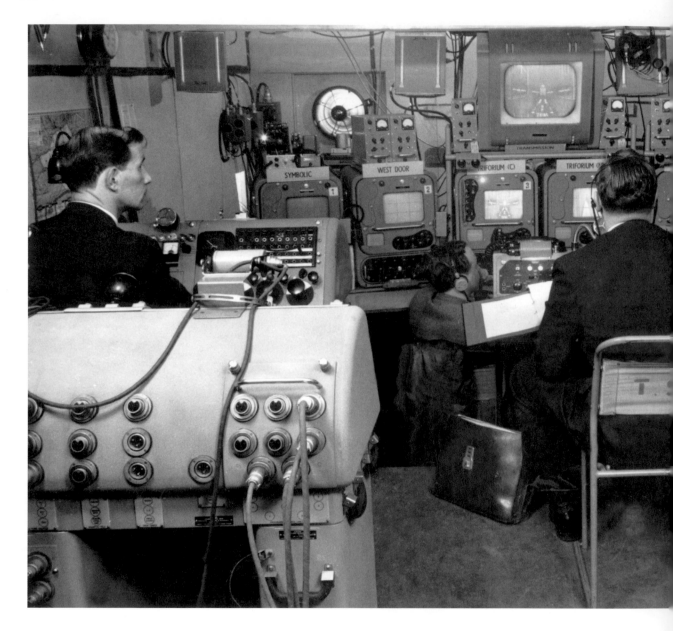

The 1953 coronation was the largest and most technically challenging undertaking the BBC had ever faced. Outside broadcast cameras, personnel, reporters, switching rooms, editing suites, vision mixers and technical equipment of all kinds were required. A temporary control room was set up in Westminster Abbey. Cameras covered the vantage points on the processional route as well as outside and inside the Abbey. Air transport was on standby to take film of the event out to the waiting world. New transmitting equipment was brought into play.

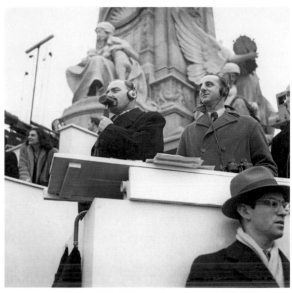

Every good vantage point – here, the Victoria Memorial outside Buckingham Palace – was commandeered as a place for cameras, sound recordists and commentators.

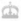

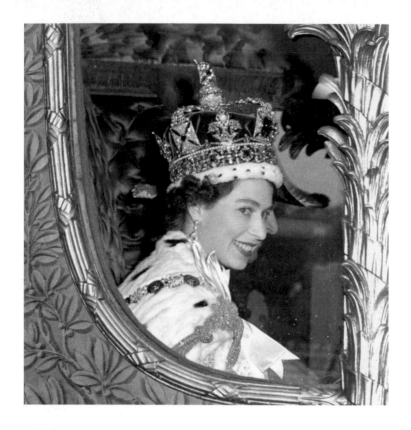

With a wide smile for the crowd, and the Imperial State Crown on her head, the Queen set back for Buckingham Palace in the Gold State Coach.

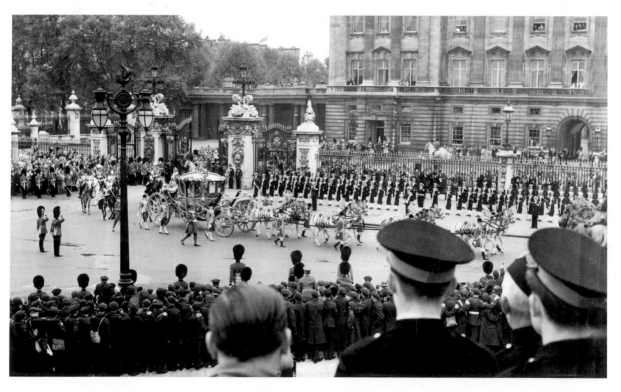

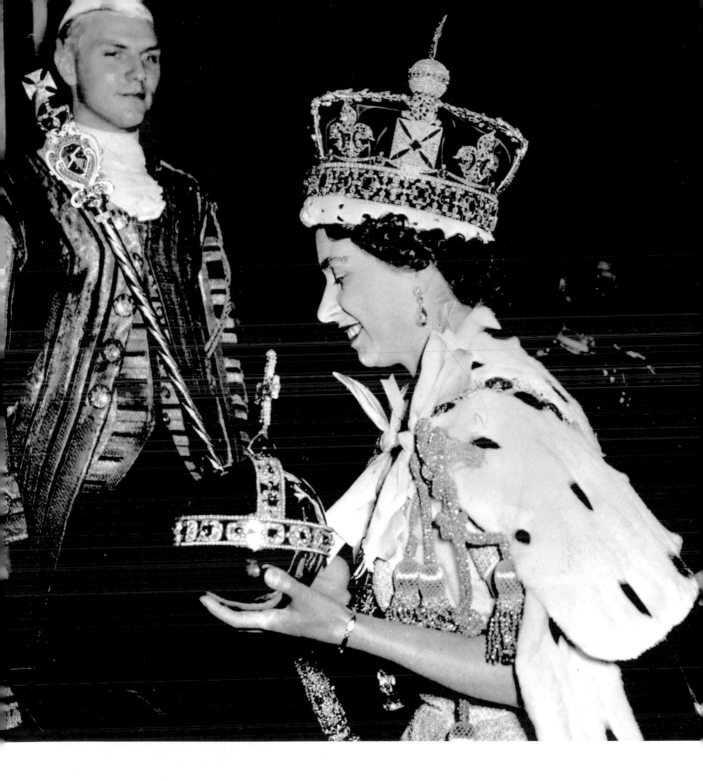

Returning to Buckingham Palace after the
coronation, the newly crowned and anointed Queen
carried the orb with her towards the waiting family,
friends, courtiers, guests and photographers.

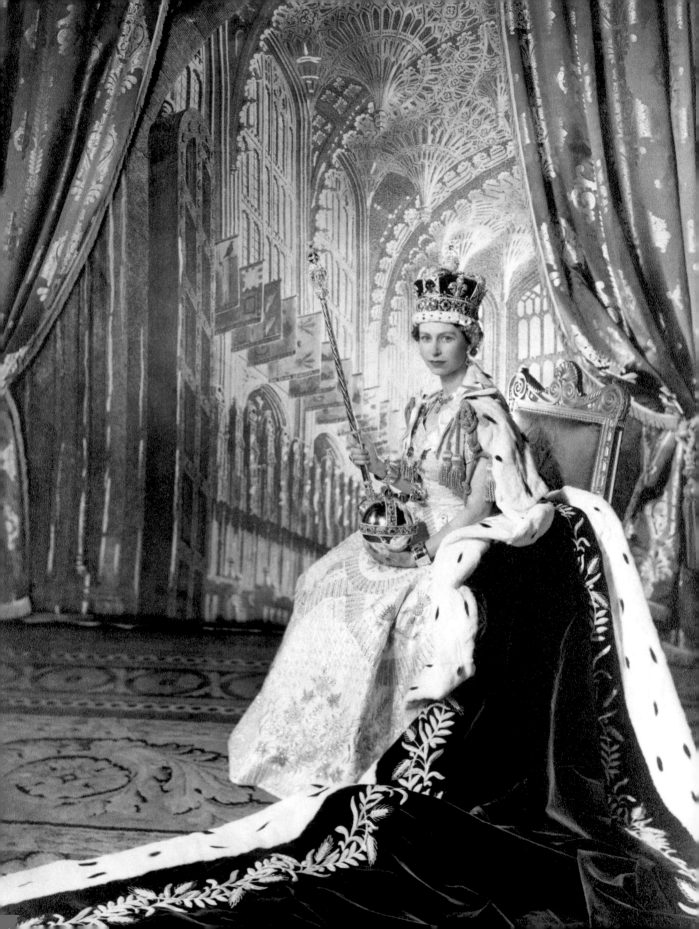

Cecil Beaton's striking official coronation portrait photograph was taken at Buckingham Palace in front of a painted backcloth of Westminster Abbey.

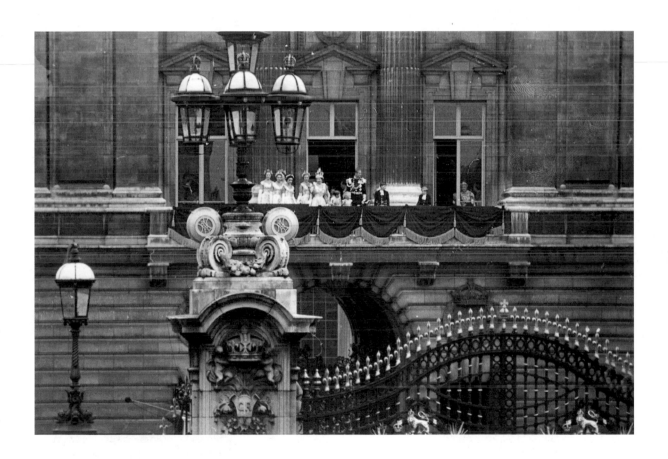

After their return from Westminster Abbey, and once the official photographs had been taken, the newly crowned Queen took one of many bows on the balcony at Buckingham Palace with her family.

THE HONOURS OF SCOTLAND

Three weeks after her coronation, the Queen was in Scotland. In Edinburgh's St Giles' Cathedral she was presented with the Honours of Scotland, the Scottish crown jewels, during the Scottish National Service of Thanksgiving and Dedication. The Duke of Edinburgh attended in field marshal's uniform. The Scottish crown was taken in procession for the first time since 1822, when George IV had visited Edinburgh; the Queen returned the crown into the safe keeping of the Duke of Hamilton, Scotland's premier peer.

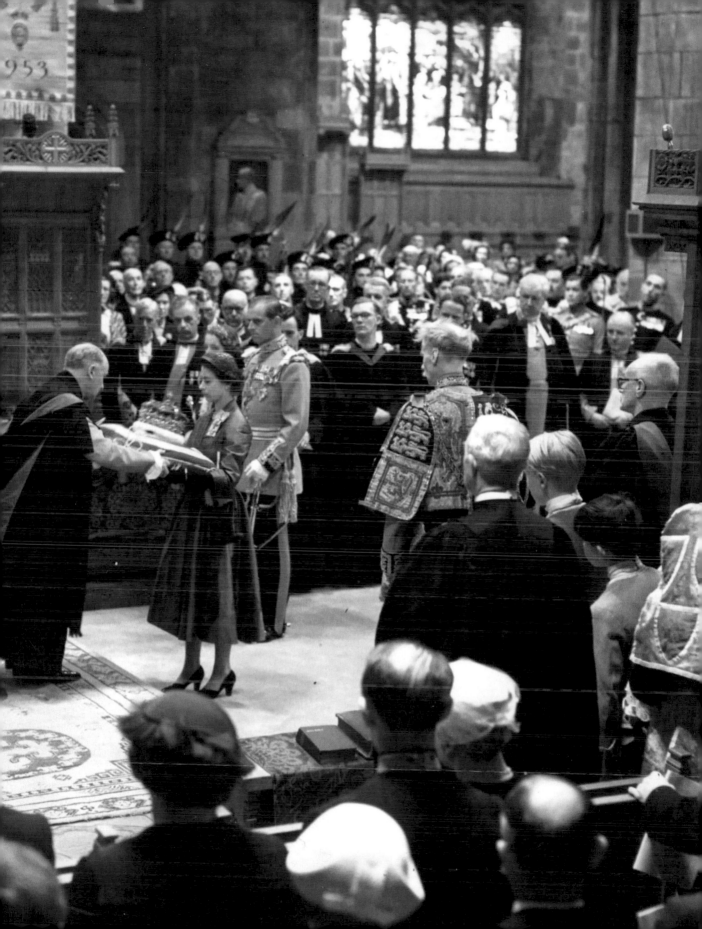

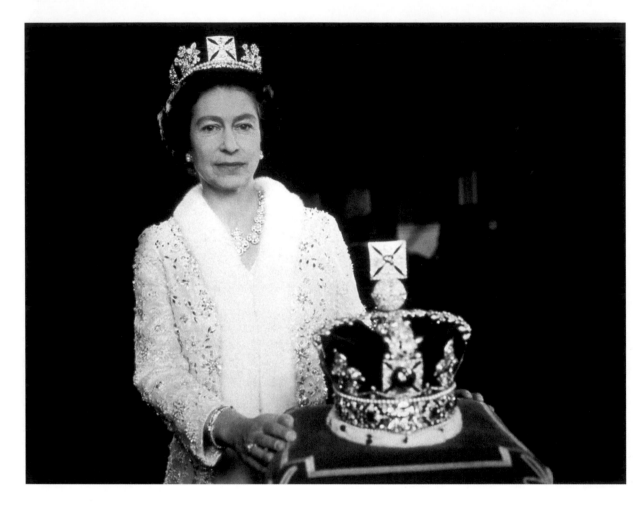

CROWNS AND DIAMONDS

In the 1977 BBC television series *Royal Heritage*, broadcaster Huw Weldon together with the historian J.H. Plumb traced the story of the Royal Collection, the fabulous art collection held in trust by each monarch. The Queen wore the diamond circlet made for King George IV in 1821, incorporating the emblems of the countries in the United Kingdom. Here she gestured towards the Imperial State Crown, worn each year at the State Opening of Parliament and which she first wore at her coronation. On that day she was crowned with St Edward's Crown, reserved solely for that moment and that occasion.

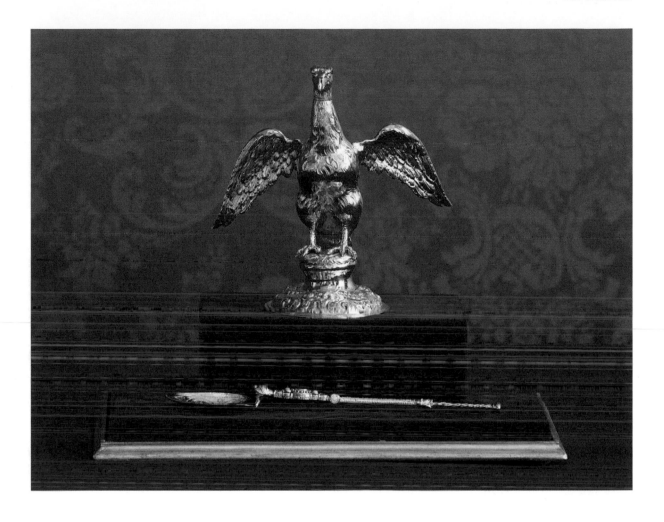

GOLD AND OIL

In 2012 the ampulla and spoon, used in the coronation ceremony when the monarch is anointed with holy oil, were brought from their secure home in the Tower of London to a multi-faith reception at Lambeth Palace, residence of the Archbishop of Canterbury. This event marked the Queen's Diamond Jubilee. The ancient ceremonial objects were a reminder of the sacred duty the Queen had taken on when she came to the throne and was acclaimed by the people.

PUBLIC LIFE

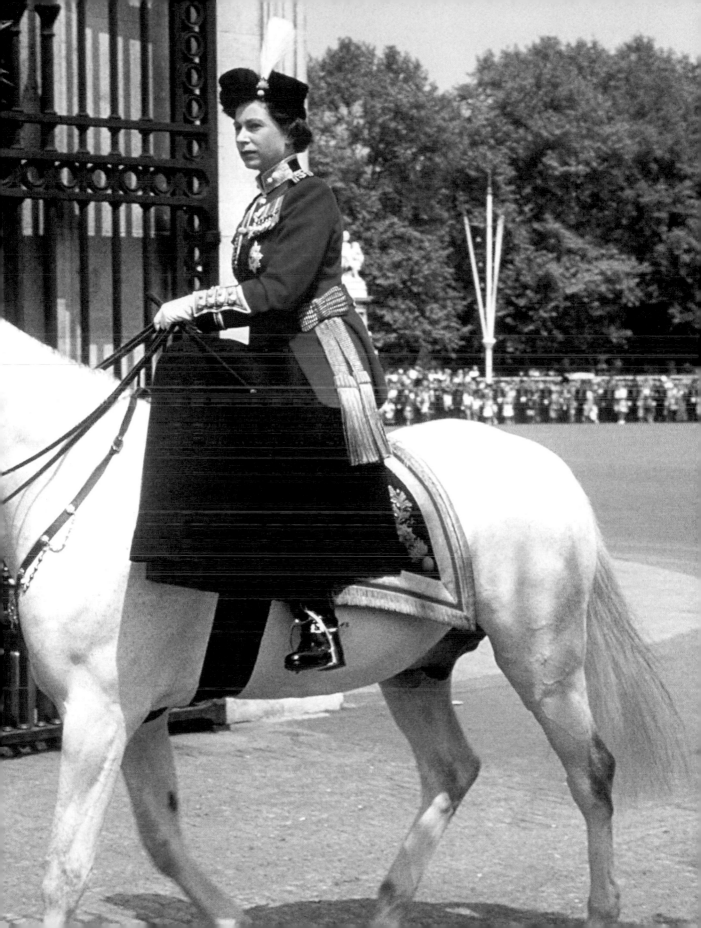

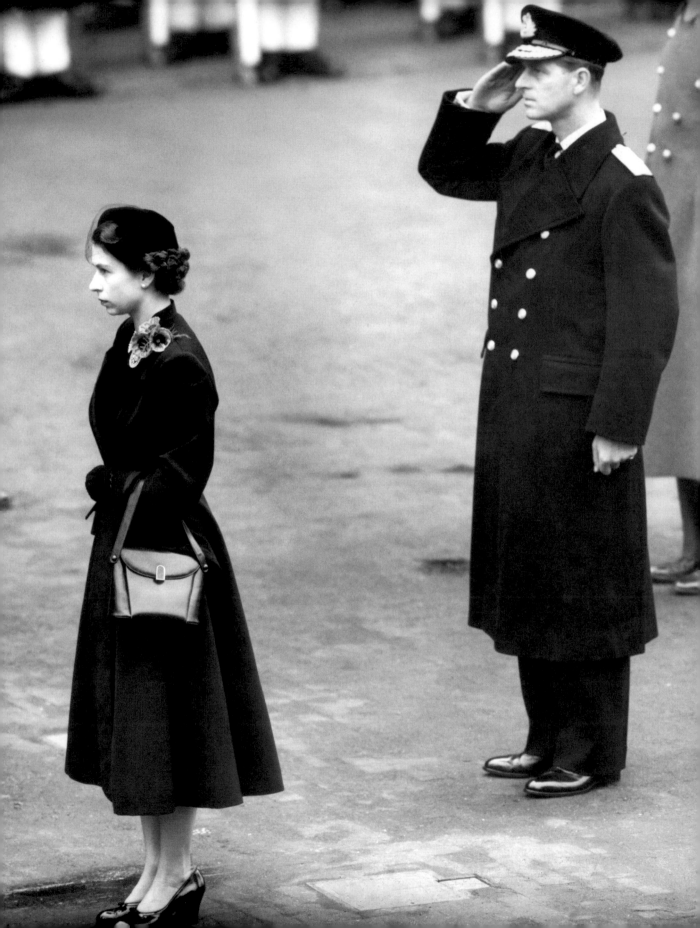

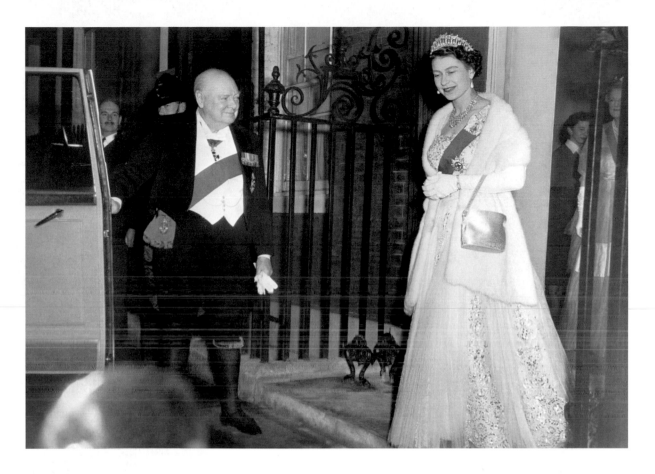

LEST WE FORGET

On Remembrance Sunday in coronation year, the Queen led the nation's commemoration of the dead in two world wars at the Cenotaph in Whitehall. This was an annual ritual that she only rarely missed throughout her reign; at that particular time British troops were fighting in Korea and combatting insurgents in Malaya. Later generations of her armed forces fought in the Falklands, Iraq and Afghanistan.

HER FIRST PRIME MINISTER

The first of the Queen's prime ministers, Sir Winston Churchill, entertained her to dinner at 10 Downing Street on his retirement from office. Having suffered a stroke two years before, news of which had been kept from the general public, Churchill was finally persuaded to step down. He was very fond and proud of the young Queen. Harold Wilson in 1976 was the only other prime minister to have the honour of the Queen coming to dinner at his retirement from office.

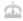

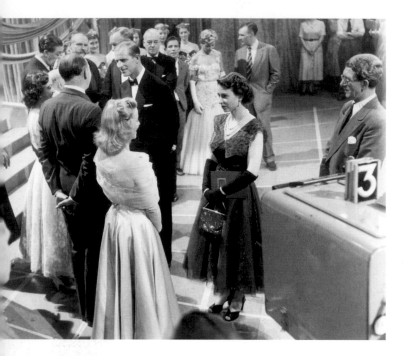

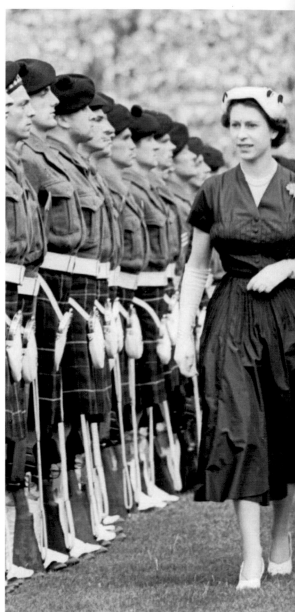

A VISIT TO THE BBC 1953

Visiting the Lime Grove studios as part
of her coronation year visit to the BBC,
the Queen watched a drama production,
The Disagreeable Man, being broadcast,
took in the variety show *For Your Pleasure*,
and joined the nation's wonder at the
knowledge displayed in the first episode
of what would prove to be the hugely
popular quiz programme *Animal,
Vegetable, Mineral?*

INSPECTION

The Queen inspecting Scottish
troops at Hampden Park in 1953.

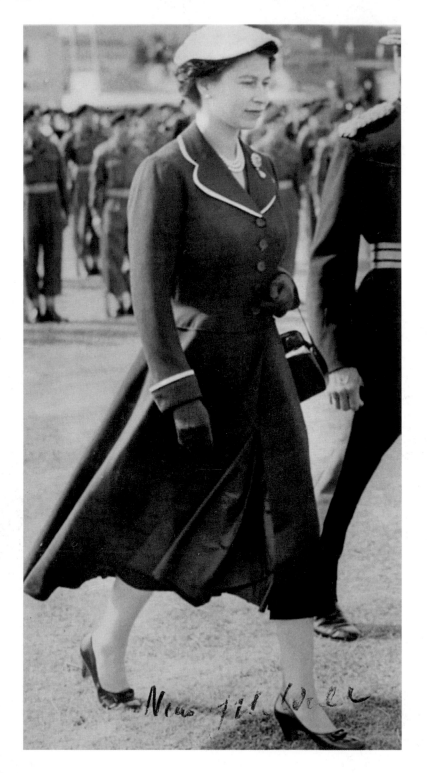

DRESS TO BE SEEN

The Queen learned to dress in a distinctive way, with bright colours that would stand out in a crowd when appropriate, or in sombre black when that suited the occasion. Her hats became an integral part of her official wardrobe, and even in 1955 when visiting Brecon her headgear made her the centre of attention.

BY ROYAL COMMAND

The Royal Command Film Performance was an annual occasion on which stars of the silver screen were presented to the Queen before the screening. In 1956 the chosen film was *The Battle of the River Plate*. Marilyn Monroe (who was filming *The Prince and the Showgirl*) met her match for glamour with Queen Elizabeth II.

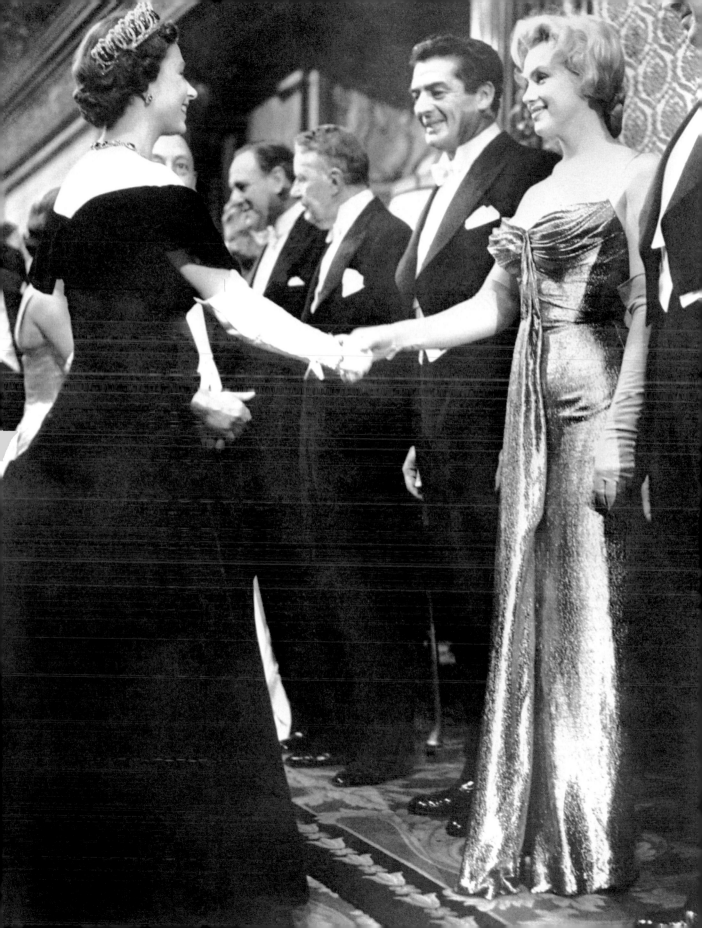

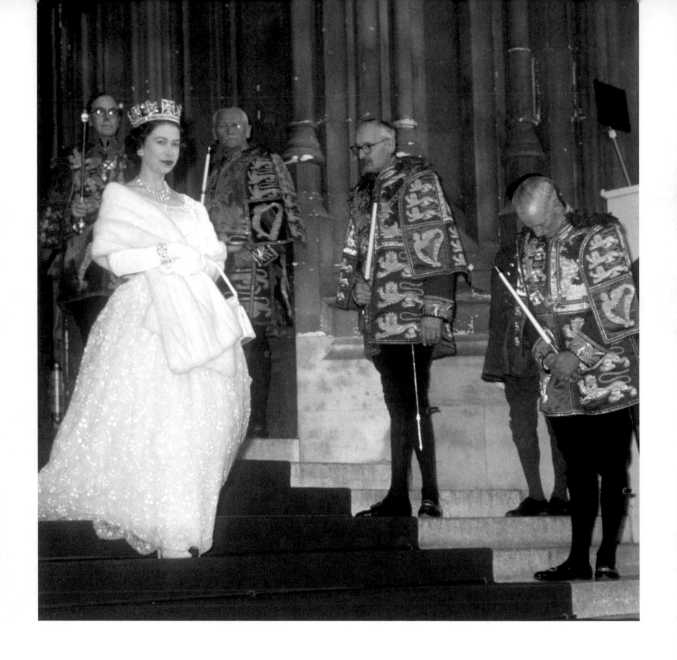

HERALDS AT WESTMINSTER

There were many official
events in 1956 for which the
ceremony demanded dressing
for the occasion.

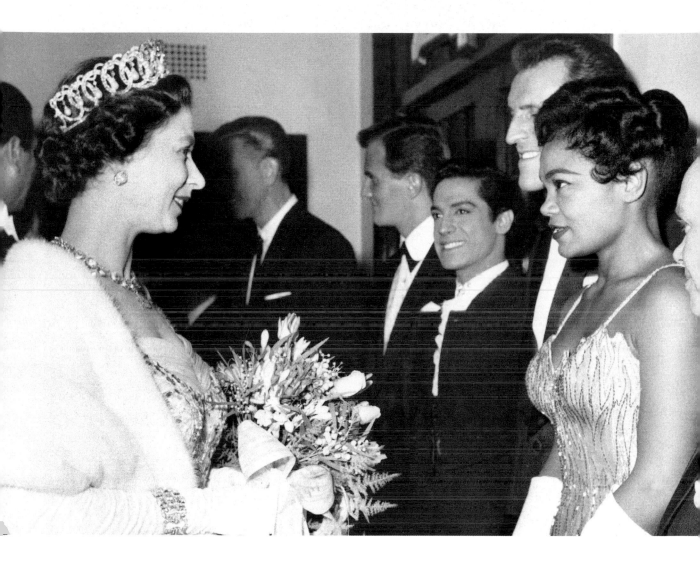

SHOWTIME

Eartha Kitt, who had sung in 1958's
annual Royal Variety Show that evening,
was able to share her thoughts about her
performance with the Queen afterwards.

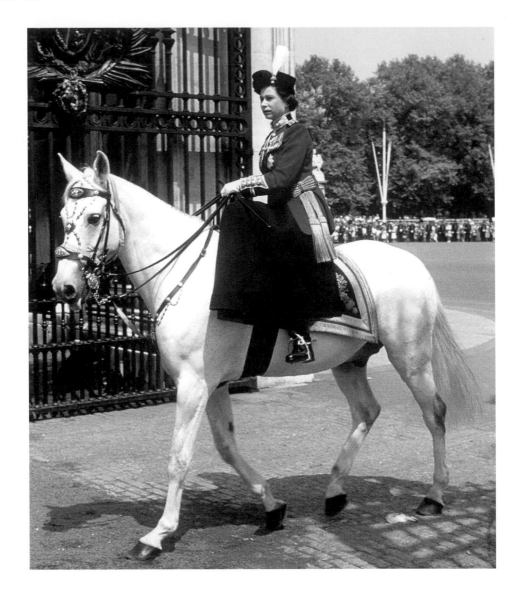

TROOPING THE COLOUR

The Queen's own birthday fell in April, but following her father's tradition she celebrated an official birthday in June. It is one of the two days on which recipients of honours are announced; it is also the occasion of Trooping the Colour, when new colours – regimental flags – are ceremonially presented to one of the Guards regiments. Massed troops and bands parade at Horse Guards Parade off Whitehall, and in most years the Queen would take the salute herself.

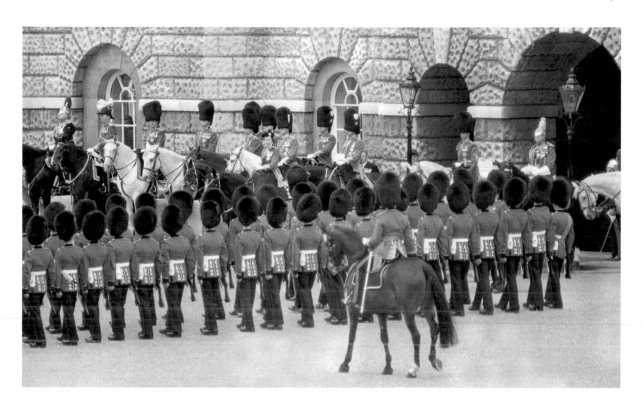

Riding side-saddle, demonstrating the fine horsewomanship for which the Queen was renowned, the annual ceremony was a high-point of the royal year. It was broadcast live and was an integral part of the BBC's annual round of royal events coverage.

The Queen Mother and her grandchildren arrived in a barouche for the 1956 Trooping the Colour ceremony.

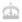

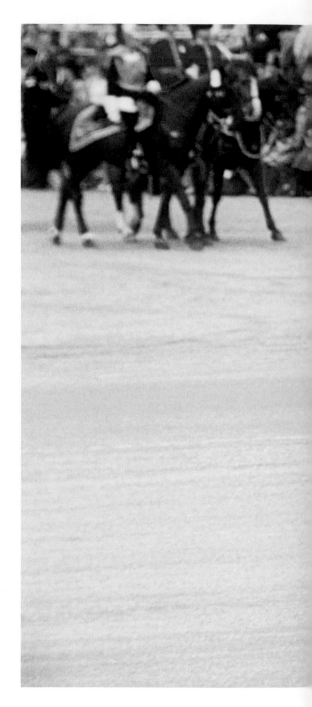

Accompanied by the Duke of Edinburgh, the Queen rode in the 1967 Trooping the Colour. Her steady horsewomanship stood her in good stead in 1981 when she controlled her horse Burmese after a bystander fired a shot from the crowd. The gun was filled with blank rounds. The event highlighted the security issues that would become ever greater as the years went by.

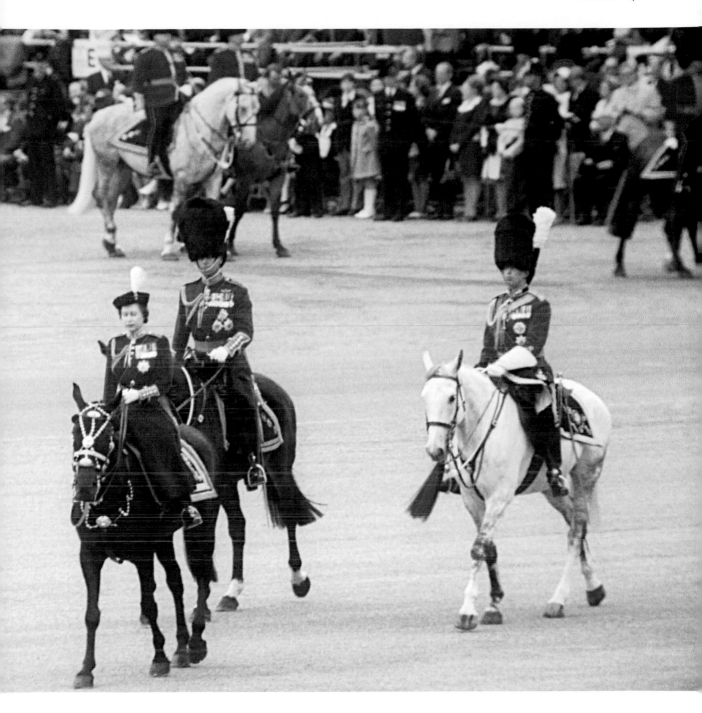

Trooping the Colour on Horse Guards Parade
in 1971, when the colour of the Welsh Guards
was trooped on the Queen's official birthday.

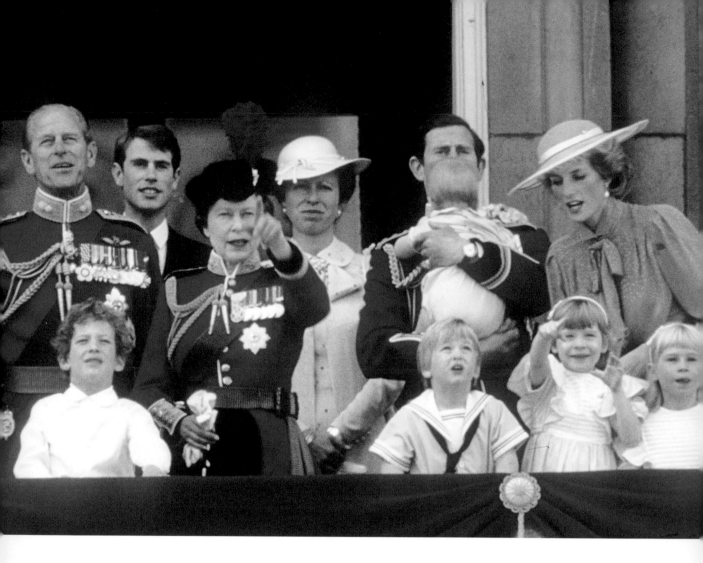

BALCONY SCENE

The royal appearance on the balcony of
Buckingham Palace after the Trooping the
Colour ceremony in 1985 was particularly
crowded as a new generation came to
enjoy the occasion. The Queen and Prince
Philip, the Prince and Princess of Wales
with their sons Prince William and Prince
Harry were among the throng.

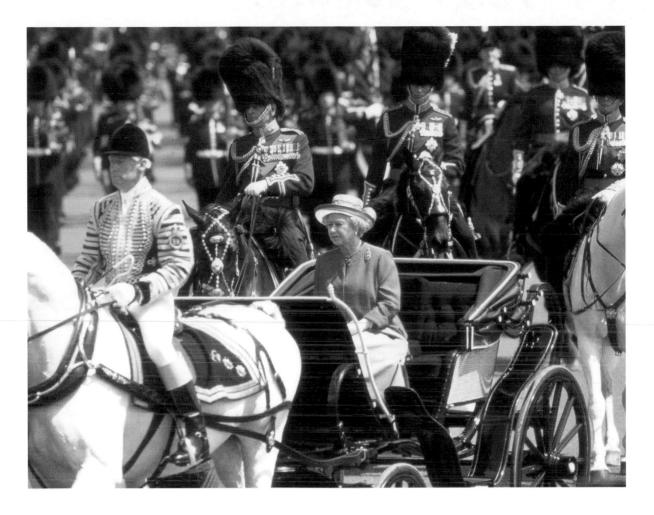

CARRIAGE RIDE

Throughout much of her reign, television
viewers had seen the Queen riding side-saddle
on horseback for the annual Trooping the Colour.
By the time of her Golden Jubilee, her advancing
years meant that she would now prefer to lead the
ceremony from her carriage, her enjoyment of
the event nevertheless undiminished.

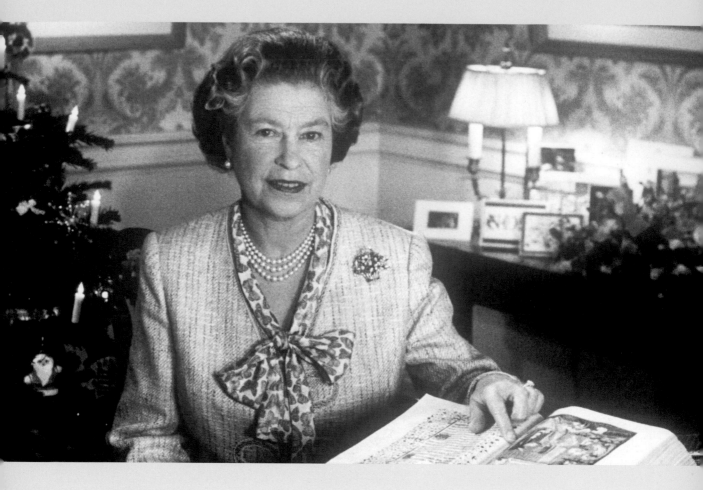

The Christmas Messages

One of the most familiar of all features of the Queen's reign, her annual Christmas broadcast message was the principal opportunity for people at home and abroad to see her and hear her thoughts. The Queen's Christmas broadcast in 1989 was in a long tradition that stretched back to her grandfather's day; there has been substantial changes in presentation and style over the years, but the essence remained reassuringly the same: thoughts on the world, on the religious significance of Christmas Day, on a sense of family near and far and on duty. Three pm on Christmas Day in the UK was originally chosen as a time when most parts of the world would be able to hear the message live. The Christmas messages were a litmus paper to changes in the monarchy, the Queen's growing certainty in her assured handling of the media and people's reactions to her.

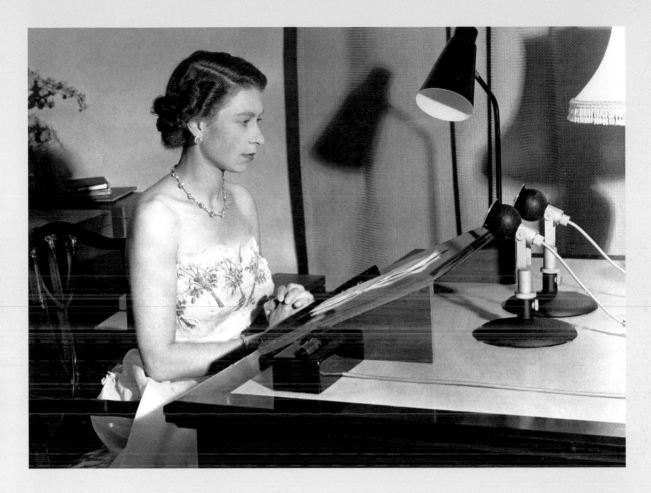

The Queen's 1953 Christmas broadcast was a technological triumph for the BBC, as well as an affirmation of the immense goodwill that had been generated by the coronation in the previous June. The Queen was in New Zealand, part-way through her Commonwealth world tour, which was as far away from Broadcasting House as it was possible to be. Existing radio communications from New Zealand were still unreliable, so a pre-recording of the speech was made on board ship in Fiji to be transmitted to London from Sydney. In the event, the pre-recorded version was not needed: the radio transmission worked faultlessly, and listeners at home could hear the Queen clearly from the other side of the world. There had been talk of a new Elizabethan Age, but in her message the new Queen had little time for that. 'Frankly,' she said, 'I do not feel at all like my great Tudor forebear, who was blessed with neither husband nor children, who ruled as a despot and was never able to leave her native shores.'

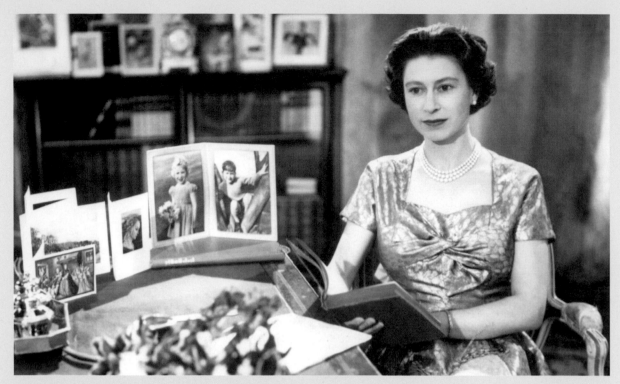

1957, the first televised Christmas message

1986, in the Royal Mews

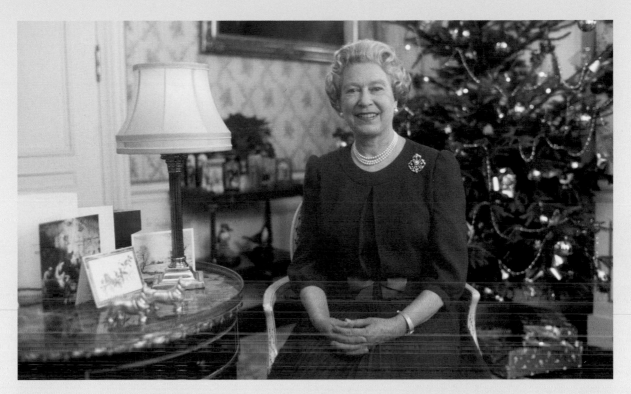

1992

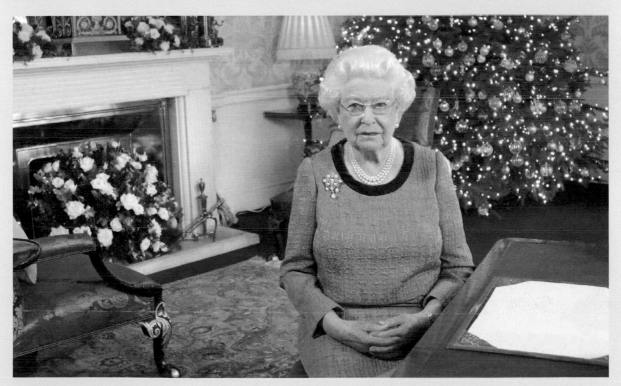

2016

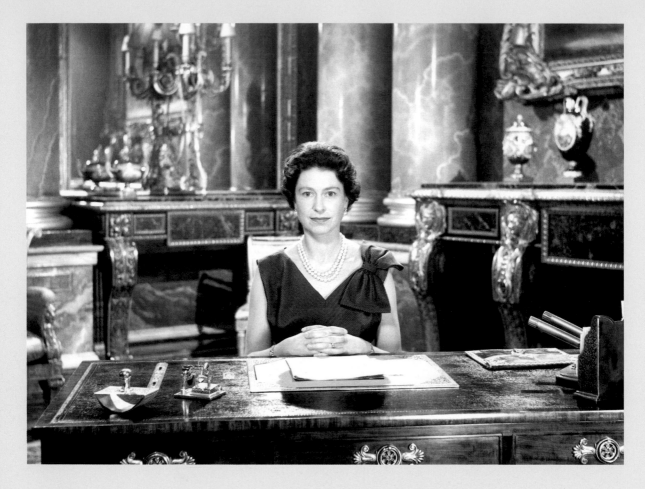

Half the British population watched the Christmas broadcast in 1961; for the first time, the Queen's message had been pre-recorded, and there was a growing naturalness in the Queen's delivery as she was becoming accustomed to the teleprompter. The BBC had wanted to keep the broadcast live, but apart from anything else this considerably disrupted the Queen's own Christmas Day at home with her family. Gradually, the broadcast would become more elaborate, taking the Queen outside her study.

The most-travelled monarch in British history – and probably the most widely travelled head of state – the Queen covered almost the whole world. In her 1970 Christmas broadcast she was able to show where she had been on one of the series of Commonwealth tours throughout her reign.

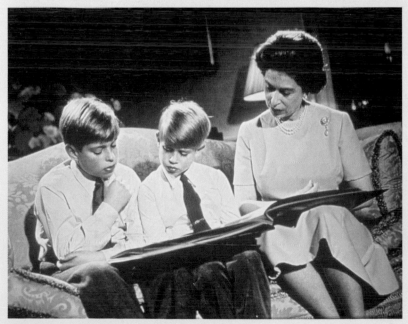

In her 1971 Christmas broadcast, the Queen involved her family more than she had done before, and was seen by viewers with her younger sons, Prince Andrew and Prince Edward.

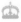

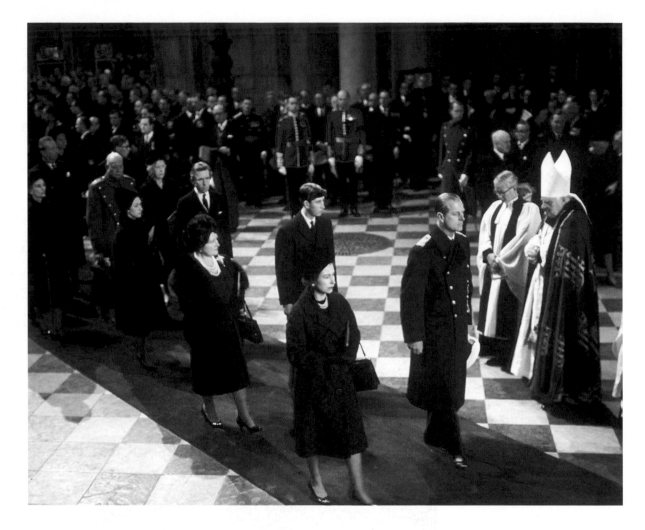

THE FUNERAL OF WINSTON CHURCHILL 1965

Leading the mourners at St Paul's Cathedral, the Queen had
ordered that Sir Winston Churchill should be accorded the
rare privilege of a state funeral. On 30 January 1965, the
nation came to a halt to remember the wartime leader who
had personified the indomitable British spirit. The scale of
the live television and radio undertaking was enormous,
following the funeral carriage procession from the lying in
state at Westminster Hall to the City for the funeral, then
by river from the Tower to Waterloo, and finally by train to
Oxfordshire. Statesmen and wartime leaders from around
the world came to London.

ENGLAND'S WORLD CUP VICTORY 1966

One of the largest BBC television audiences in its history watched England win the World Cup at Wembley in 1966, with a close finish in extra time after a disputed goal that still excited controversy decades later. The Queen presented the Jules Rimet trophy to the England captain, Bobby Moore, and the nation went wild.

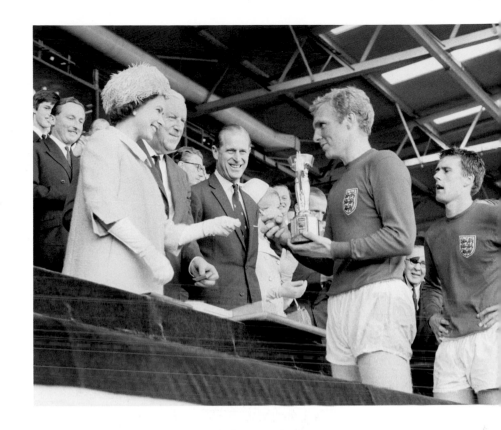

ANOTHER CUP

Congratulating Jimmy Scoular, captain of Newcastle United, the Queen is about to give him the FA Cup after the 1955 final against Manchester City.

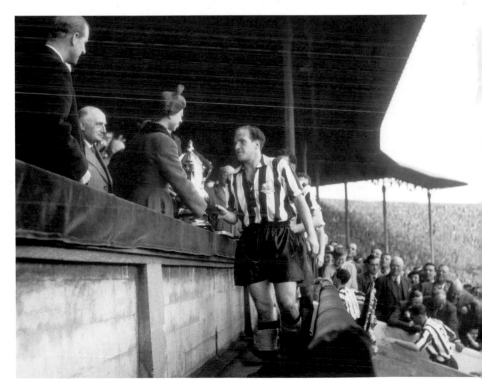

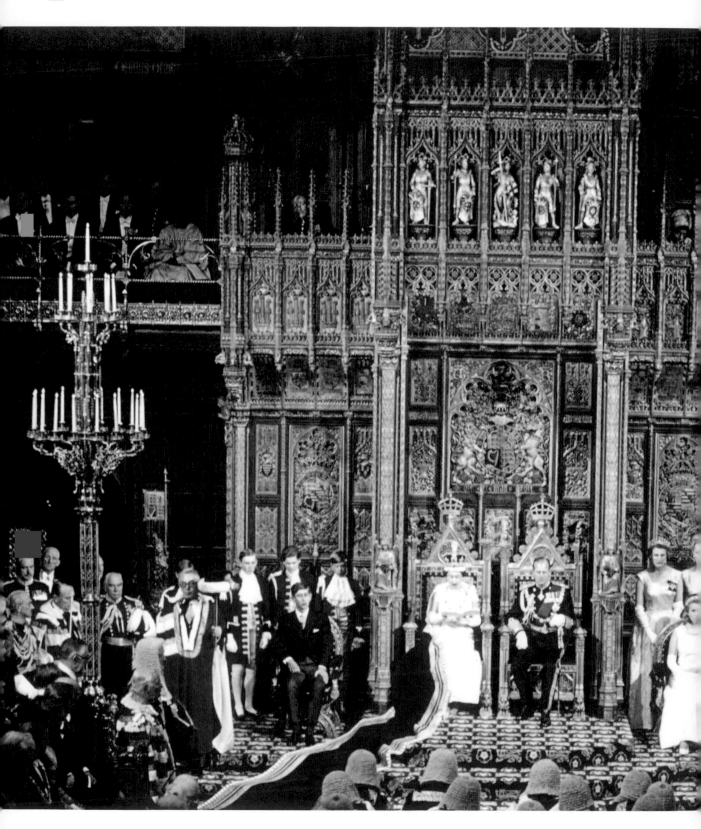

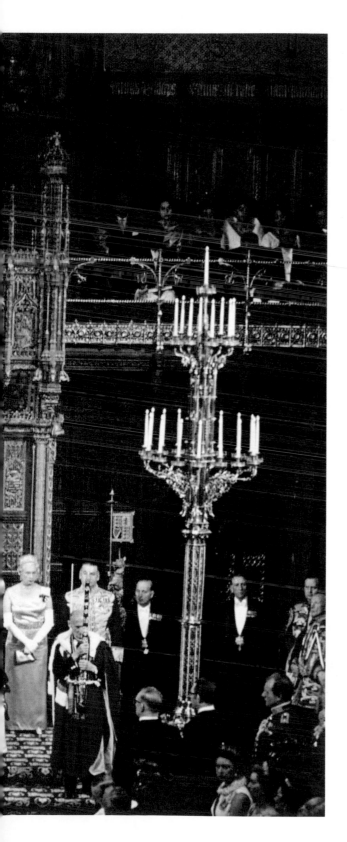

THE QUEEN'S SPEECH AT THE STATE OPENING OF PARLIAMENT 1967

A royal ceremony of considerable antiquity, well-established by the late 14th century, the State Opening marks the start of a new parliamentary year. It is a symbolic reminder of the unity of the three elements of Parliament: the Sovereign, the House of Lords and the House of Commons. The modern ceremony dates to 1852, when the new Palace of Westminster was opened; the Irish State Coach in which the Queen rode in 1967 had been used for the first time in 1852. Here the Queen would read the Speech from the Throne, setting out the government's agenda and key legislative plans. It may have been called her Speech, but it was written by the government of the day. The ceremony was first photographed and first televised on 23 October 1958.

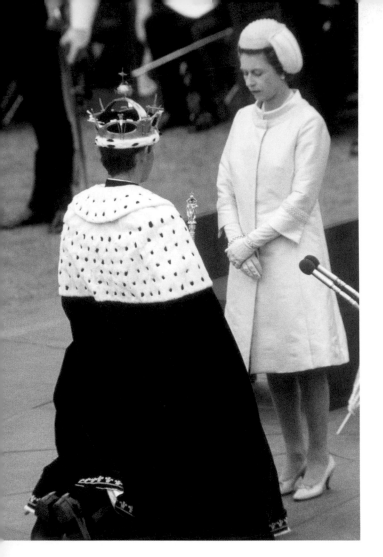

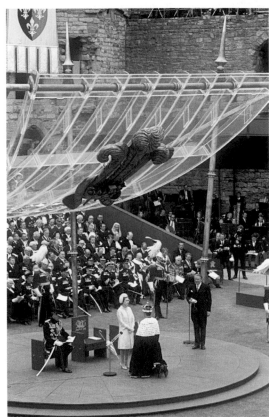

THE INVESTITURE OF THE PRINCE OF WALES

On 1 July 1969, the Queen invested her eldest son Charles as Prince of Wales, in a ceremony at Caernarfon Castle. This was an occasion that brought old and new together, with pageantry in an ancient place, containing an architectural setting of swooping Perspex designed by the Queen's brother-in-law, the Earl of Snowdon, who had masterminded the occasion. The crown (with the single arch of a prince's crown) was designed in a spiky modern idiom by Louis Osman. Ten years before, in a recorded message played at the Commonwealth Games in Cardiff (as the Queen was pregnant with Prince Andrew at the time), she had announced she was giving Charles the title Prince of Wales, and 'when he was old enough' she would bring him to Wales to show him to his people. The cheers and the prayers re-echoed, 'God bless the Prince of Wales'.

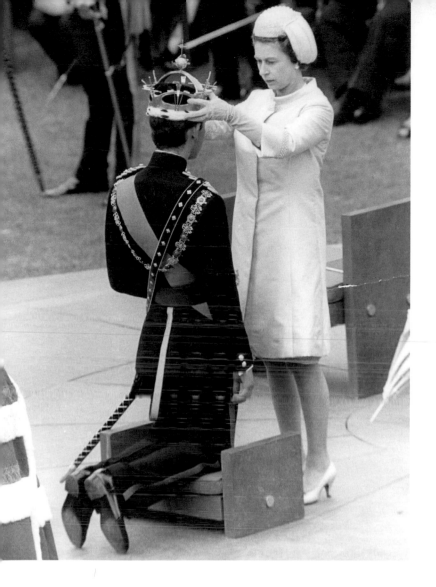

The moment of
investiture.

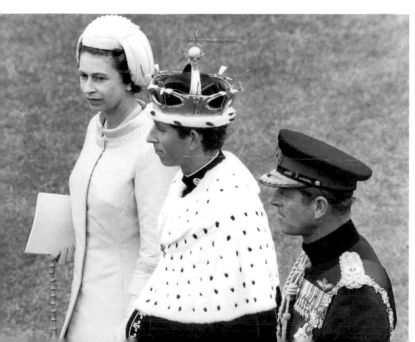

The Queen and the Duke
of Edinburgh flanked their
son Charles, crowned
Prince of Wales.

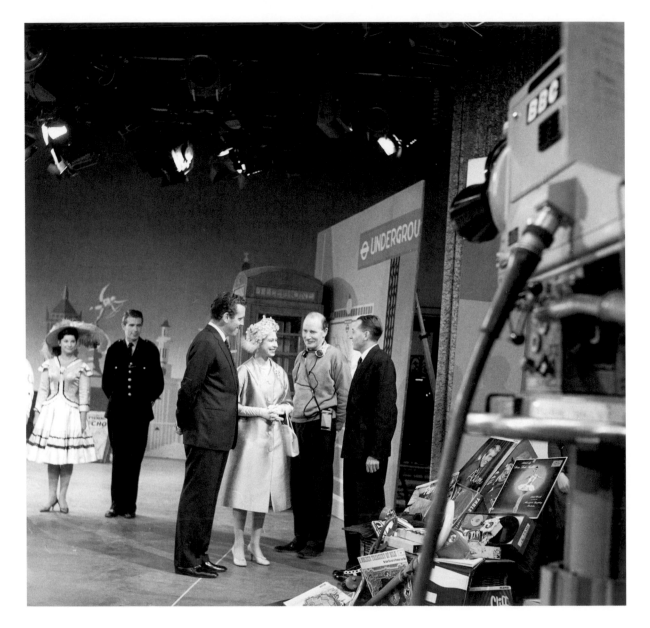

CELEBRATING THE BBC

Marking the 25th birthday of the BBC
Television Service, the Queen met
the cast and production team of the
popular children's entertainment show
Crackerjack on her visit to the new BBC
Television Centre on 2 November 1961.

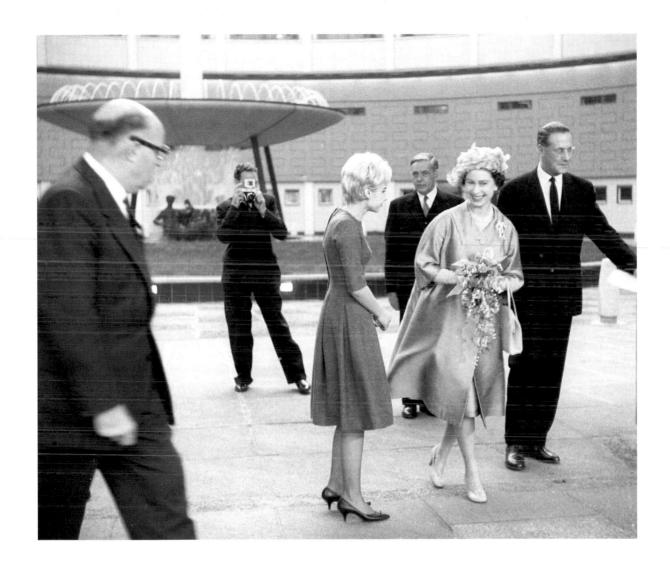

Television Centre, the
headquarters of BBC Television
between 1960 and 2013, was
a distinctive circular doughnut
design. This occasion was the
first of many royal visits to the
flagship of British broadcasting.

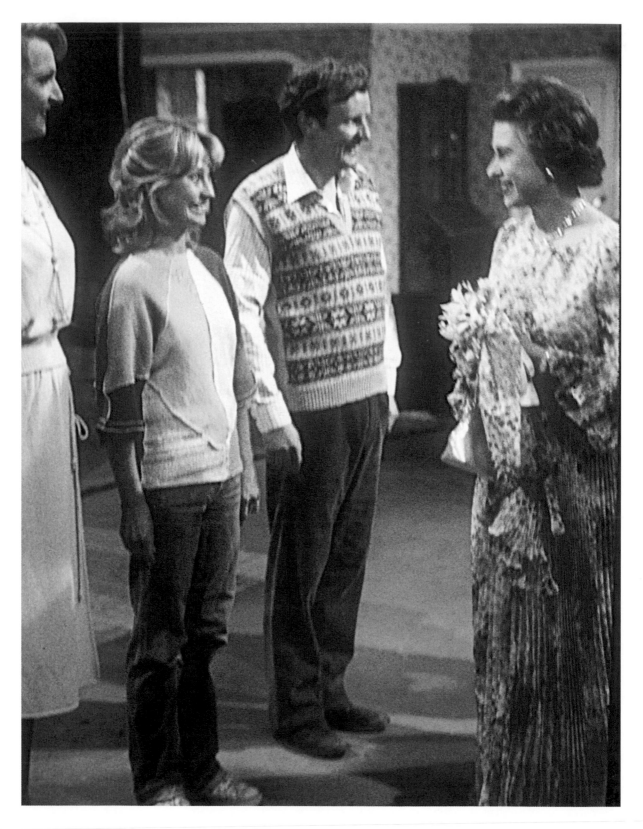

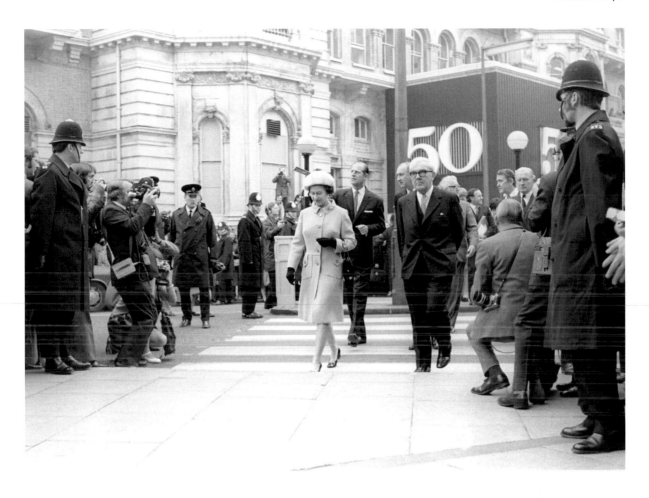

The popular BBC television comedy series *The Good Life*, set in suburban Surbiton, Surrey, was graced with the royal presence for a special edition. The stars Penelope Keith, Felicity Kendal and Richard Briers welcomed the Queen onto the set.

In 1972, the BBC celebrated its 50th birthday, and the 46-year-old Queen opened the exhibition at Broadcasting House in Portland Place. She was accompanied on her tour by Charles Hill, formerly famous as the 'radio doctor' (and also as a government minister under Harold Macmillan), who was Chairman of the BBC, 1967–72.

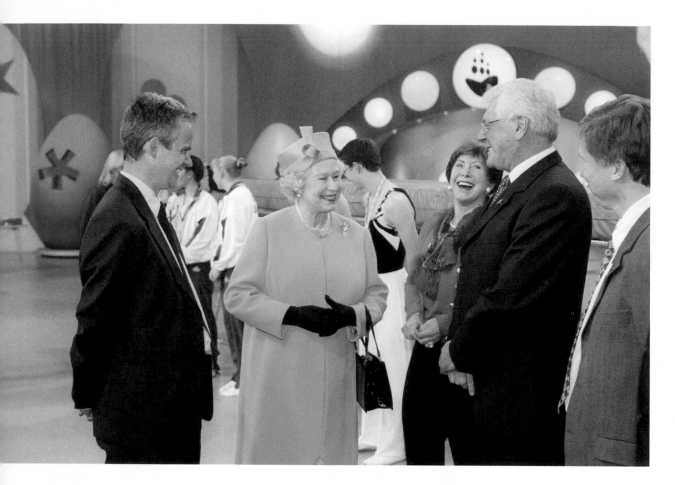

With a continuing run almost as long as the Queen's reign, first broadcast in October 1958, the BBC children's programme *Blue Peter* had an ongoing relationship with the Queen and members of her family. Princess Anne and presenter Valerie Singleton had gone on a Royal Safari to Kenya in 1971. In November 2001 the Queen came to the studios to meet current and past presenters of the show, including Valerie Singleton, Peter Purves and Peter Duncan (who would later become Chief Scout).

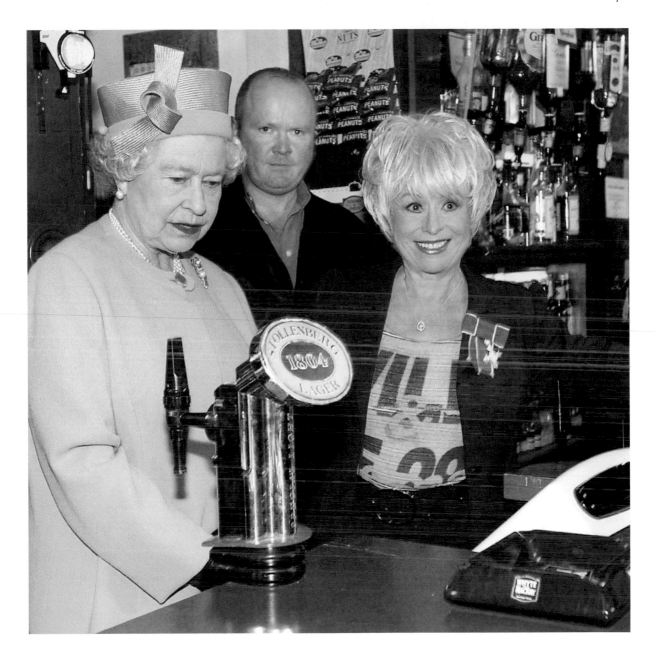

From there, the Queen met with
the aptly named actress Barbara
Windsor and her on-screen son Steve
McFadden on the set of *EastEnders*.

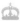

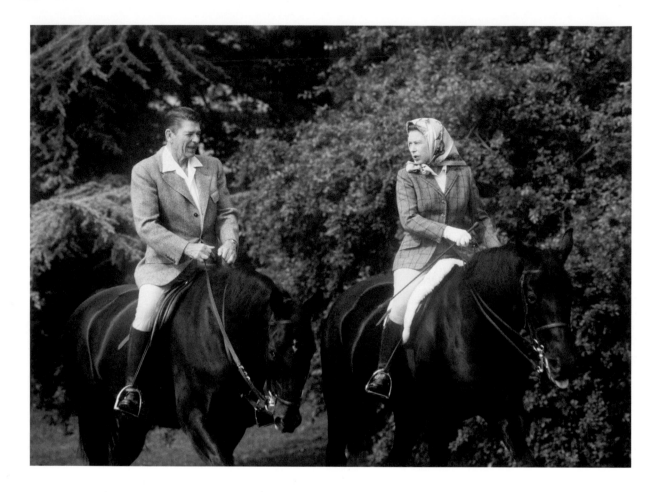

LEADING REINS

In the American President Ronald Reagan, the Queen found a fellow leader who was very comfortable on horseback. His visit in 1982 helped cement a strong Anglo-American alliance with Margaret Thatcher, who had become prime minister in 1979.

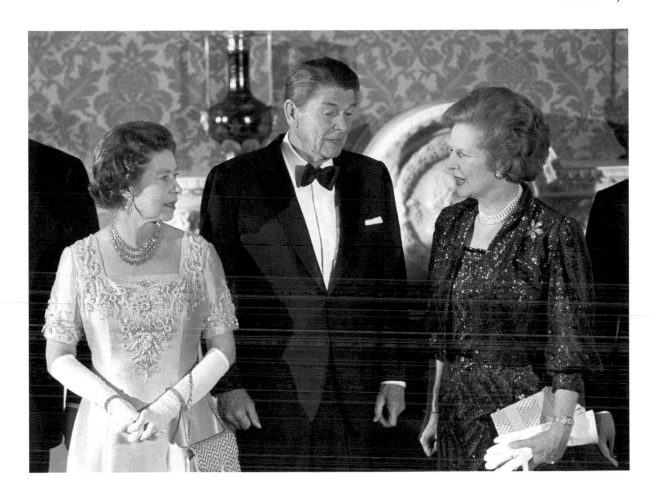

WORLD LEADERS

Following the tenth 'G7' meeting of
Western world leaders, the London
Economic Summit in June 1984,
the Queen hosted a banquet at
Buckingham Palace. She is pictured
here together with President Ronald
Reagan and the Prime Minister,
Margaret Thatcher.

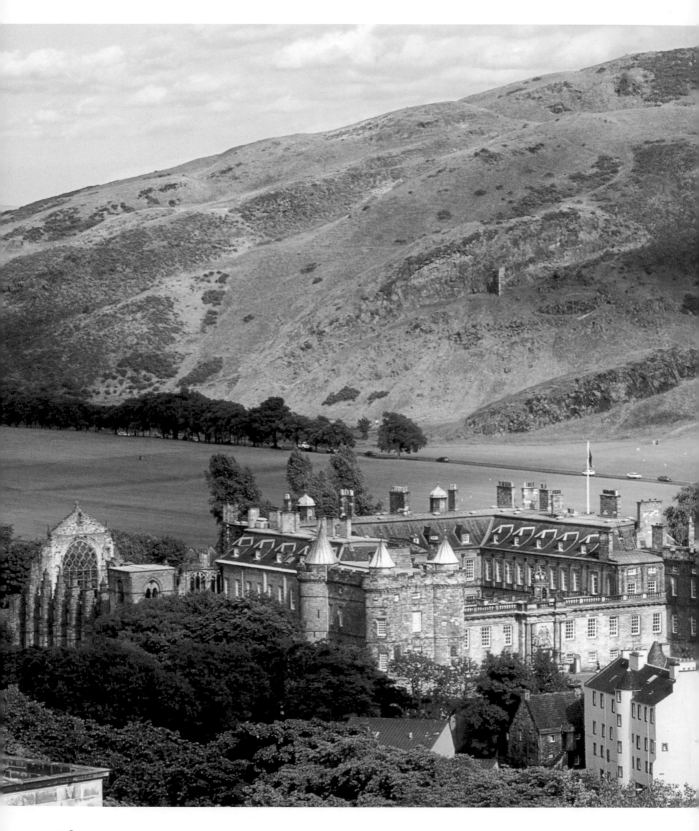

TO SCOTLAND

The Palace of Holyroodhouse, Edinburgh.
Every July the Queen would visit Edinburgh,
hold investitures and host garden parties.
She always felt very much at home in
Scotland. From Holyrood she traditionally
went to Balmoral, the Highland house built
by Queen Victoria and Prince Albert, for her
summer break.

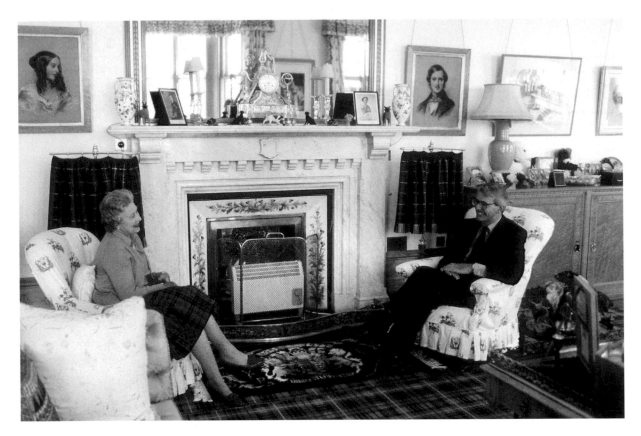

AT BALMORAL WITH JOHN MAJOR 1991

Britain's prime minister has always been
a summer guest at Balmoral, where some of the
cares of office and government could be shed.
John Major, the Conservative prime minister
from 1991 to 1997, was pictured with the Queen
when he had only recently taken over from
Margaret Thatcher, settling into comfortable
armchairs for their regular chat. A fixture on
the Balmoral calendar was the royal picnic,
with food prepared – and washing up done – by
the Queen and her family.

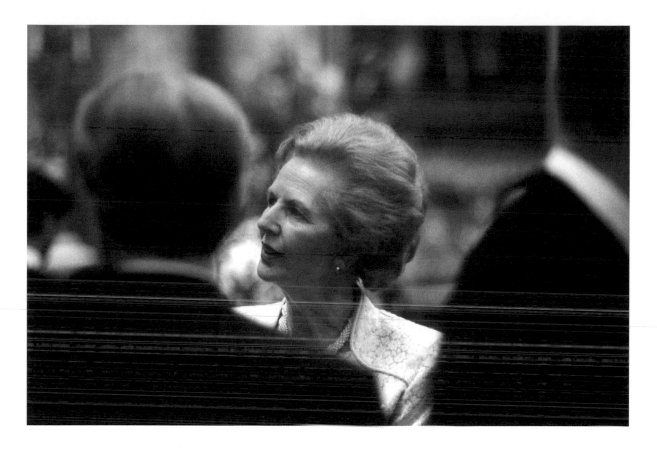

PRIME MINISTER

Margaret Thatcher was one of the Queen's
longest-serving prime ministers, and one of
the very first Western women to be a head
of government. Pictured at a reception at
Buckingham Palace, not long before her
dramatic exit from office, Mrs Thatcher, as all
the Queen's prime ministers, enjoyed a weekly
private audience with her. Even as a princess,
once she had turned 18 the Queen was given
access to state papers, and examining the
'red boxes' of official papers was a daily and
necessary routine. Having lived through the
tenure of over a dozen prime ministers, the
Queen was one of the most experienced and
informed of all world leaders.

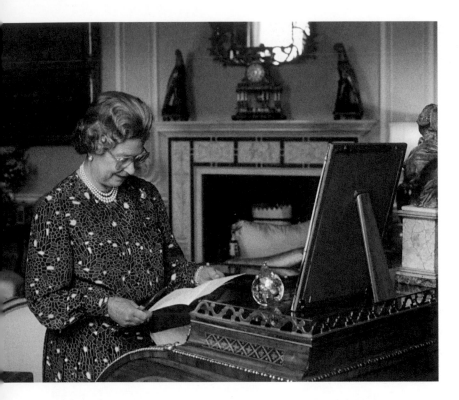

IN THE AUDIENCE ROOM AT BUCKINGHAM PALACE 1990

Throughout her reign, the Queen received mountains of mail, in praise or criticism, seeking redress for a wrong or giving thanks for something right. Although much of the correspondence was dealt with by support staff at Buckingham Palace, the Queen would read many of the letters herself.

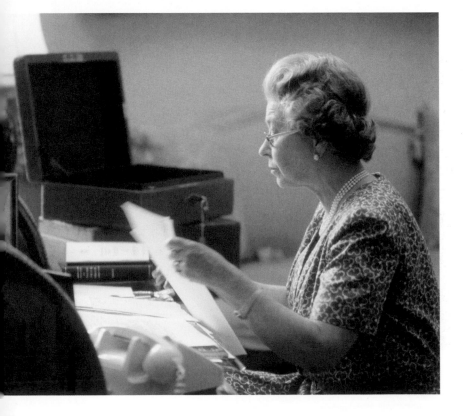

READER NO 1

The Queen at her red boxes, reading official government papers in the Audience Room at Buckingham Palace in 1991. 'Reader No 1' of state papers, the Queen would have seen every significant government communication and most MI5 and MI6 advice in her reign.

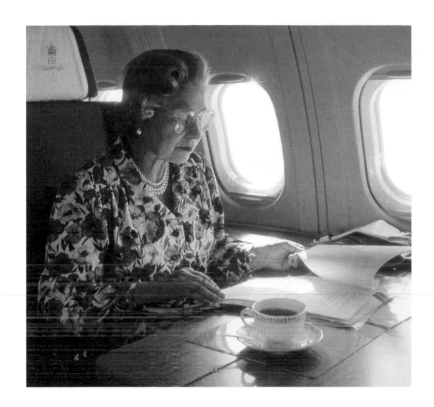

On a flight back home from her historic visit to Northern Ireland in 1991, which had been kept a closely guarded secret until the moment she arrived, the Queen still needed to find time to go through papers to prepare for her next engagements.

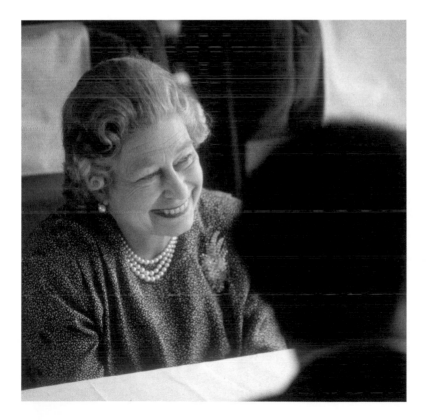

TRAVELLING TO WORK

On the Royal Train to Edinburgh in her Golden Jubilee year, the Queen was preparing for her annual visit to the Palace of Holyroodhouse. Every year the Queen held Royal Week, visiting different parts of Scotland as well as hosting events in Edinburgh.

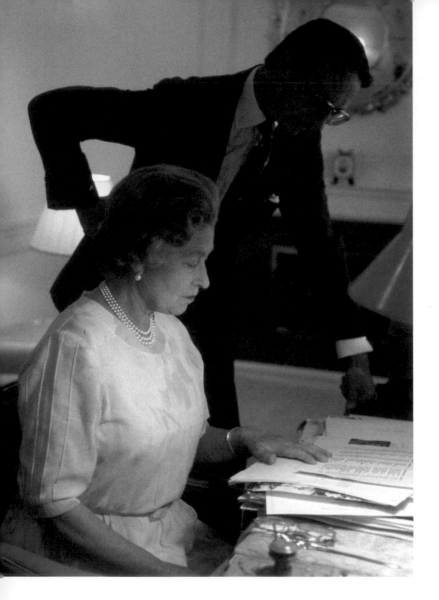

THE QUEEN'S PRIVATE SECRETARY

Sir Robert Fellowes, the brother-in-law of Diana Princess of Wales, was the Queen's private secretary for nine years from 1990, when this photograph was taken. Royal private and press secretaries have always had a particularly important place in the Royal Household, both as guardians of the Queen's privacy and as advisers on coping with the demands of public life.

In conversation with Sir Robert Fellowes in the gardens at Balmoral.

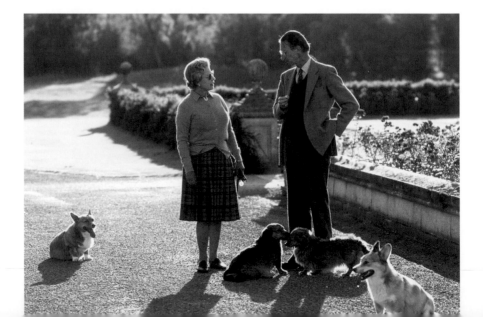

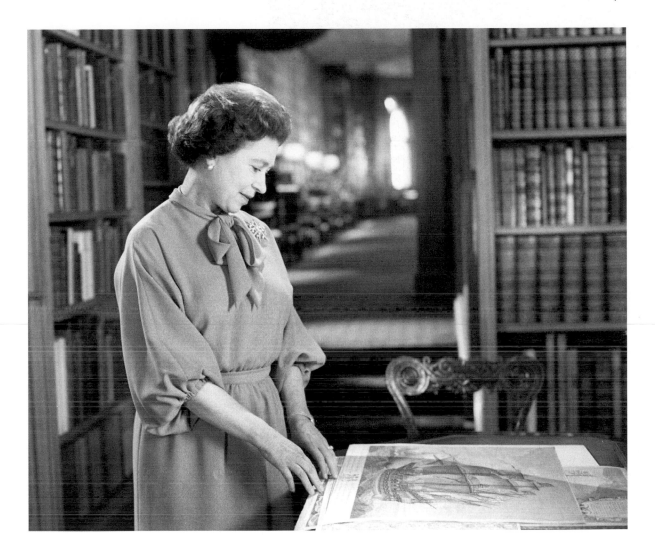

IN THE LIBRARY AT BALMORAL

Balmoral is the Queen's summer retreat
and her Scottish private residence. Built
for Queen Victoria and Prince Albert,
Balmoral remains the sole Victorian
great house essentially still run as when
Queen Victoria was on the throne.

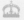
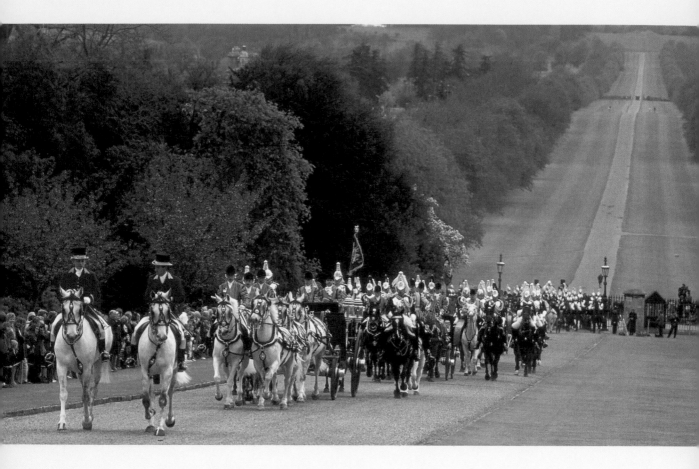

STATE VISITS

State visits to Britain, and by the monarch to other
countries, have long been a staple of international
diplomacy and alliance-making. An official
welcome, a state banquet, receptions, perhaps an
address to Parliament, and certainly a stay in one
of the palaces, have been integral elements. In 1991
Lech Wałęsa, former shipyard worker, co-founder
of Solidarity, and president of Poland between 1990
and 1995, came on a state visit. The King's Troop of
the Royal Horse Artillery accompanied his carriage
up the Long Walk towards Windsor Castle.

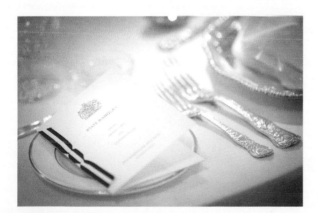

For all the ceremonial around a state visit, economic facts play an equally large part. On the visit of President Xi Jinping of China, who was welcomed to Buckingham Palace after a carriage ride up the Mall, over £30 billion-worth of trade deals were secured.

President Nicolas Sarkozy of France was the principal guest at the state banquet at Windsor Castle on his 2008 state visit. These events are a mixture of international diplomacy, splendour, forging economic links and cementing relationships, usually with dishes (and now wines) celebrating British food and skills.

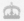

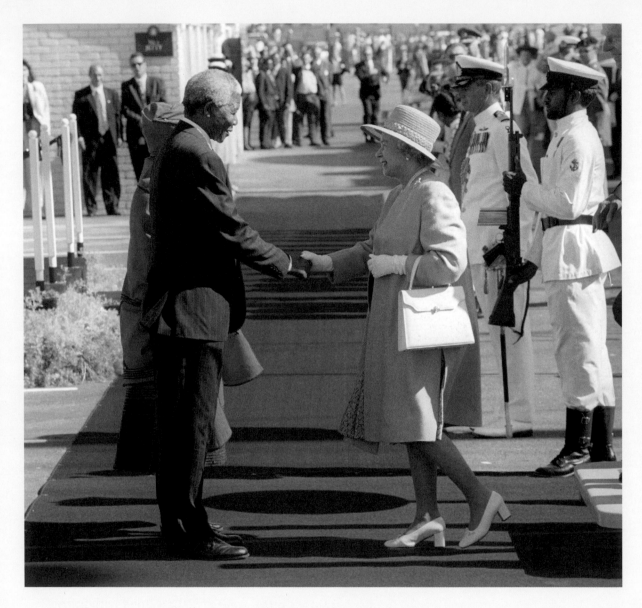

WITH NELSON MANDELA 1995

Returning to South Africa, which had rejoined the Commonwealth, the Queen met President Nelson Mandela on a state visit in 1995. He was the symbol of the new nation. When the Queen had left, nearly 50 years before, the apartheid system was being installed; now she returned when that had been dismantled and white minority rule had been overthrown.

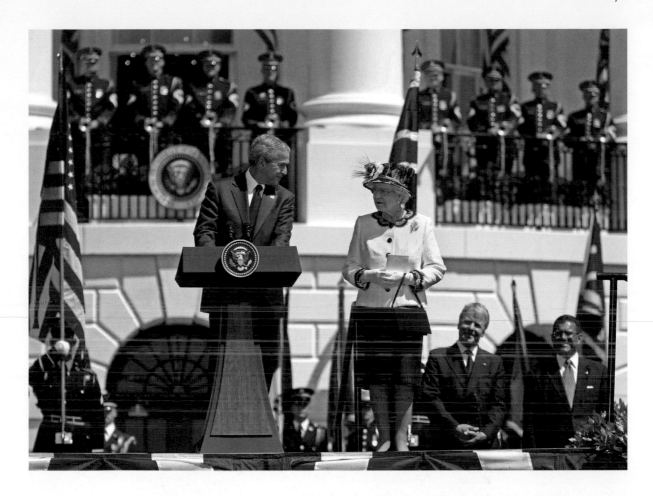

WITH GEORGE W. BUSH 2004

Visiting the USA in 2004, the Queen stood with
President George W. Bush in the garden at the
White House, where she had stood with four of
his predecessors as far back as Harry S. Truman.

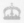

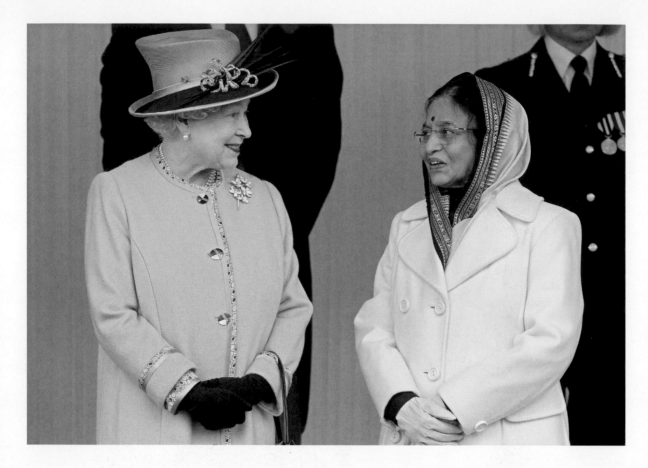

WITH PRATIBHA PATIL 2009

In 2009 the Queen welcomed the President of India, Pratibha Patil, on a state visit. India's first woman head of state, the President was entertained at Windsor Castle, where she was shown many of the Indian treasures of the Royal Collection and the Royal Library. King George VI had been the last Emperor of India, before independence was gained in 1947.

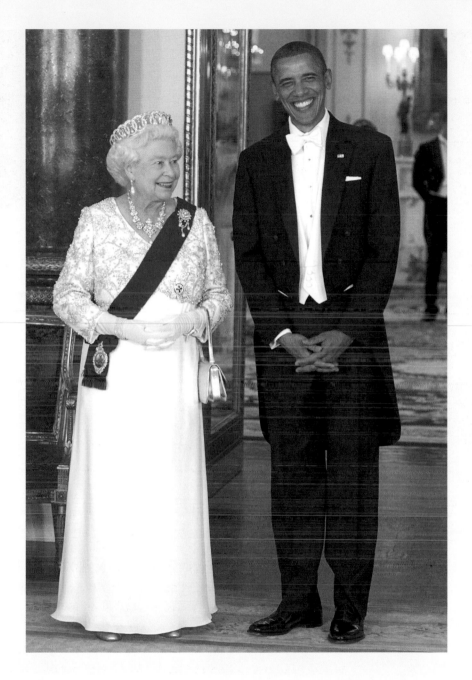

WITH BARACK OBAMA **2011**

President Obama's official gift to the Queen was a volume
of photographs of her parents visiting Washington, DC
in 1939, on the eve of war, as a reminder of the long and
special relationship between the two nations.

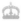

VISITING BATTLEFIELD SITES OF THE FIRST WORLD WAR 2004

As Commander-in-Chief of the armed forces, the Queen was always acutely conscious of the sacrifice that many had made in her name and the name of her forebears.

MILITARY CEREMONIAL

Presentation of new colours to the Grenadier Guards in a ceremony at Buckingham Palace in 2001.

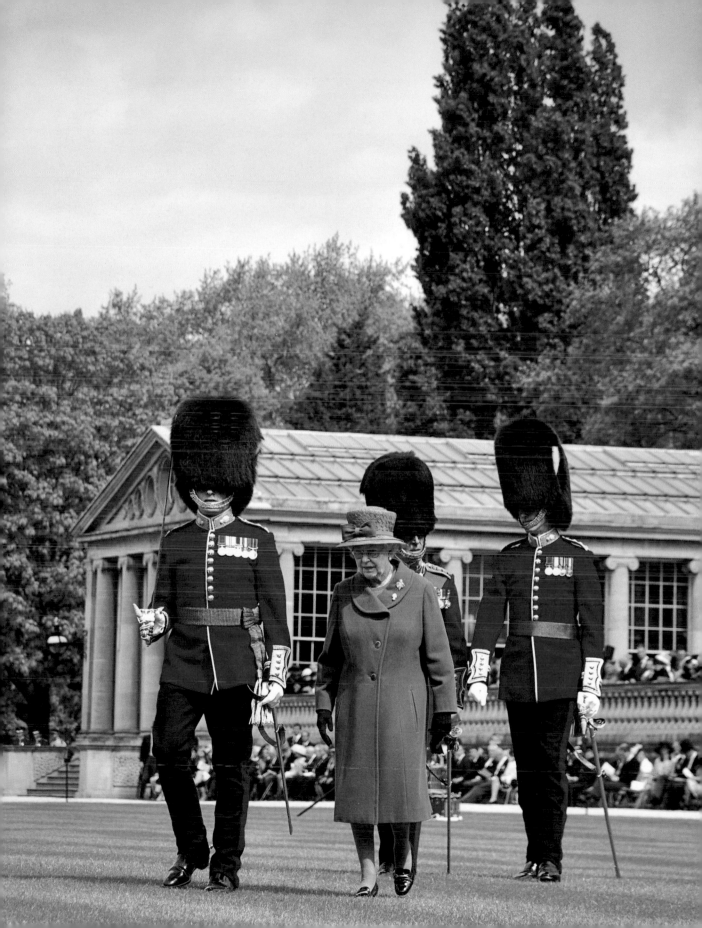

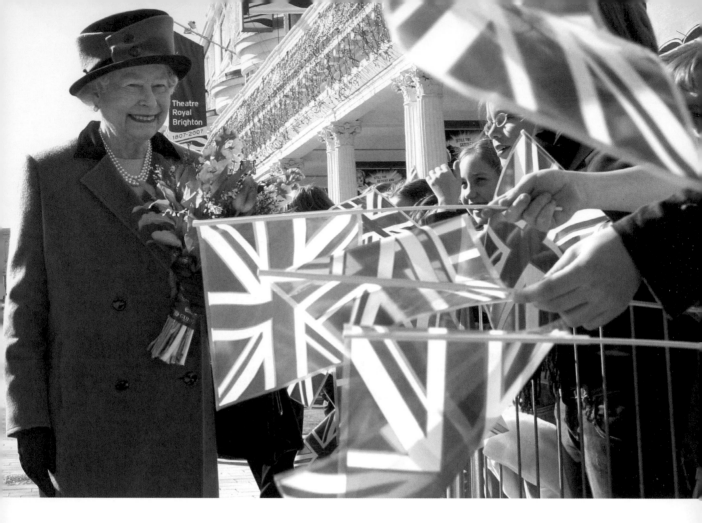

A VISIT TO BRIGHTON IN 2007

No part of the United Kingdom went unvisited
by the Queen, who travelled through her
realm at a pace none of her predecessors
would have recognised or even imagined. So
many hands shaken, bouquets received, bows
and curtseys acknowledged, speeches heard.
So many questions of what people did or how
far they had come to see her.

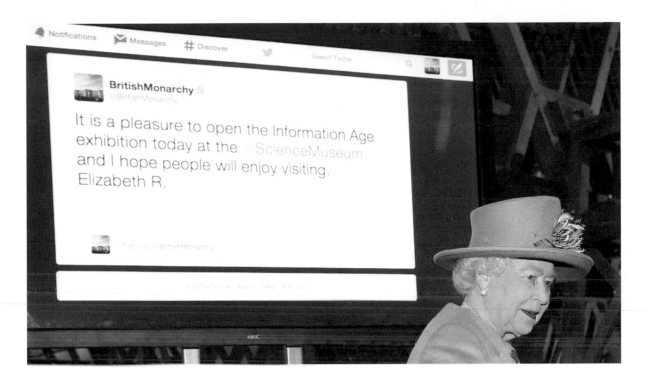

MONARCHY IN THE DIGITAL AGE

The Queen sent her first royal tweet from the Science Museum in 2014, when she opened the new Information Age Gallery. Telecommunications had come a long way since film of the coronation was sped by air to Canada in 1953 or since she had made the first transatlantic telephone call to Canada in 1961.

THE TOWER OF LONDON

The centenary of the outbreak of the First World War fell in 2014, and was commemorated in many striking and moving ways. One of the most memorable was the artwork at Her Majesty's Fortress and Palace of the Tower of London, a sea of ceramic poppies, one for each British or imperial soldier who died in the Great War.

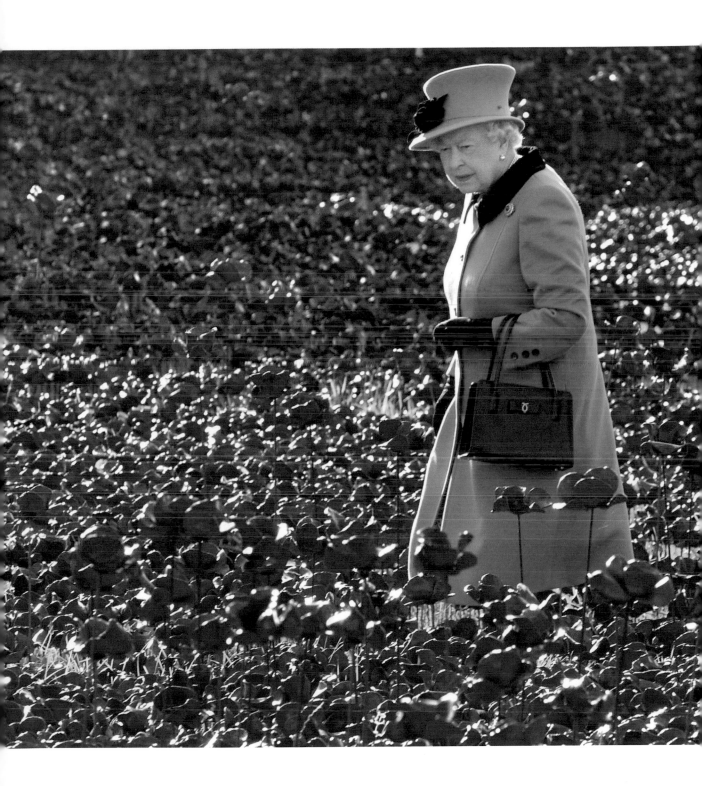

PARTYING

The Queen's garden parties, at Buckingham Palace and other royal residences, were a feature of the summer social calendar. Each year thousands of people from all walks of British life were entertained by the massed military bands, enjoyed the food and drink, and hoped to get more than a glimpse and perhaps a conversation with Her Majesty. The garden party on 23 May 2017 came in the immediate wake of a deadly terrorist bombing in Manchester, and the Queen led the partygoers in silent remembrance. She went to Manchester herself shortly thereafter, to meet victims and the bereaved.

REMEMBERING

The annual Festival of Remembrance at the Royal
Albert Hall in 2016, on the eve of Remembrance
Sunday when the Queen would lead the official act
of remembrance at the Cenotaph on Whitehall.

COMMONWEALTH

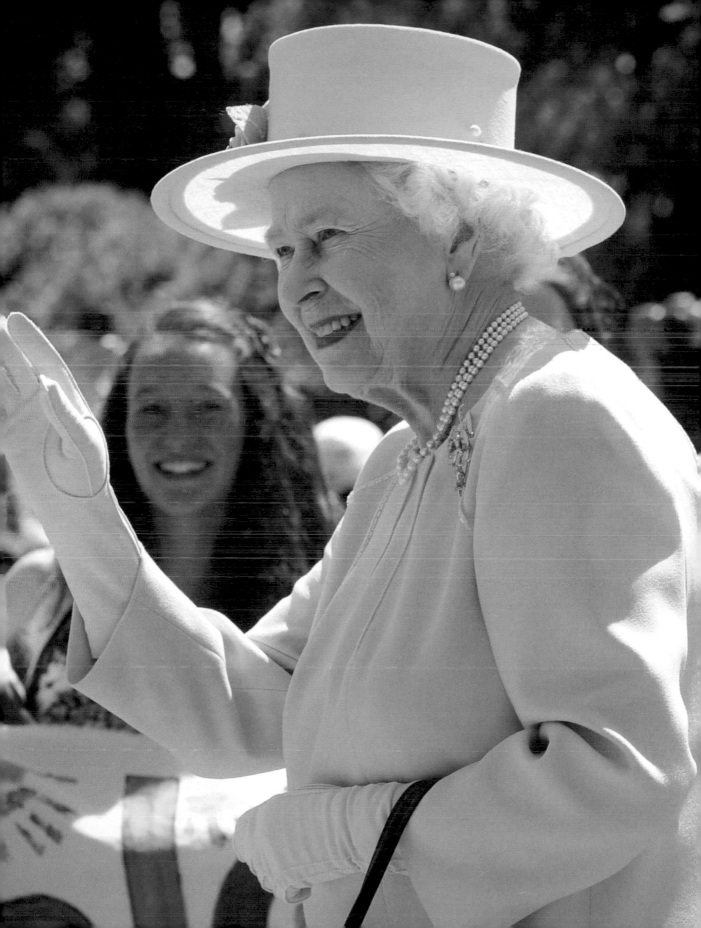

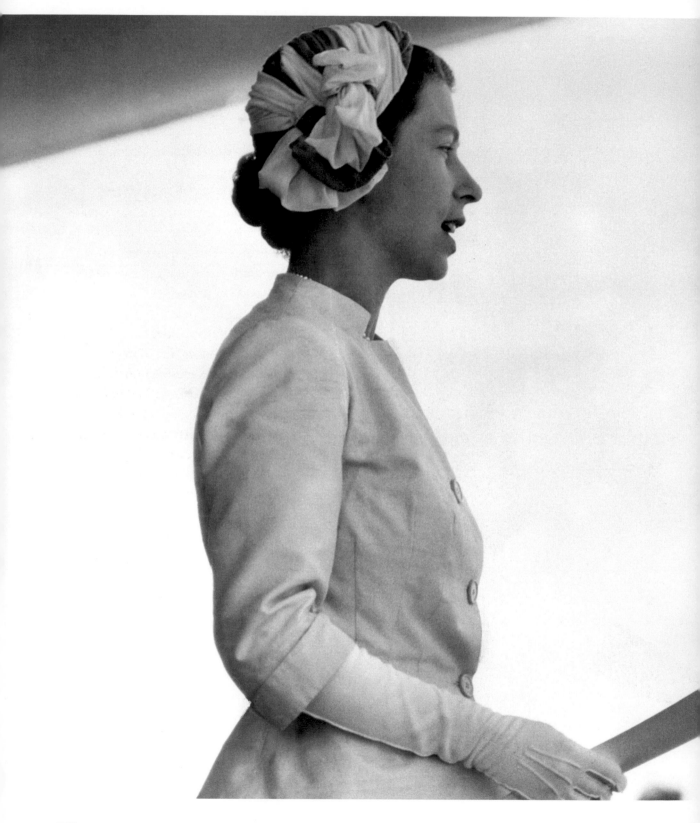

CORONATION TOUR

In 1949 the Commonwealth of Nations was created, with King George VI as its head. This was the role to which Queen Elizabeth II succeeded in 1952, 'the symbol of the free association of independent member nations'. Very soon after the coronation, the Queen and Prince Philip set off on a Commonwealth tour that broke every record for visiting and endurance. Three-quarters of the adult population of Australia saw her when she was there in 1954.

Replying to a welcome address at Timaru, New Zealand, this was one of over a hundred speeches made in Australia and New Zealand. The tour had begun in Bermuda and Jamaica, reached by plane, and then the royal party travelled by ship through the Panama Canal to Fiji, Tonga and New Zealand for Christmas. Then on to Australia, Ceylon (now Sri Lanka), the Cocos Islands, Uganda, Aden and so to the Mediterranean. There the royal party joined the newly built Royal Yacht *Britannia*, and sailed home again.

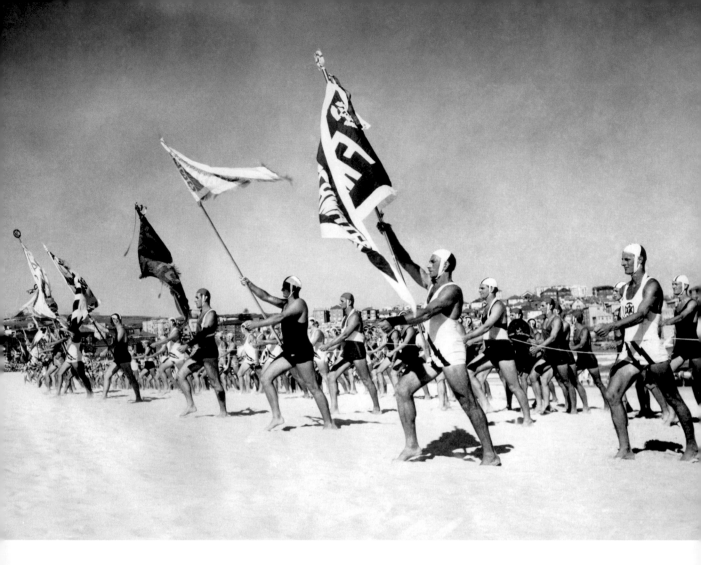

BONDI BEACH 1954

A stirring sight: Surf Life Savers, their banners waving, marched to the Queen's dais during the surf carnival staged in honour of the royal visitors at Sydney's Bondi Beach in February 1954.

THAMES WELCOME HOME

On 15 May 1954 the cameras and microphones were there to witness the homecoming of the Queen and the Duke of Edinburgh at the end of their 50,000-mile and 173-day Commonwealth tour. The Royal Yacht *Britannia* brought the royal party up the Thames and under Tower Bridge, which bore a giant 'Welcome Home' sign, into the Pool of London.

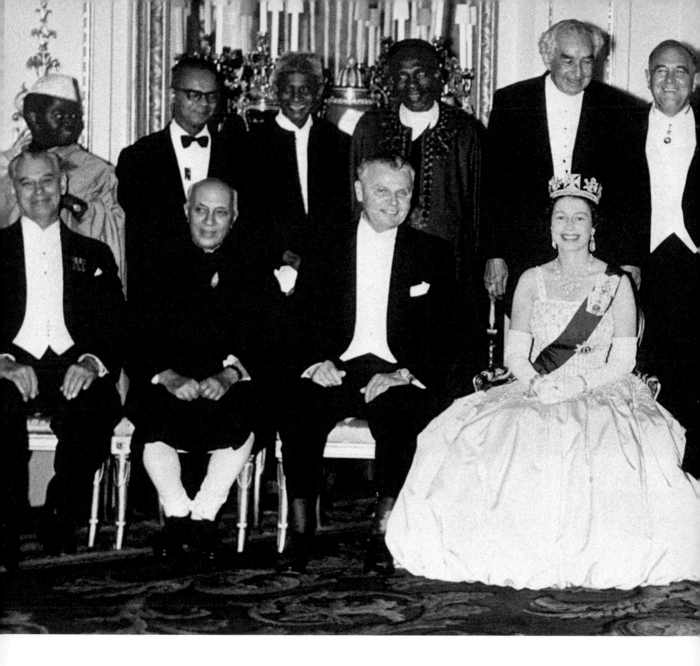

COMMONWEALTH LEADERS

In 1962 the Queen entertained the
Commonwealth prime ministers and
presidents to dinner at Buckingham
Palace. Back row left to right: Mr
Rashidi Kawawa (Tanganyika), Dr
Eric Williams (Trinidad & Tobago),
Sir Milton Margai (Sierra Leone),
Sir Abubakar Tafawa Balewa

(Nigeria), Sir Alexander Bustamante (Jamaica), Sir Roy Welensky (Rhodesia), Tun Abdul Razak (Malaya), Mr F.K.D. Goka (Ghana), Mr Sam P.C. Fernando (Ceylon) and Archbishop Makarios (Cyprus). Front row: Mr Keith Holyoake (New Zealand), Pandit Jawaharlal Nehru (India), Mr John Diefenbaker (Canada), the Queen, Mr Robert Menzies (Australia), Field Marshal Ayub Khan (Pakistan) and Mr Harold Macmillan (Britain).

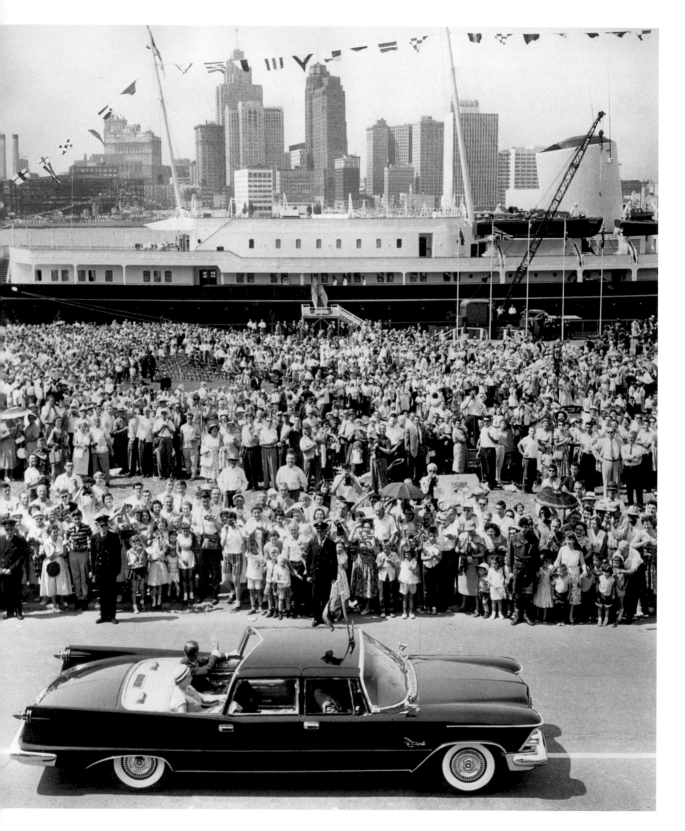

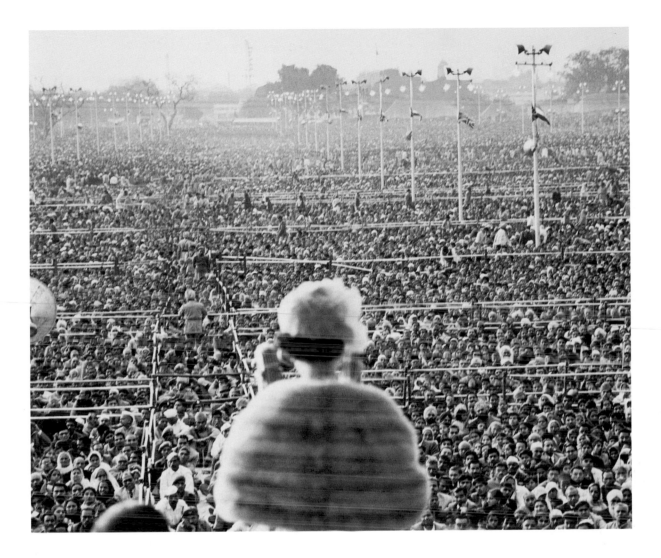

INDIA 1961

On her first visit to India, the Queen travelled to the major cities of the vast country. A quarter of a million people heard her speak at the Ramlila Ground between Old and New Delhi, the new capital inaugurated by her grandfather at his Imperial Durbar in 1912.

CANADA 1959

The soaring Detroit skyline lay across the border beyond the Royal Yacht as jubilant Canadians and Americans cheered the royal party on their tour of Canada.

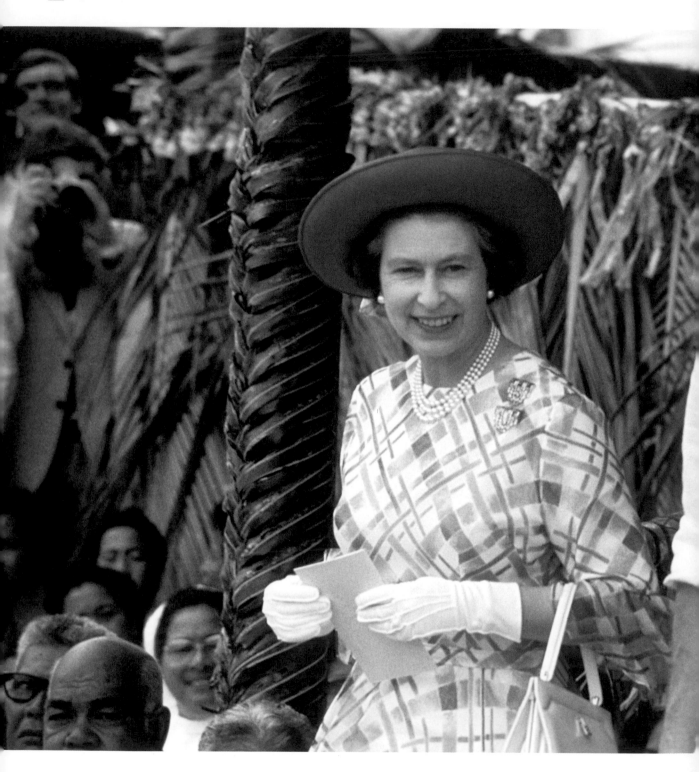

TONGA **1977**

The Queen and Prince Philip arrived in the Pacific island kingdom of Tonga in February 1977, one of many destinations on the Silver Jubilee tour of the Commonweath.

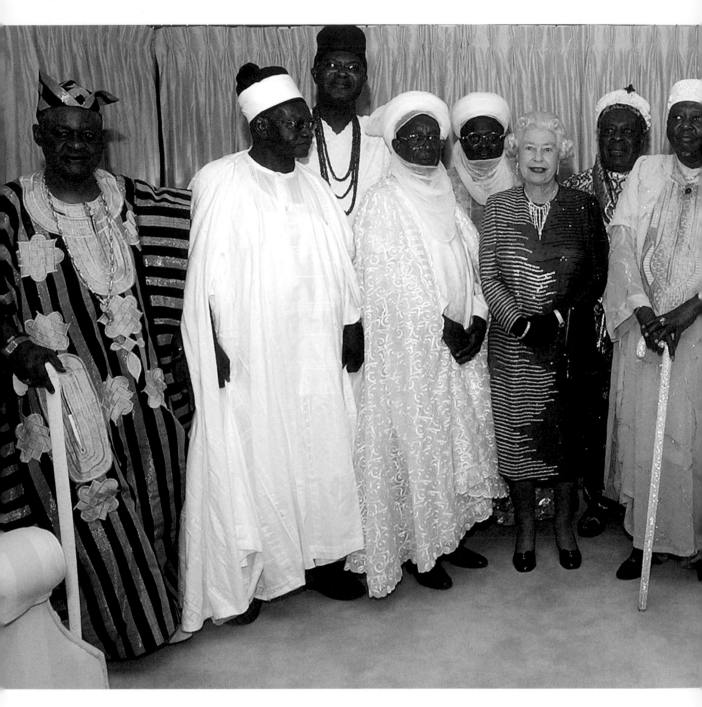

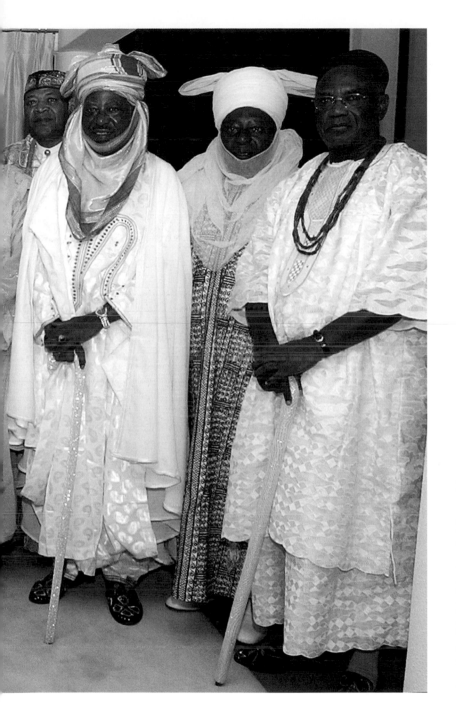

NIGERIA 2003

During her four-day official
visit to Nigeria at the end
of 2003, the Queen met the
Royal Fathers at the British
High Commision in Abuja.
Earlier she had launched
a radio soap opera that was
being staged by the BBC, and
visited a street market.

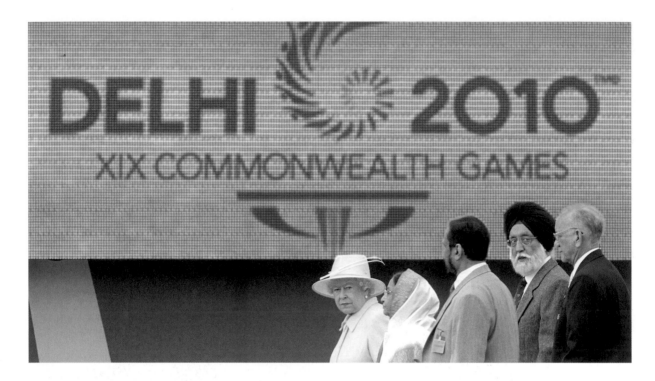

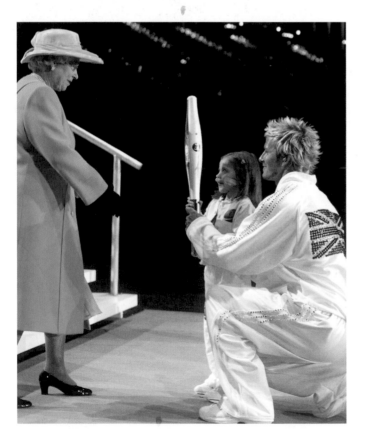

LET THE GAMES BEGIN

The Queen was present and performed the opening ceremony of the Commonwealth Games at many venues around the world. In 2010 it was the turn of Delhi, her third visit to the teeming city.

At the Commonweath Games of 2002, held in Manchester, David Beckham and terminally ill Kirsty Howard presented the Queen with the torch. The Games are held every four years, in a cycle staggered against the Olympic Games. Founded in 1930 as the Empire Games, this has been one of the world's major sporting events.

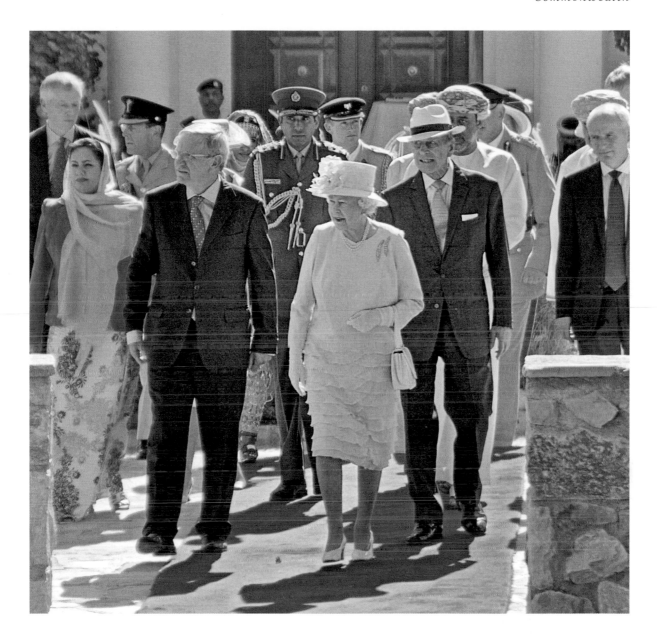

OMAN **2011**

Visiting Oman in the Arabian Gulf, the Queen met
the long-lived and much-loved Sultan Qaboos.
Oman had long had a history of British protection,
and the Sultan had always been a committed
Anglophile, so this was a very cordial encounter.
This was the 88th overseas visit of her reign.

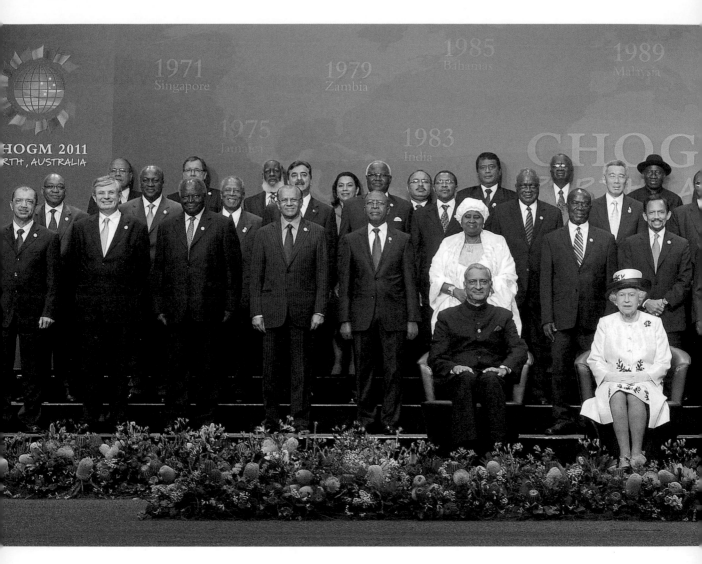

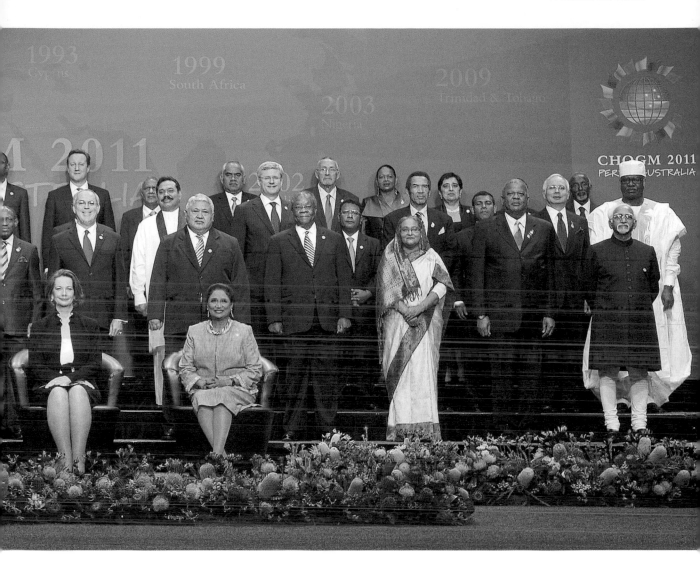

AUSTRALIA **2011**

At the Commonwealth Heads of Government meeting in Perth, Western Australia, in 2011, all the leaders of Commonwealth countries assembled for the traditional group photograph. Sometimes these meetings were unremarkable, sometimes they were marked by political in-fighting between nations.

Those were the occasions when the Commonwealth meetings really made the news. The Queen was the single, constant presence, and she made it her duty to attend all but a very few of the meetings. Many of the bonds of Empire had long been dissolved, but there was a personal dynamic represented by Queen Elizabeth.

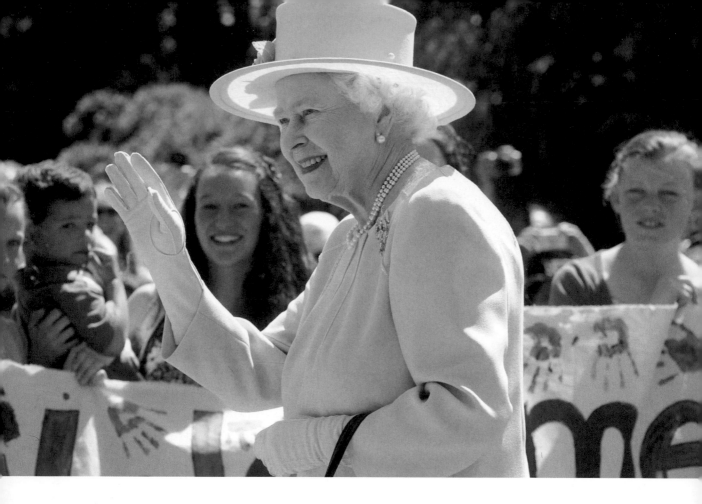

WELCOME TO CANBERRA

With Quentin Bryce, Governor-General of Australia, the Queen greeted guests at Government House, Canberra. Official receptions, gift exchanges and banquets are an integral element in international diplomacy and royal etiquette.

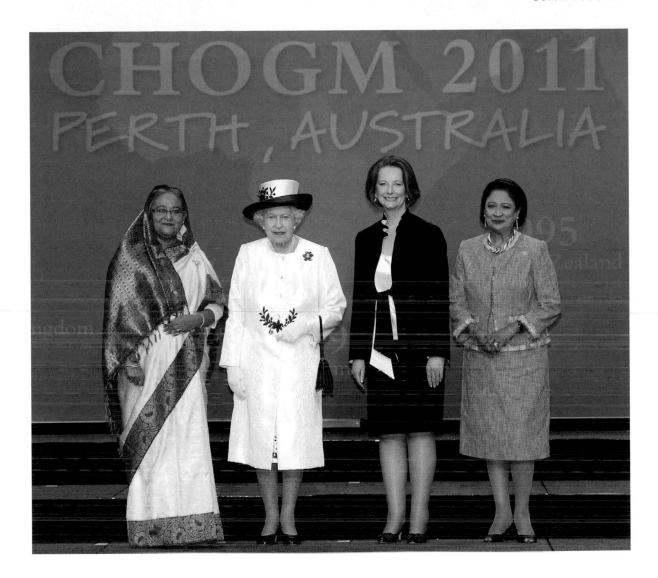

FEMALE LEADERS

At the 2011 meeting of Commonwealth Heads of
Government, the Queen posed with all the other female
leaders of the Commonwealth: prime ministers Sheikh
Hasina of Bangladesh, Julia Gillard of Australia and Kamla
Persad-Bissessar of Trinidad & Tobago. In her reign, more
women assumed positions of power than was ever the case
before. In 2011 the rule of male primogeniture in British
royal succession was overturned, and in future generations
an earlier-born sister will outrank a brother.

ROYAL FAMILY

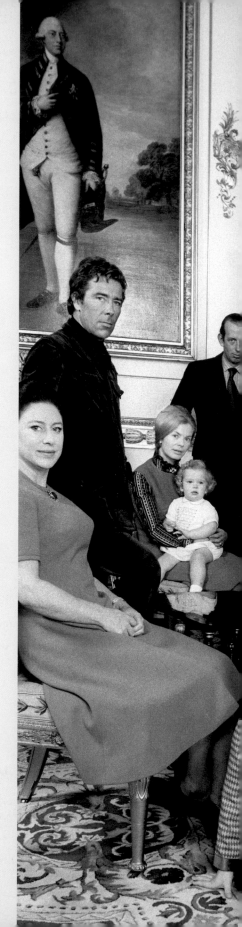

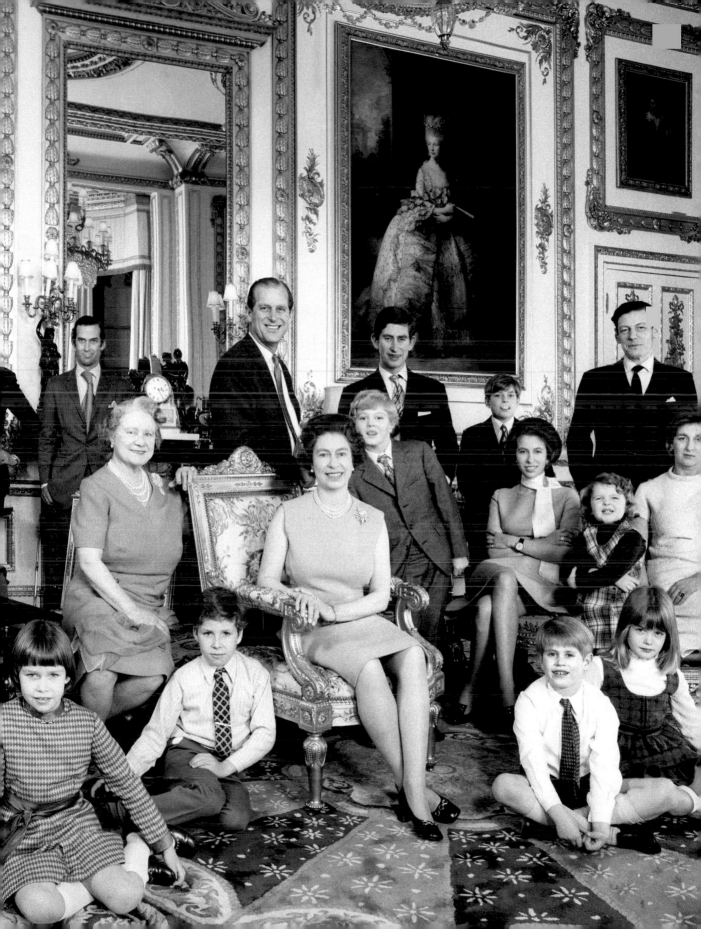

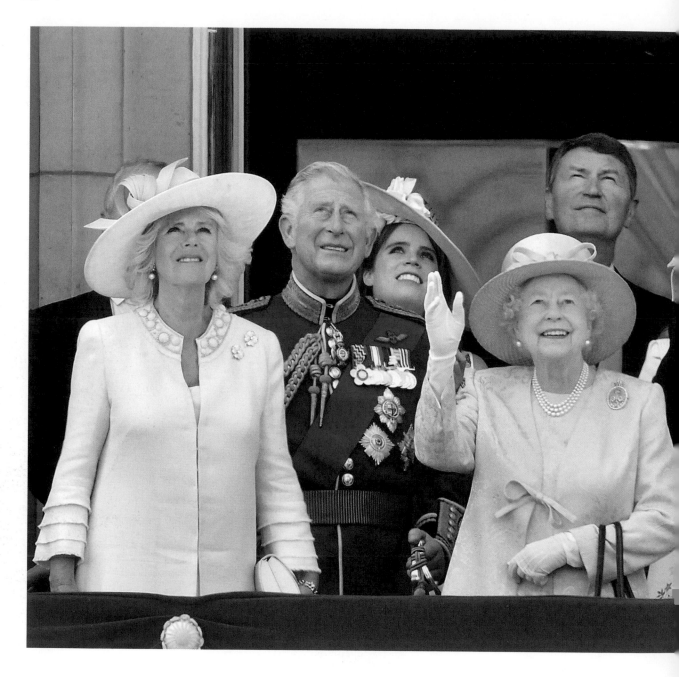

The quintessential view of the
Royal Family is the appearance
on the balcony at the front of
Buckingham Palace, after a great
public or family occasion. This
was a very special occasion, the
Queen's 90th birthday (or rather
her official birthday, some two
months after the actual event).
The size of the Royal Family
has grown and shrunk over
time; none could match Queen

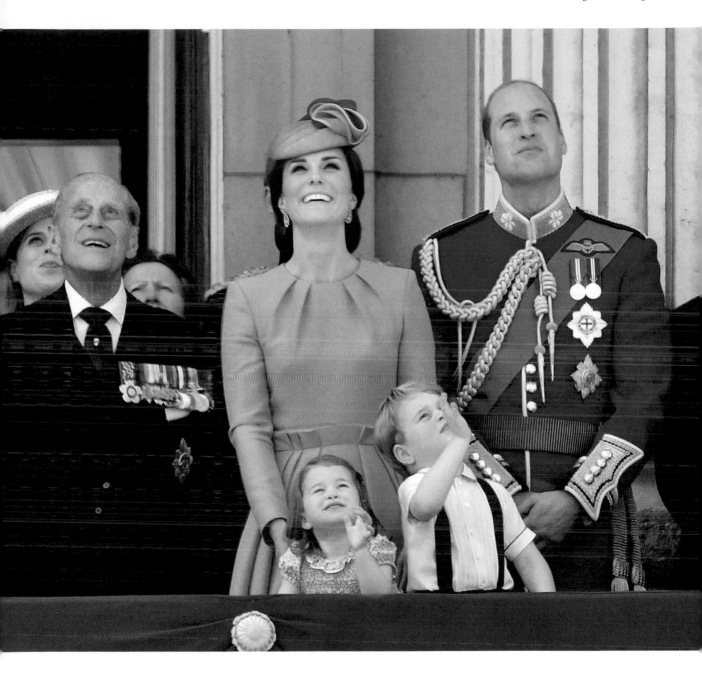

Victoria's extensive family, but Queen Elizabeth II with her four children, who have all had families of their own, came a close second. The Queen stood at the centre, accompanied as always by her husband Prince Philip. Their eldest son the Prince of Wales had sons and grandchildren of his own, establishing the royal succession for further generations.

AT THE BBC 1959

The Queen's eldest children Prince Charles and Princess Anne met David Attenborough in the BBC studio in 1959. Born while their mother was still a princess, their lives were deliberately shaped in different ways from their mother's, being sent to school rather than tutored at home, and given early opportunities to shine in the public eye.

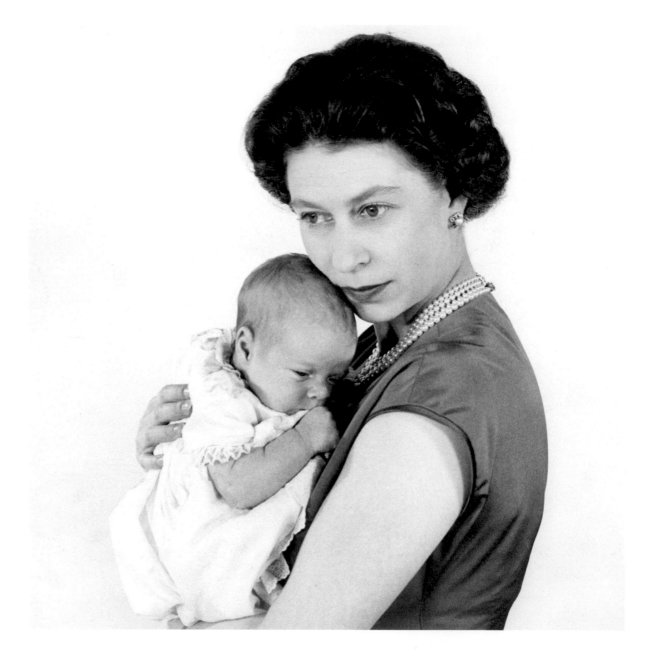

PRINCE ANDREW

The Queen with Prince Andrew,
photographed by Cecil Beaton
in 1960.

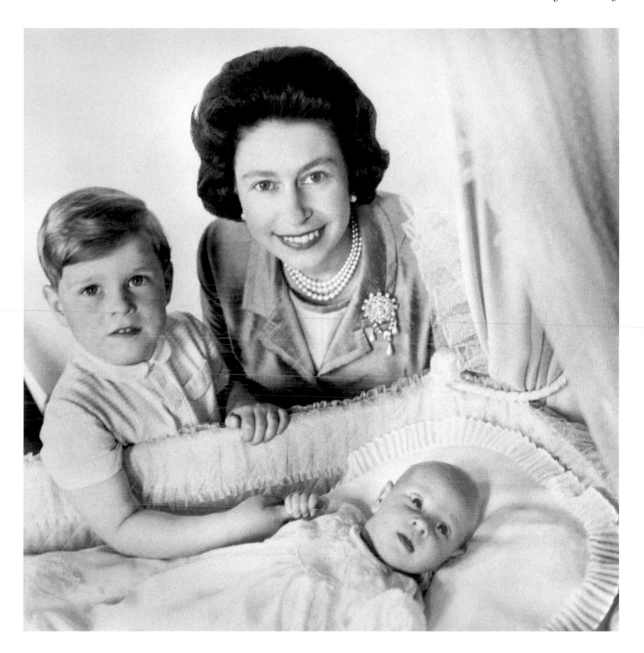

PRINCE EDWARD

With an almost ten-year gap between her second
and third child, the Queen's family was complete
with the birth of Prince Edward in 1964. The baby,
watched over by his proud mother, gripped the
finger of his four-year-old brother Prince Andrew.

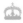

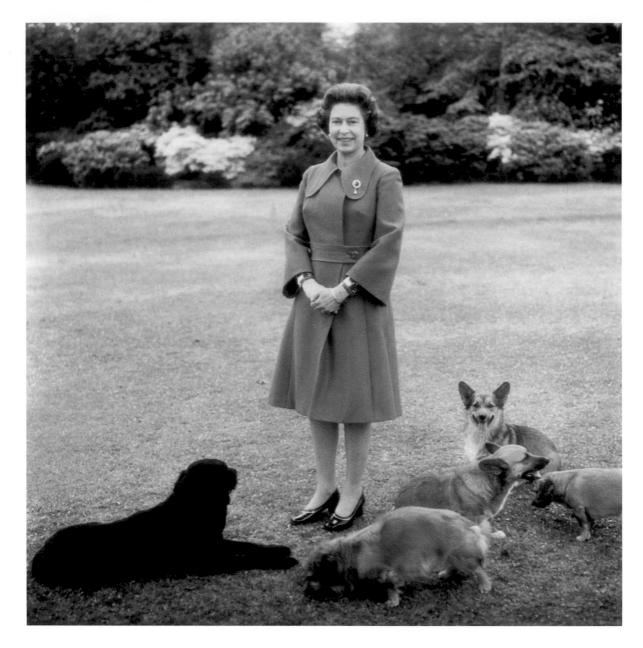

ALL CREATURES GREAT AND SMALL

Among the Queen's closest friends were her animals.
Throughout her life, dogs and horses accompanied her.
Welsh corgis, her mother's favourite dogs, became the
Queen's favoured pet. Horses to ride, or for jockeys to
ride in races, were an enduring passion.

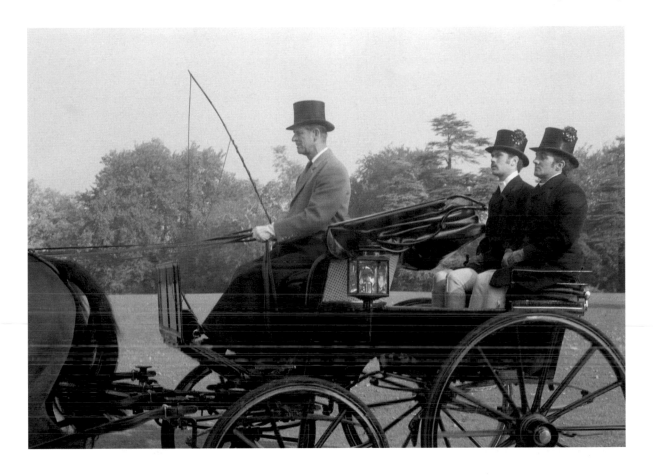

DRIVEN

Horses played a part in the lives
of many of the Royal Family:
Prince Philip was a keen – and
champion – driver of horses
with carriages in events.

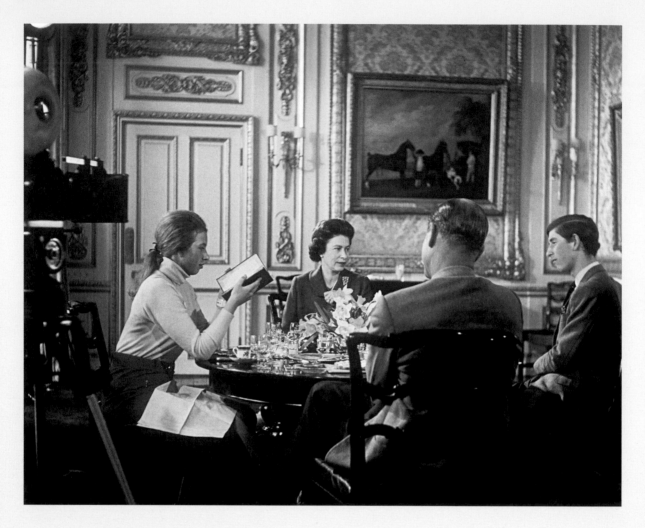

Royal Family 1969

Richard Cawston's 1969 documentary *Royal Family* was broadcast on BBC1 and a week later on ITV, a fly-on-the-royal-wall film showing the Queen and her family as few had ever seen them before. Relaxed, spontaneous, anxious, annoyed, distressed, jubilant, poised. Watched by millions, it was part of a deliberate attempt to make the Royal Family more approachable, to let a little light into the dark mystique of monarchy. The moves were particularly prompted by the Duke of Edinburgh, who acted with a new wave of courtiers and advisers to help lessen the distance between the Queen and the people. The images are a powerful reminder of how close the cameras got, and how extraordinary this was seen to be.

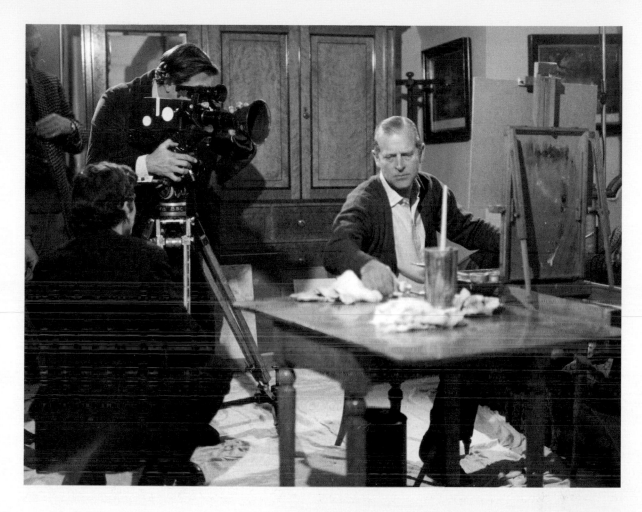

Prince Philip relaxes
with his painting
for the cameras in
Royal Family.

What the television
camera saw when
Prince Philip was at
his easel.

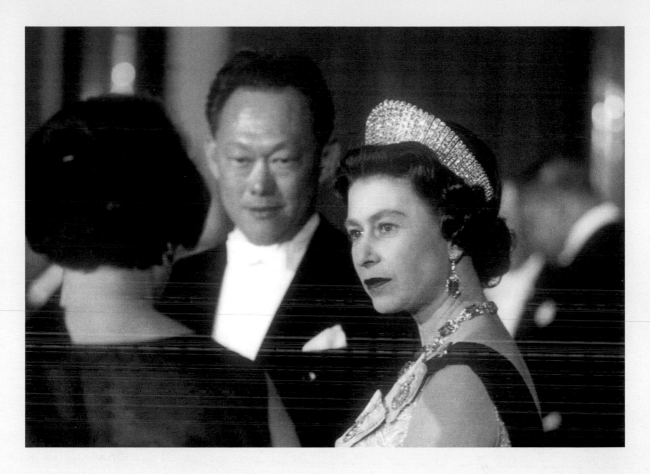

Prince Charles was the first member of the immediate Royal Family to enjoy a university education in the same way as other students, and he was an undergraduate at Trinity College, Cambridge, between 1967 and 1970.

The *Royal Family* documentary showed the public and ceremonial side of royal life alongside the family and domestic, as when the Queen hosted a reception for the Prime Minister of Singapore.

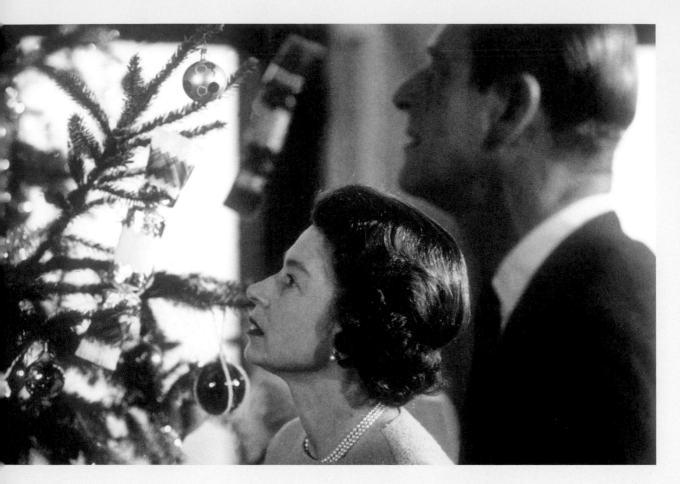

Christmas in the Royal Family: usually
celebrated at Sandringham, the Queen's
private home in Norfolk, the Christmas
celebrations were always a way to bring
everyone together. When broadcasts
were live, the day was interrupted by the
Queen delivering her annual message
at 3pm, so recorded messages gave the
family their day back.

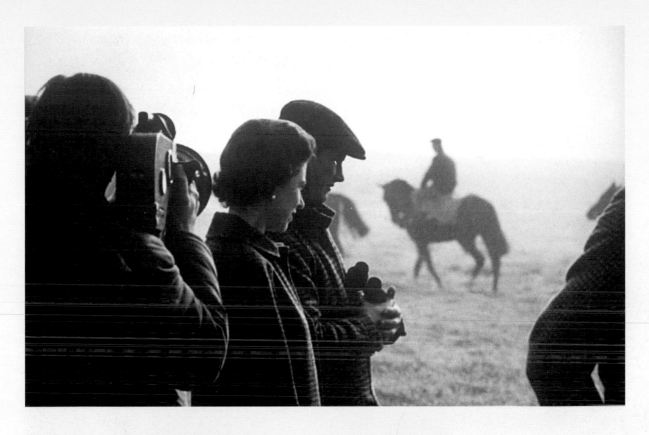

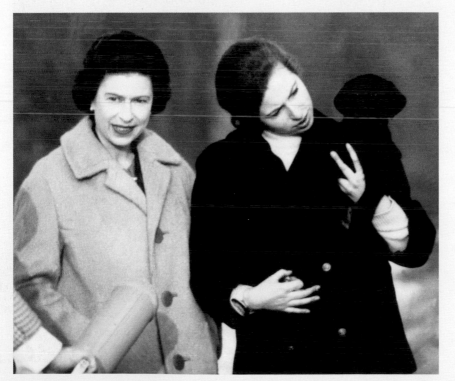

A misty morning
examining horses,
captured by the
documentary crew.

Mother and daughter,
the Queen with
Princess Anne in a less
guarded moment for
the camera.

State occasions, such as
a reception at Buckingham
Palace for a state visit,
interweave with domestic life for
members of the Royal Family.
The documentary showed how
regimented days might be,
and how packed they were,
not least with the changes of
clothes that were required.
Ceremonial events, lunches,
dinners, speeches, travel,
visits, walkabouts, opening
ceremonies, investitures, with
documents to read and papers
to sign in the gaps. The holidays
seemed entirely justified.

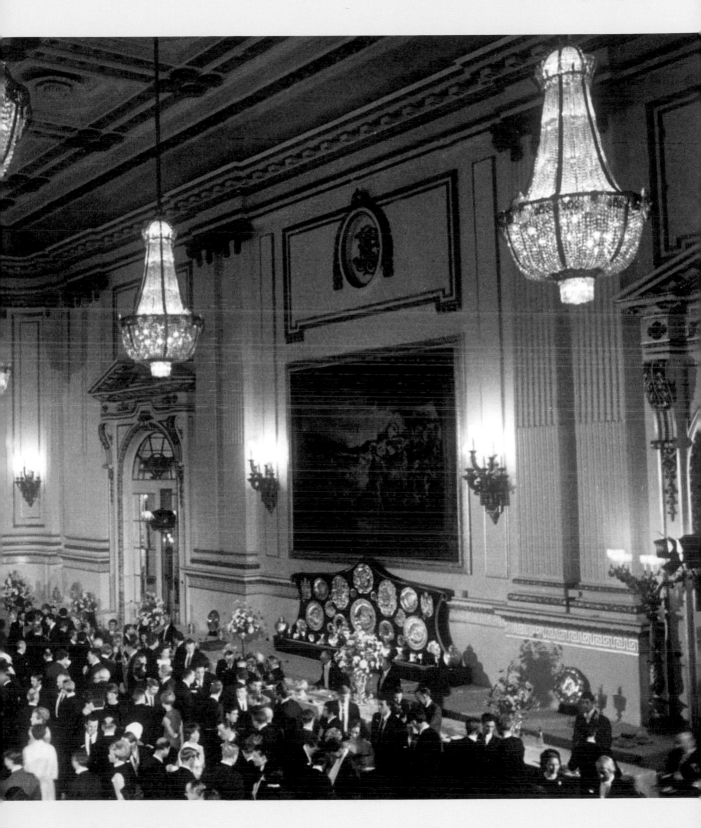

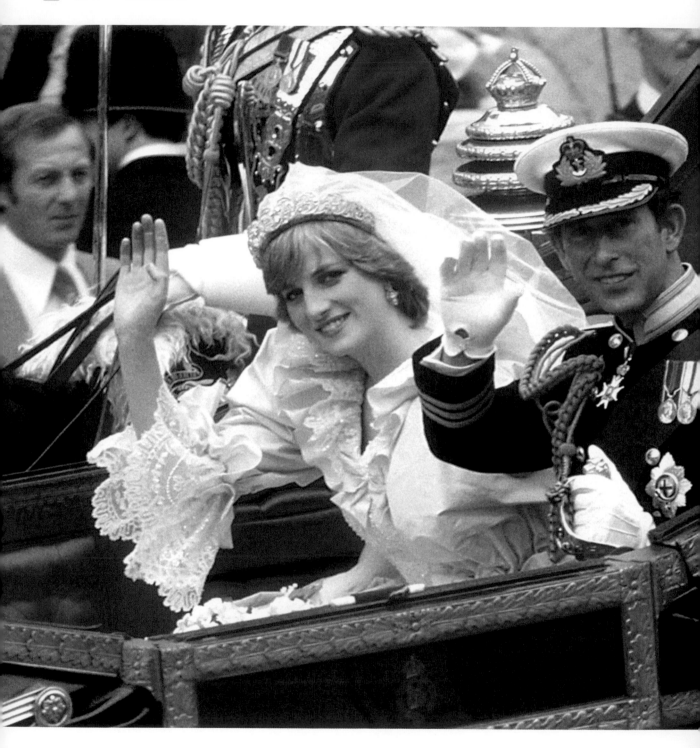

WEDDING DAY

On 29 July 1981, the wedding of Prince Charles to Lady Diana Spencer took place at St Paul's Cathedral. There had been years of speculation as to when and who the heir to the throne would marry. Diana was considerably younger, but very much in love. The marriage began as a fairytale romance, and two sons were born.

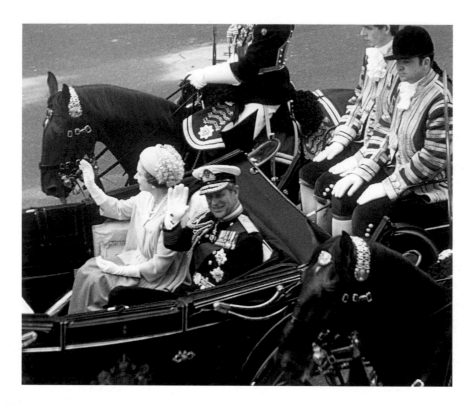

The Queen and Prince Philip in the open carriage procession at the wedding, being driven among the jubilant crowds from St Paul's Cathedral to Buckingham Palace.

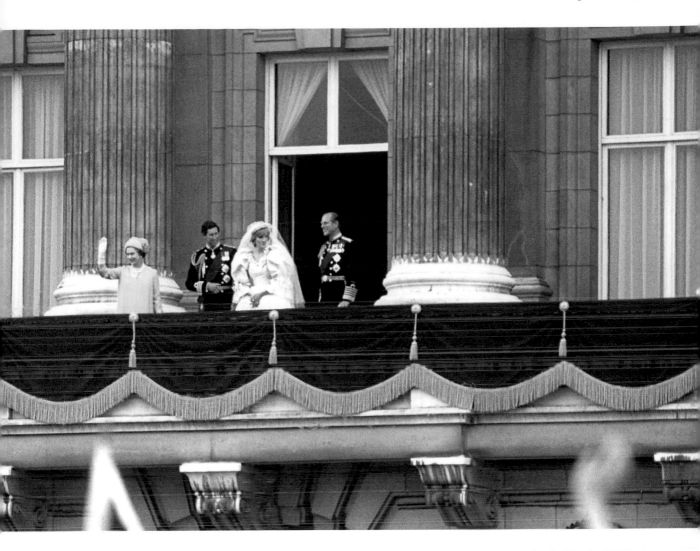

The balcony appearance of the
Prince and Princess of Wales
with the Queen and Prince
Philip after the wedding.

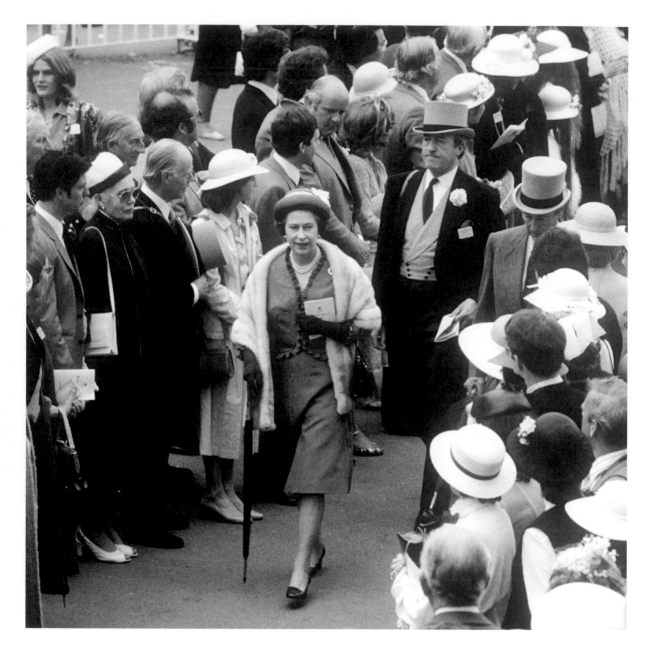

AT THE RACES 1981

The elegant figure of the Queen could often be seen walking through crowds of racegoers at major horseracing events.

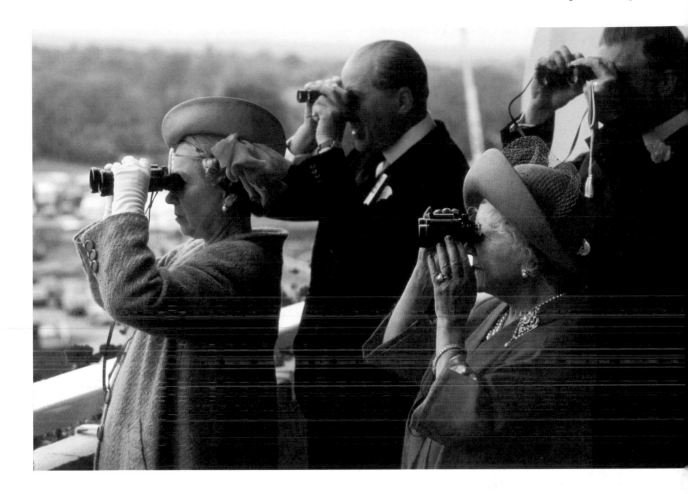

ROYAL WATCHING

The first race on 1991's Derby Day
at Epsom, with the Queen and the
Queen Mother – both of whom
were serious racing fans and horse
breeders – watching avidly.

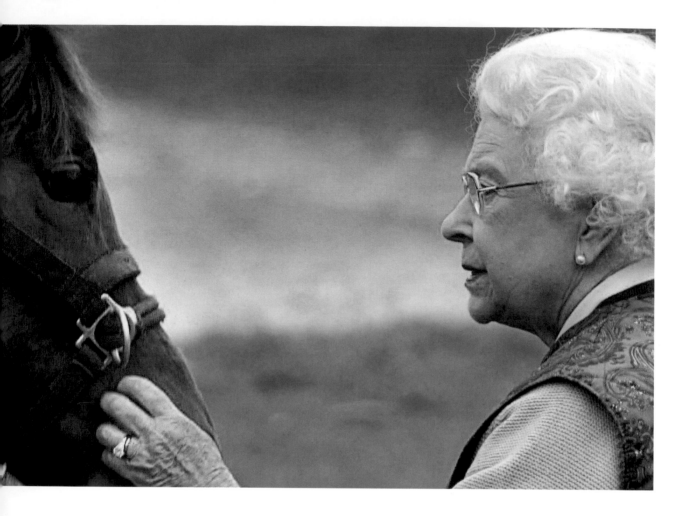

ROYAL FAVOURITE

Greeting a thoroughbred yearling
at Polhampton Stud, the Queen
demonstrated her enduring
passion for horses.

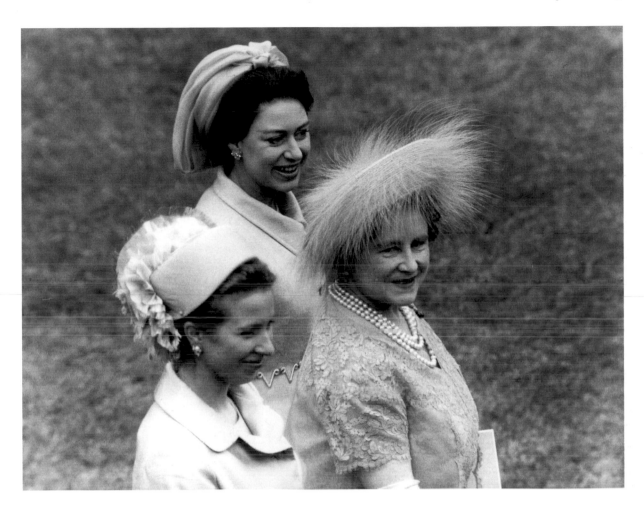

The Queen's mother (right) and her sister Margaret (back), seen here with Princess Anne, were constant and much-loved presences in her life. The sisters had grown up closely together, especially when they were separated from their parents in wartime or when royal duties called the King and Queen away. Both the Queen Mother and Princess Margaret were colourful characters, with many similar characteristics but also many differences from the Queen. The year 2002 would be difficult for the Queen, as her mother and sister died within six weeks of each other. The previous year the Queen Mother had celebrated her 100th birthday, amidst an outpouring of popular affection. The Golden Jubilee year began in personal sorrow.

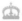

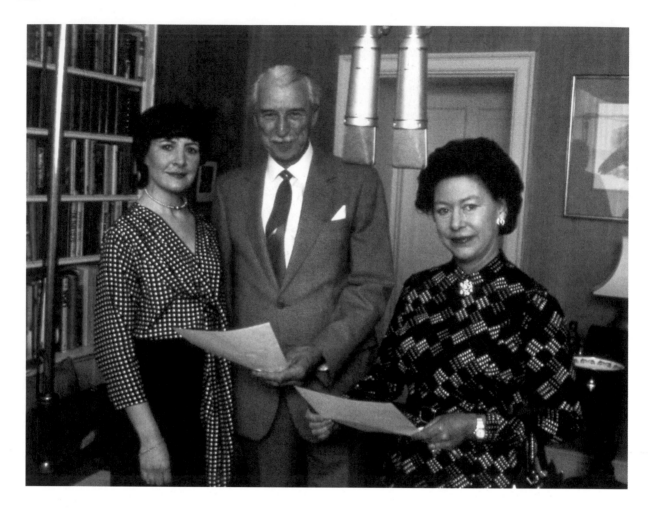

ON AIR

Princess Margaret had married the society
photographer Antony Armstrong-Jones, who was
created Earl of Snowdon, in 1960. They were the
glamour couple, inhabiting quite different social
circles from the Queen's. Yet within that Margaret
remained firmly a princess. In 1978 the couple
divorced, then an extremely rare event in royal
circles; thereafter the Princess was rarely far from
the society pages of the newspapers, and although she
was less frequently involved in royal ceremonial she
was a dedicated patron of the arts. She even had her
own cameo in *The Archers* radio serial in June 1984.

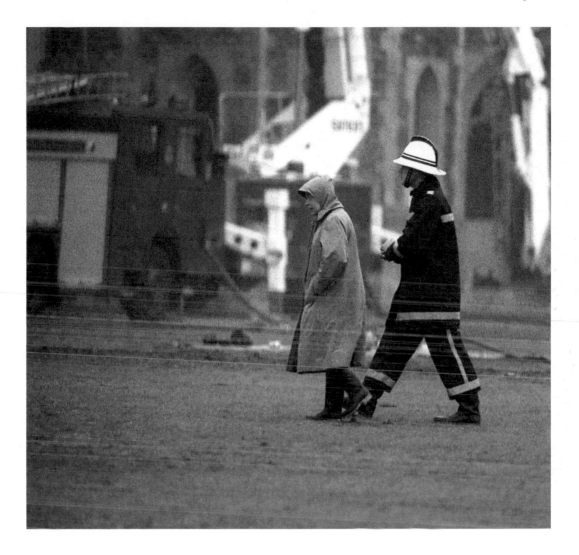

ON FIRE

The year 1992 was the Queen's self-styled *annus horribilis*. It witnessed the end of the marriages of three of her children, Prince Charles, Princess Anne and Prince Andrew. An often hostile press took a far less deferential line, publishing the sensational revelations of the collapse of the marriage of the Prince and Princess of Wales in particular. Finally, on 20 November, fire devastated Windsor Castle, where the Queen had spent much of her childhood. Eventually the press and public opinion would become more favourable, but this was one of the Royal Family's darkest moments.

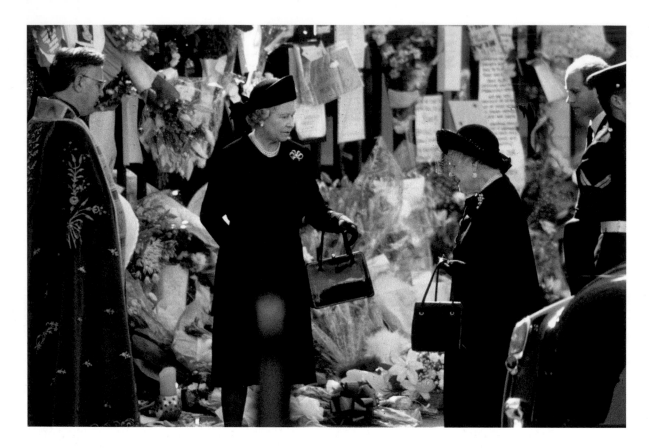

THE DEATH OF DIANA 1997

The funeral of Diana, Princess of Wales was the culmination of one of the most extraordinary outpourings of national grief in the 20th century. The tragedy of her death in a car crash in Paris on 31 August touched raw nerves. A sea of flowers stretched across the gardens in front of her home at Kensington Palace, and flowers also piled up outside Buckingham Palace and Westminster Abbey, where her official funeral was held.

The Queen and Queen Mother were among the members of the Royal Family looking at the floral tributes. It was a defining moment in the modern monarchy: public opinion demanded the Queen come back to London from Balmoral, and that against established protocol the flag over Buckingham Palace fly at half-mast. She made a moving television address to the nation, 'speaking as your Queen and as a grandmother'.

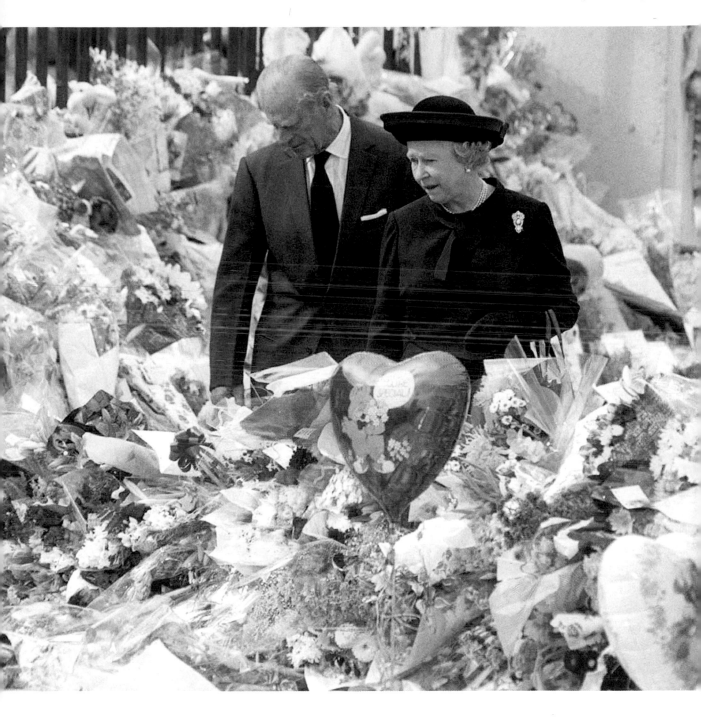

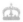

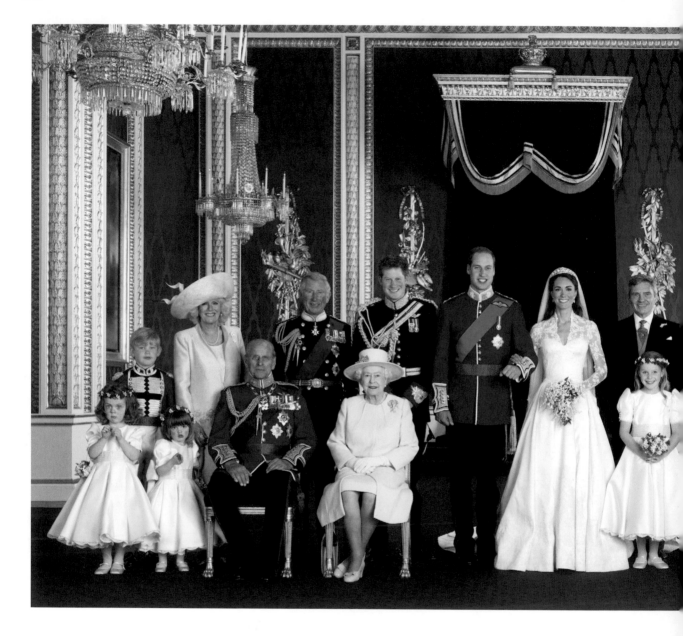

WEDDING STYLES

New and old ways were on display in a new series of royal weddings. Prince William, Duke of Cambridge and elder son of the Prince of Wales, married Catherine Middleton at Westminster Abbey on 29 April 2011. The bride was without royal or aristocratic connections, a departure from previous royal protocol. The couple had met as students at the University of St Andrews. Their children, two sons and a daughter, were born in 2013, 2015 and 2018.

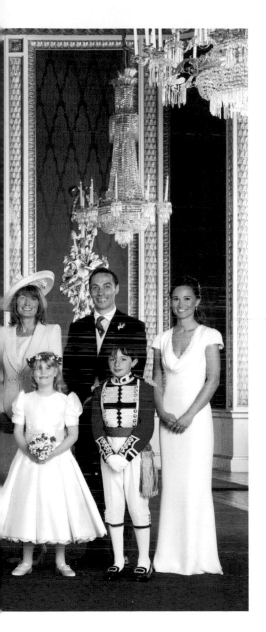

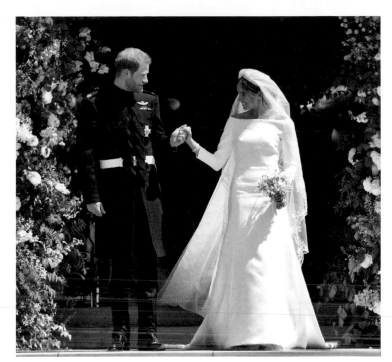

On 19 May 2018, William's brother Prince Harry, Duke of Sussex, married Meghan Markle at St George's Chapel, Windsor. The bride was American, of mixed race; the ceremony joyfully reflected that. Attitudes change: Meghan was divorced, but new rules allowed them to marry in church, rather than a civil ceremony with blessing after as for the Prince of Wales and Camilla Parker Bowles in 2005. Following the birth of their first child, Archie, the Sussexes left royal life in 2020, relocating to the USA.

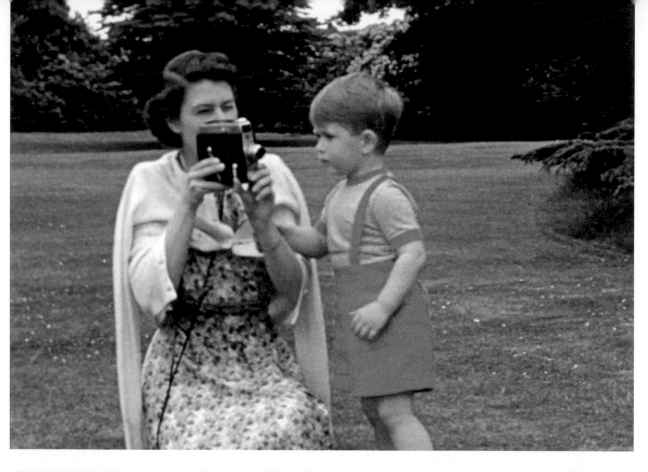

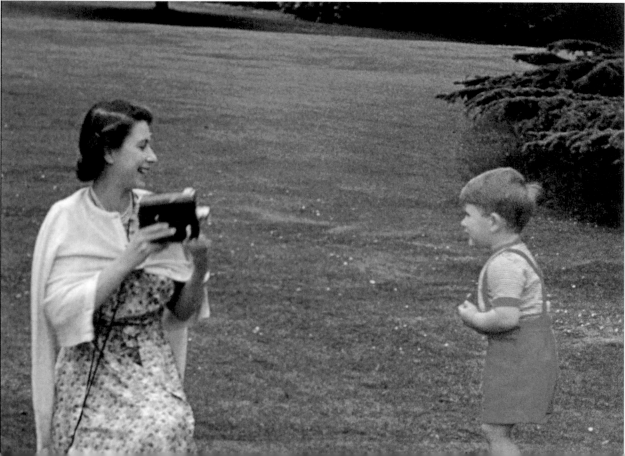

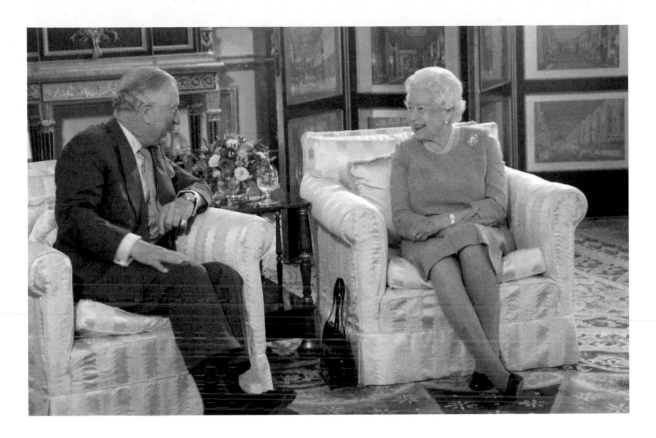

MOTHER AND SON, QUEEN AND PRINCE

Home movies were revived for the 90th birthday celebrations, showing the television audience the clear bond of affection. The Queen and the Prince of Wales shared happy memories of when she was a young mother with a cine camera and he was a little, playful boy.

LEGACY

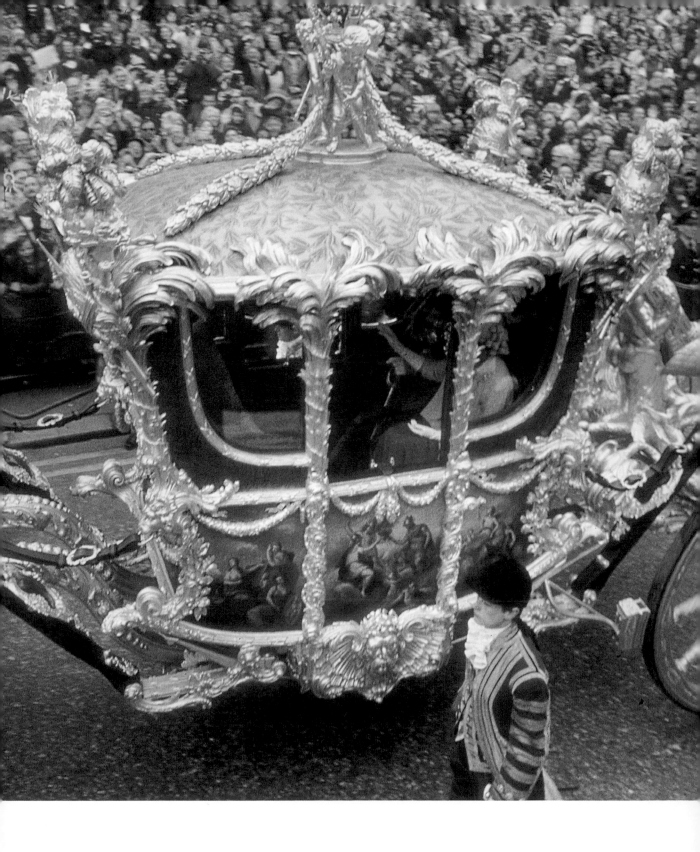

THE SILVER JUBILEE 1977

King George III had been the first British monarch to
have reigned long enough to celebrate the length of his
time on the throne with a Jubilee in 1810, after 50 years.
Queen Victoria celebrated both Golden and Diamond
Jubilees, for 50 and 60 years, in 1887 and 1897. These
were both national and imperial events, in which the
reluctant, aged Queen was persuaded into the limelight.
The idea of celebrating a Silver Jubilee, marking 25 years,
came with King George V in 1935, partly as a means of
focusing popular opinion after the long years of political
upheaval since the mid-1920s. A precedent was set, and
celebrations began for the Queen's first 25 years on the
throne in 1977. Of course there was ceremonial: the
Queen arrived at St Paul's Cathedral, in the Gold State
Coach made for George III, for the national service of
thanksgiving for her Silver Jubilee.

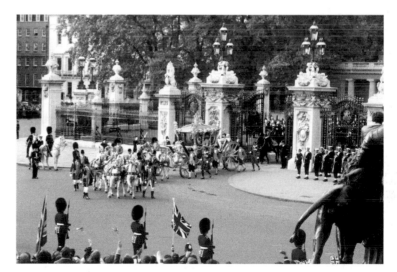

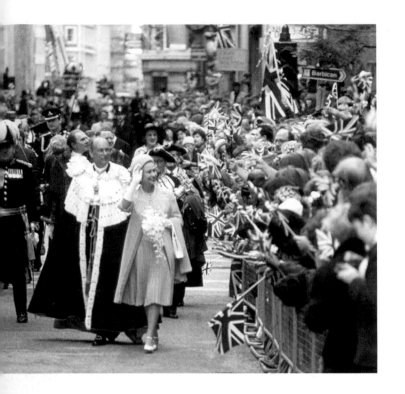

THE ROYAL WALKABOUT

Accompanied by the Lord Mayor of London, following the service at St Paul's, the Queen ensured that the waiting throng had a chance to see her at close quarters. The royal 'walkabout' was first essayed in Australia, on the tour of 1970, so that the Queen could meet ordinary people rather than just dignitaries. The Aboriginal phrase was adopted for royal use, and the practice swiftly became embedded in royal ritual. On this occasion, in a break from traditional royal distance, the Queen walked among the crowds, accepting gifts of flowers and greeting well-wishers.

STREET LIFE

The Silver Jubilee was a national outpouring of celebration and patriotic emotion for the Queen. Bunting was strung, streets were closed and outdoor parties were held, all in conscious emulation of the popular celebrations for the coronations of 1937 and 1953.

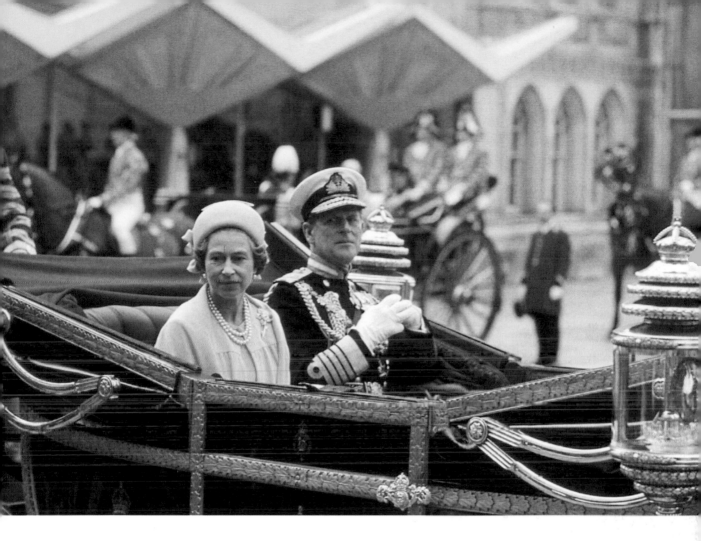

THE ROYAL RIDE

The year 1977 saw a summer of televised events. The Royal Mews were exceptionally busy preparing carriages and horses for the ceremonies and celebrations. The royal couple were on this occasion driven away from the Lord Mayor's celebration luncheon at the Guildhall.

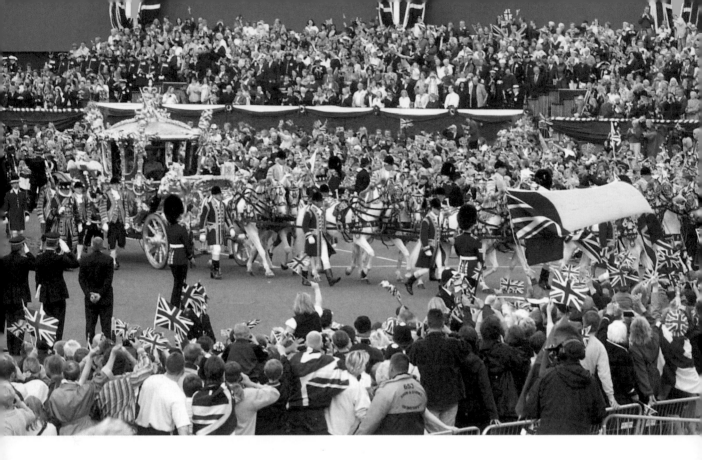

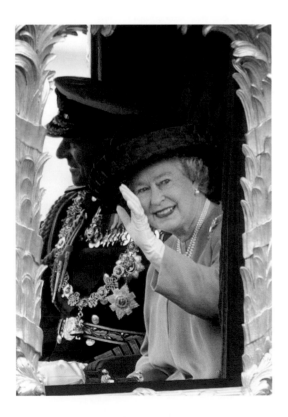

THE GOLDEN JUBILEE 2002

In 2002, Queen Elizabeth II celebrated 50 years on the throne; only King George III and Queen Victoria had previously celebrated such a long reign.

GOLD COACH FOR A GOLDEN DAY

George III's Gold State Coach was pressed into service again for the ceremonial drive to St Paul's Cathedral for the national service of thanksgiving on 4 June. The celebrations had begun officially five weeks before when the Queen addressed both Houses of Parliament in Westminster Hall.
'I resolve,' she said, 'to continue, with the support of my family, to serve the people … to the best of my ability through the changing times ahead.'

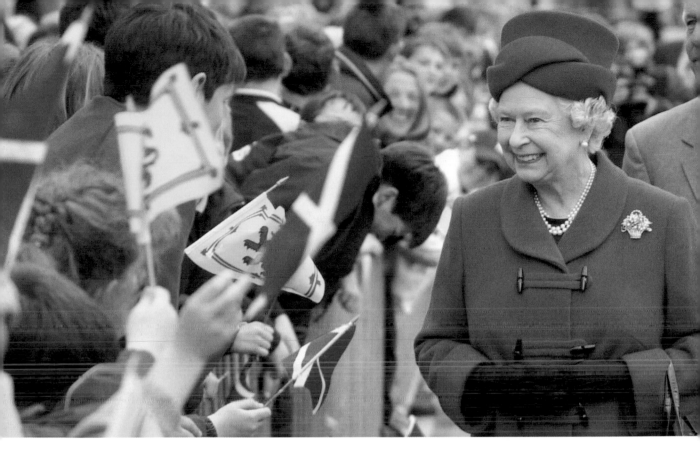

By the time of her Golden Jubilee, the Queen had received more public scrutiny than probably any of her predecessors, and certainly none had been given the same exposure, seen by billions whether in the flesh or through the media and especially on television. The BBC Radio 2 series *50 Royal Years* traced the course the Queen had to steer, through good times and bad, in a reign where royal duties needed to live side by side with the intense interest of a curious press and public.

GOLDEN POST

As with many such occasions, special commemorative postage stamps were issued for the Golden Jubilee. The United Kingdom is unique in that its stamps do not bear the country's name. The Queen's head signified the nation instead.

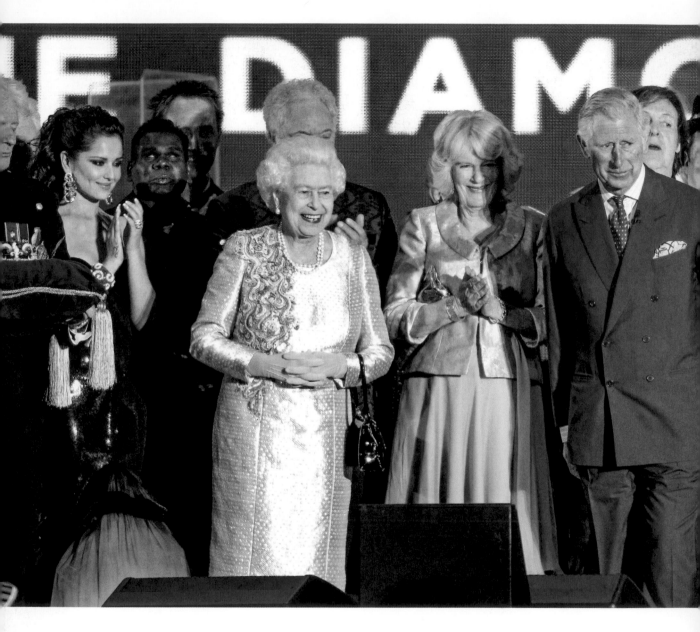

NEW TRADITIONS

In both 2002 and 2012, a particular highlight of the Jubilee celebrations was a huge rock concert in front of Buckingham Palace and on the Mall (and in guitarist Brian May's case in 2002, from the roof of the Palace). Music stars young and not so young from 60 years of music-making performed on 4 June 2012, with the Queen watching at a distance before it was her turn to come on stage, receive the warm cheers of audience and musicians, and out-star the stars.

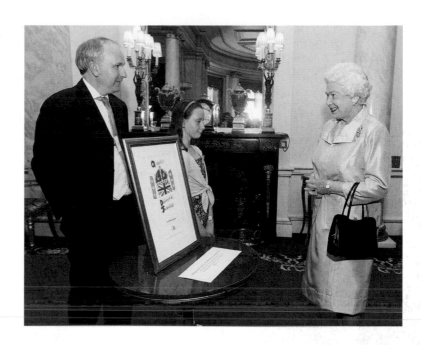

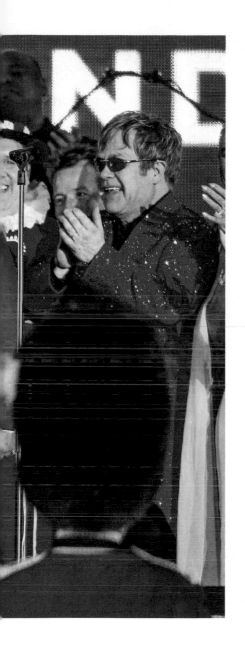

THE DIAMOND JUBILEE 2012

Ten-year-old Katherine Dewar from Chester
submitted the winning design for an
emblem for the Queen's Diamond Jubilee,
in a competition run by BBC TV's *Blue
Peter*. Accompanied by her father David,
she presented her design to the Queen at
Buckingham Palace in 2011. The emblem was
to be seen everywhere the following year.

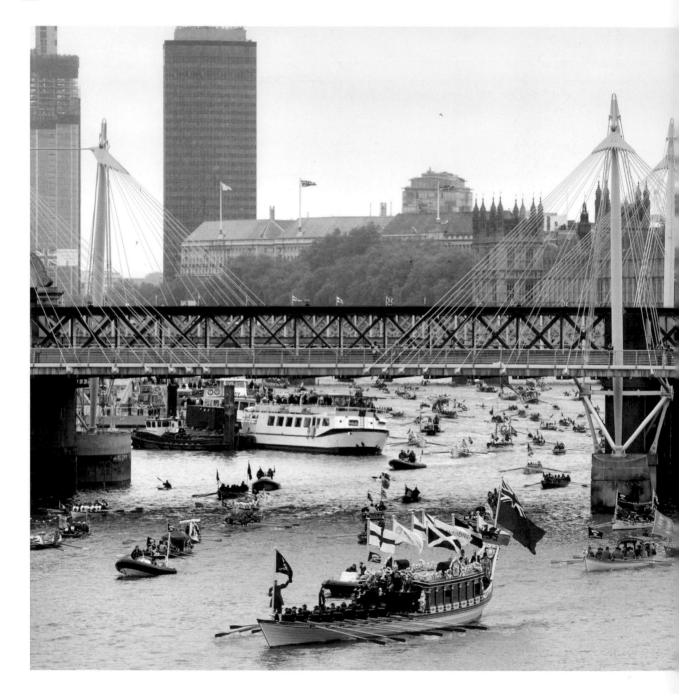

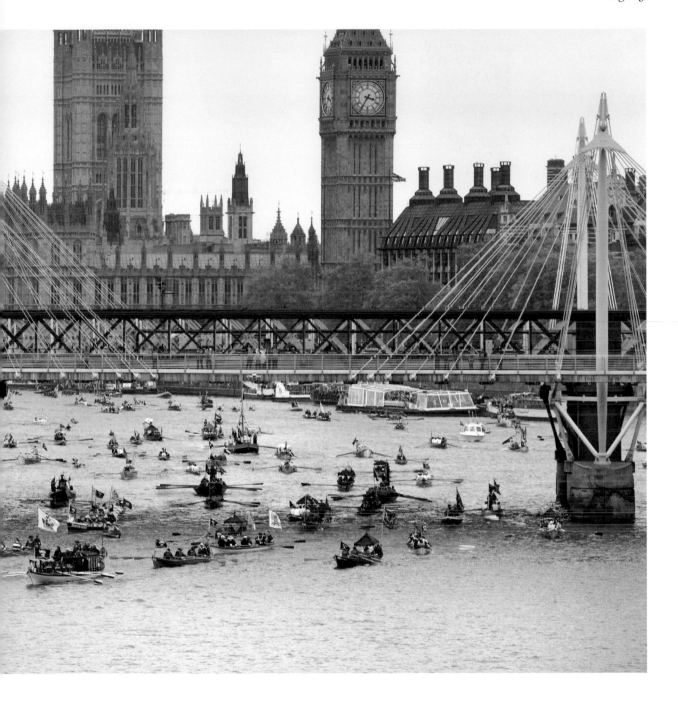

RIVER PAGEANTRY

On a wet and cold 3 June, weather that recalled the coronation 60 years before, a new royal barge led a procession of a thousand boats down the Thames, with the Queen (in white for visibility) and Prince Philip standing throughout to receive the crowd's cheers.

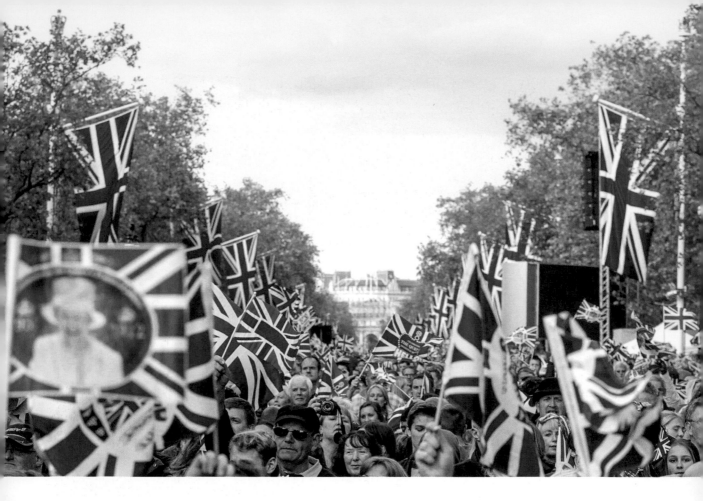

CELEBRATION

Ten thousand ticket holders
crowded into the lower end of
the Mall, and many more without
tickets who were further away,
were able to enjoy the Party at
the Palace on 4 June, culminating
in fireworks on the grand scale.
Lottery funds had been made
available so that parties could be
held up and down the country,
celebrating a life, a reign and
the diverse nation the United
Kingdom had become.

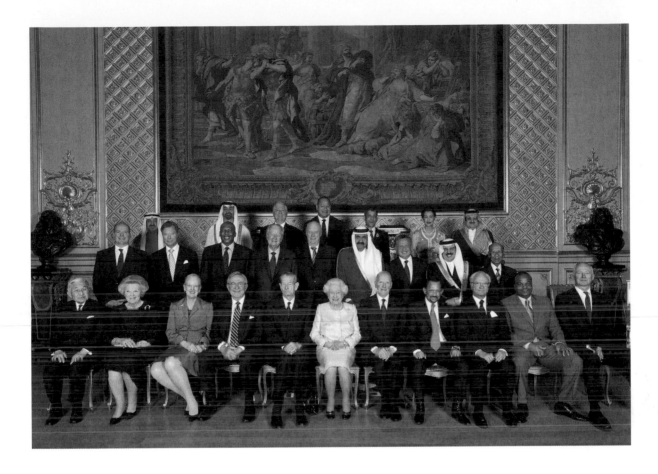

CROWNED HEADS

The Queen was not alone, and to celebrate that fact she invited 20 monarchs to lunch at Windsor Castle on 18 May, and a celebration dinner that night. There were a few absences, but the event marked the living world tradition of monarchy.

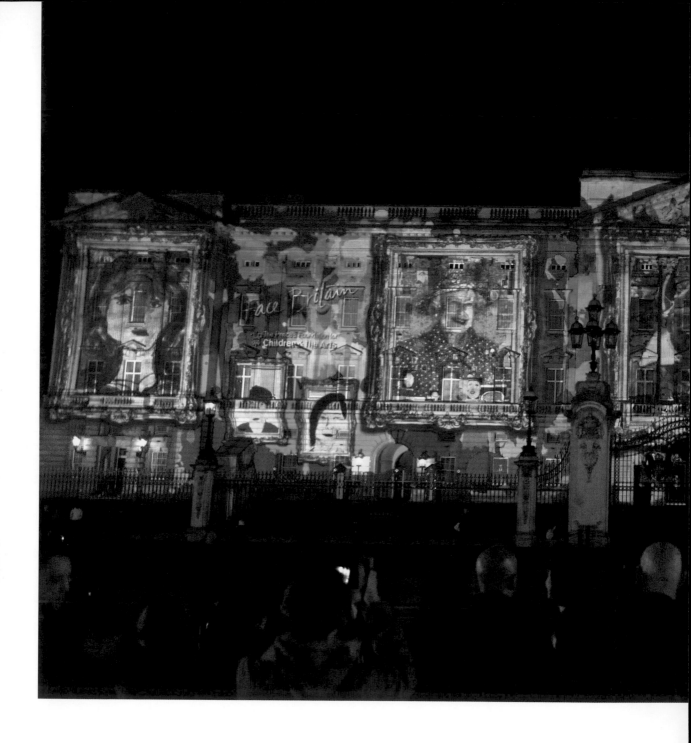

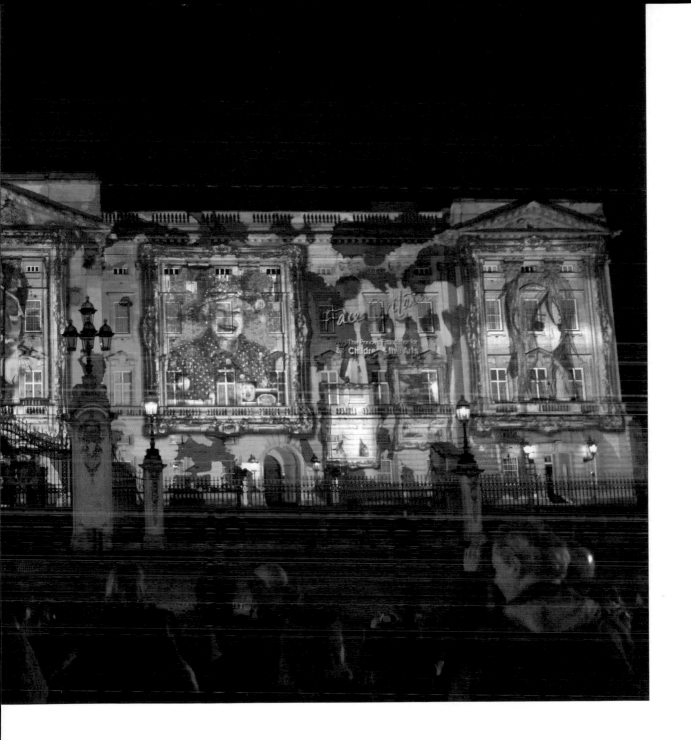

DIAMOND QUEEN

Photographs of hundreds of children were projected onto the front of Buckingham Palace in March 2012, making a series of montage portraits of the Queen, in one of the most colourful of the year's tributes.

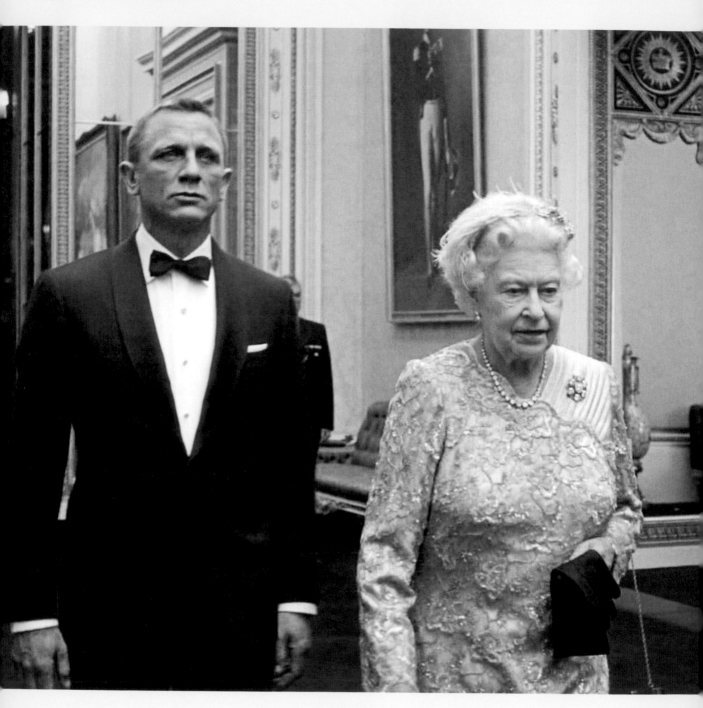

THE LONDON OLYMPICS **2012**

The world gasped as James Bond, played by Daniel Craig, escorted the Queen from Buckingham Palace during the live transmission of the opening ceremony of the 2012 London Olympics. Could it really be her? It was, although a stuntman wearing the same apricot dress parachuted from a helicopter onto the stadium – and then the Queen walked in to perform the official opening.

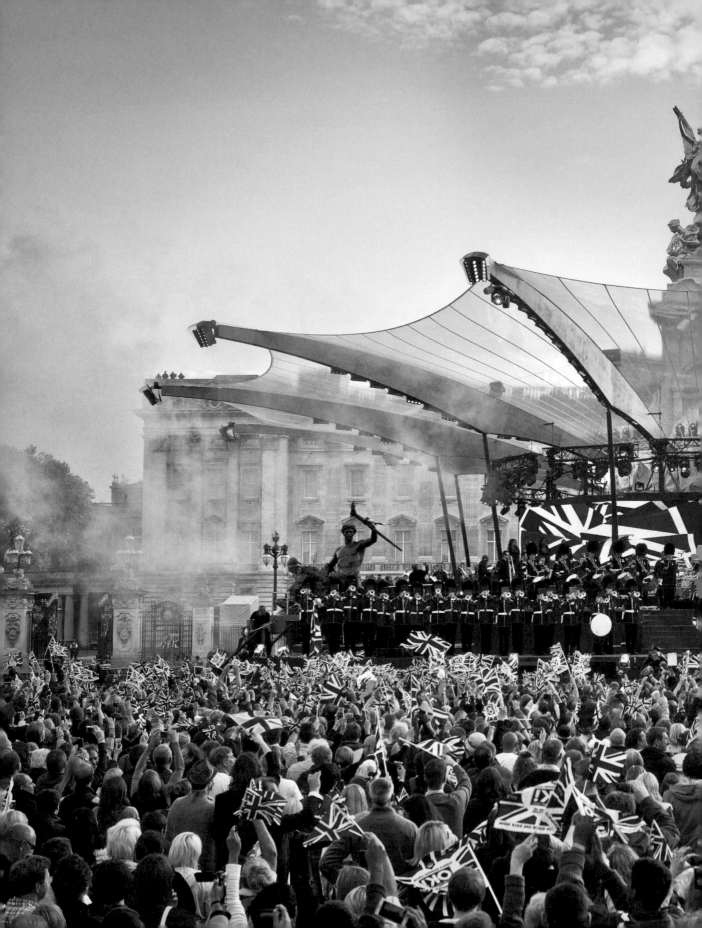

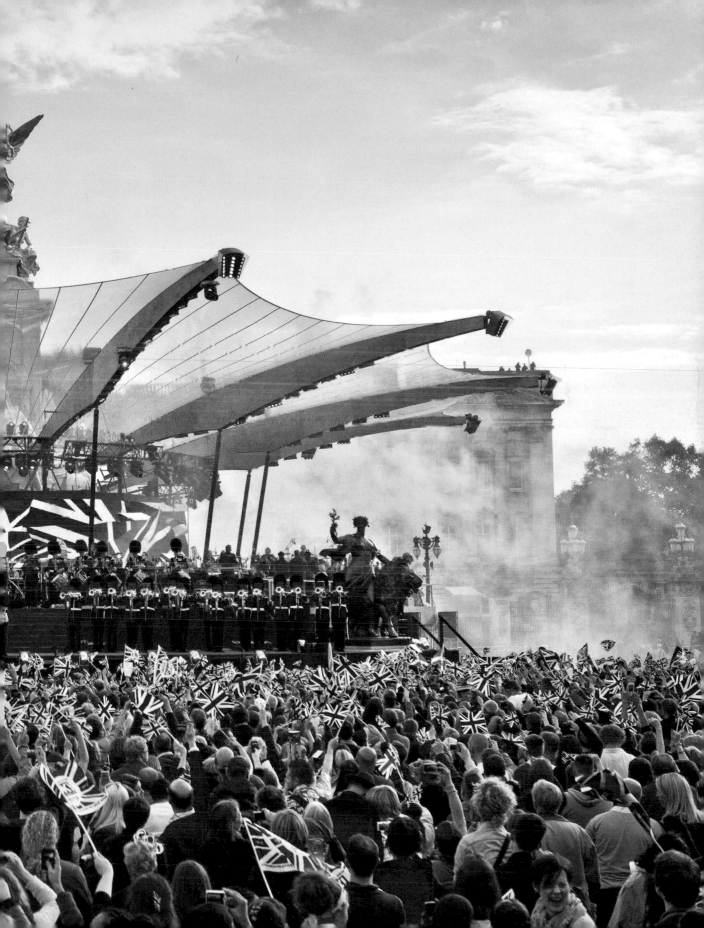

MAUNDY MONEY

On Maundy Thursday, four days before
Easter, the monarch has traditionally
distributed money to the poor. Throughout
the Queen's reign this revived tradition
took place in cathedrals in turn, pensioners
receiving specially minted coins, one for
each year of the reign. In 2017, at Leicester
Cathedral, it was a bonanza year. This event
also meant that in her reign the Queen
had attended every Anglican cathedral to
distribute the Maundy money.

ELIZABETH MEETS ELIZABETH

When opening the new elephant centre at Whipsnade Zoo in April 2017, the Queen and Prince Philip were introduced to the eight-month-old Asian elephant named in her honour.

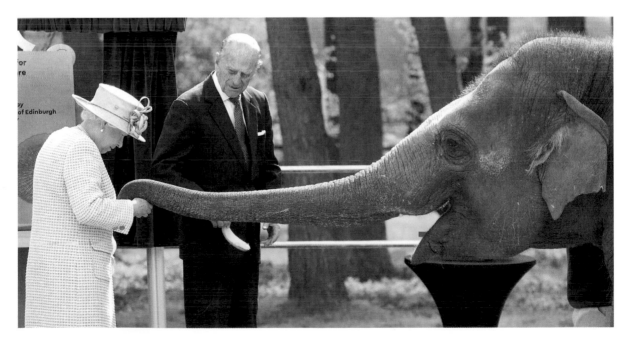

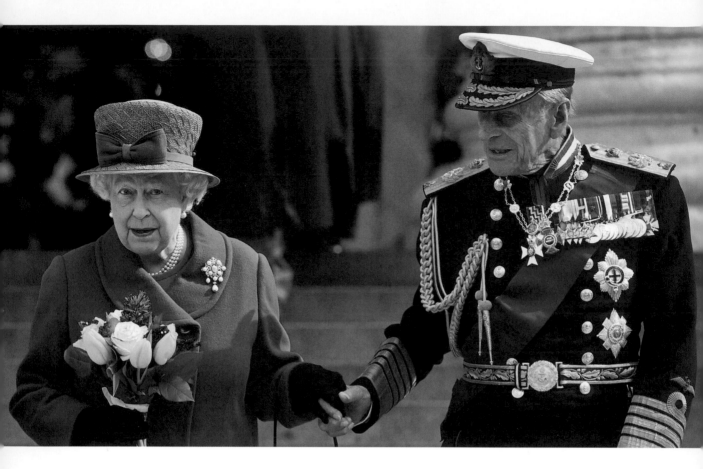

A PRINCE RETIRES

In August 2017, Prince Philip retired from public life, after over 22,000 solo public engagements since the Queen came to the throne in 1952. At the age of 96, he bowed out in his role as Captain-General of the Royal Marines, at an event to mark servicemen's sometimes superhuman achievements in the Global Challenge to raise funds for the Royal Marines charity.

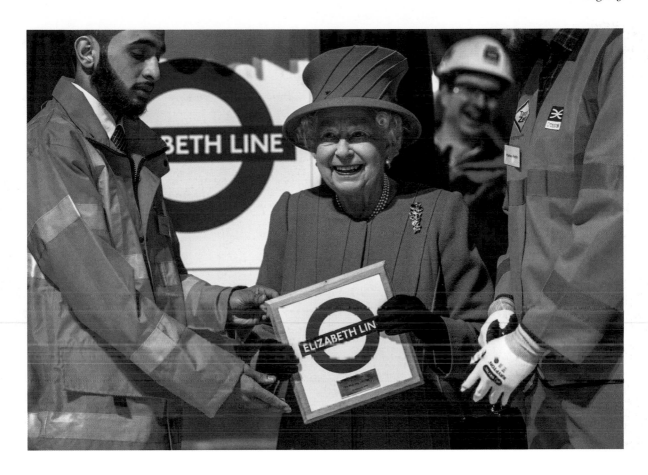

A ROYAL LINE

Queen Victoria had a railway station named after her, and the western tower on the Houses of Parliament. Marking the Diamond Jubilee and then the Queen overtaking her great-great-grandmother's record number of years on the throne, the Clock Tower at Parliament housing Big Ben was named the Elizabeth Tower, and the new Crossrail line through London was named the Elizabeth Line, its brand colour a regal purple.

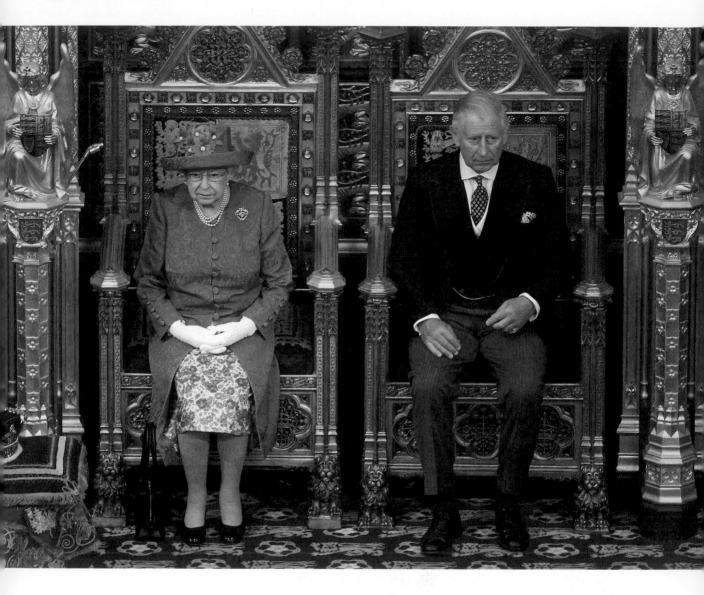

At the 2017 State Opening of Parliament, the Queen did not wear the robes of state and Imperial State Crown, but appeared in an outfit of what appeared to be the blue of the European flag, with hat to match, incorporating the stars of Europe. Many took this as a covert (and exceedingly rare) statement on the Brexit negotiations with the UK's impending secession from the European Union.

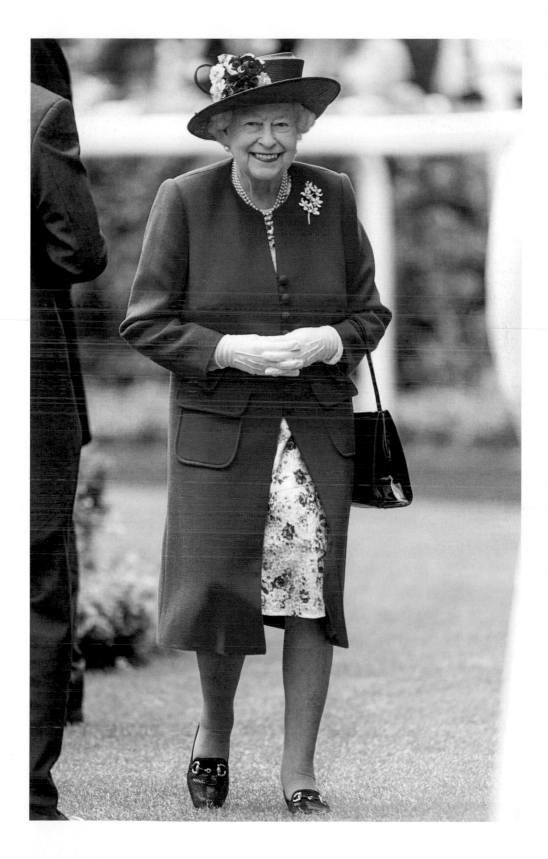

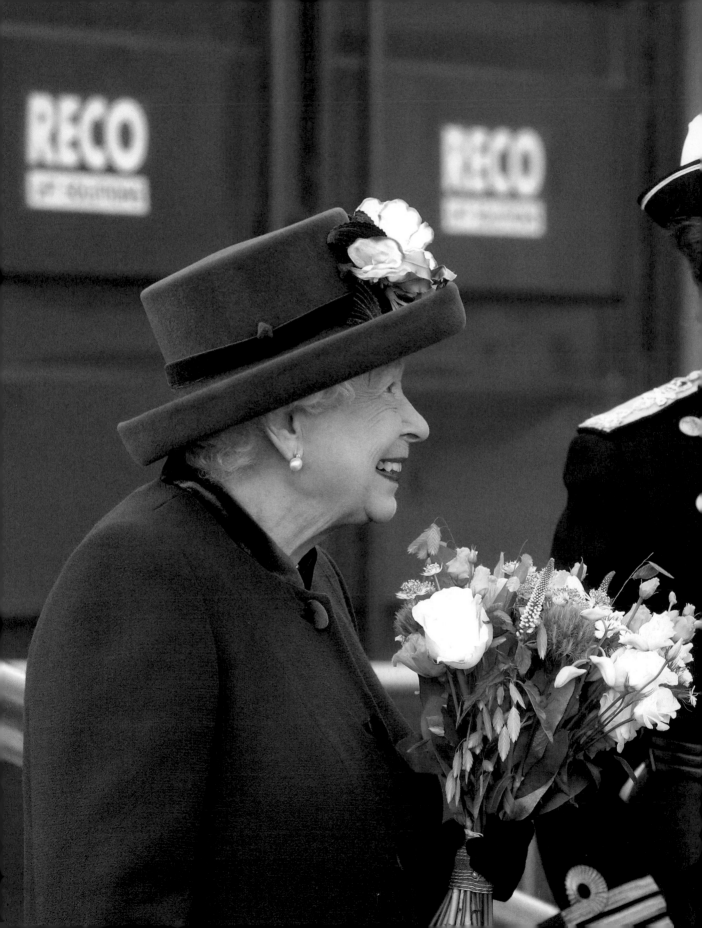

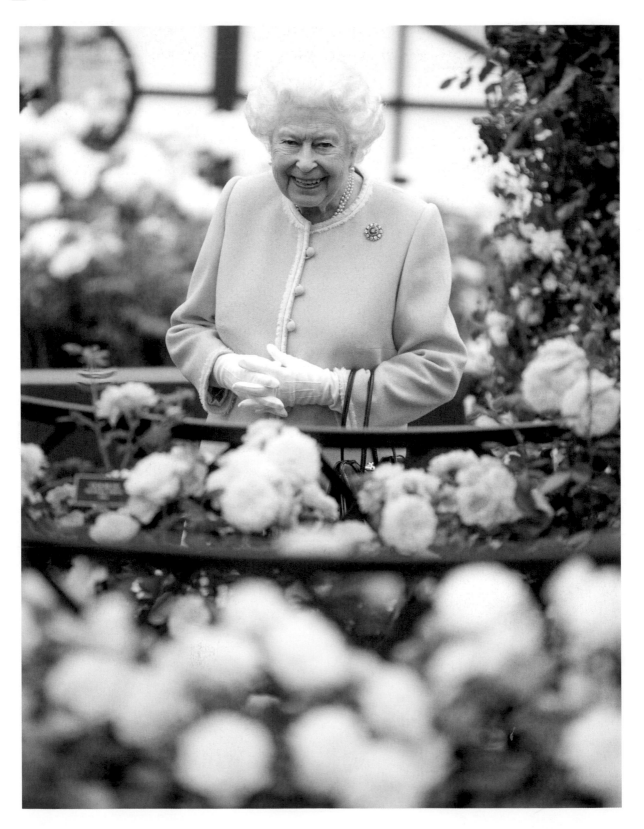

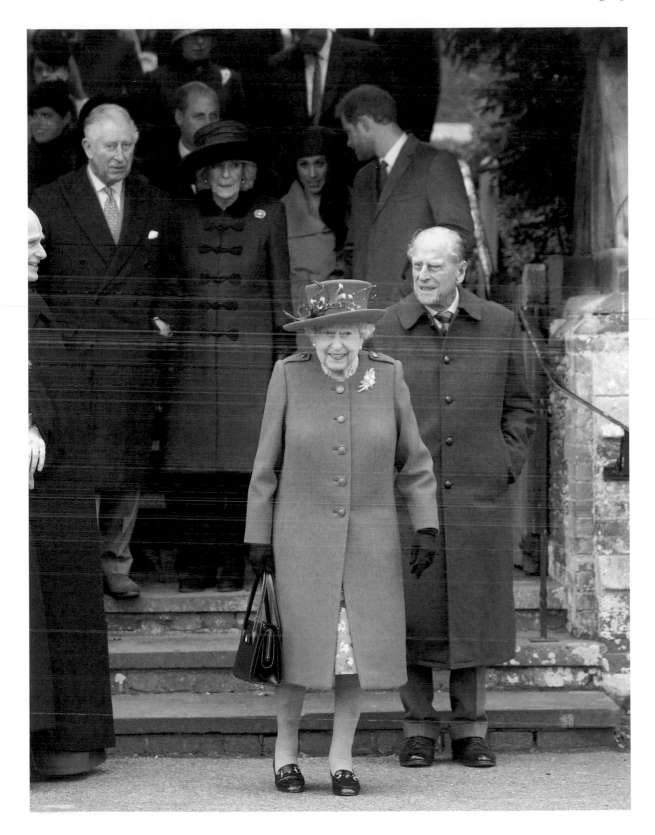

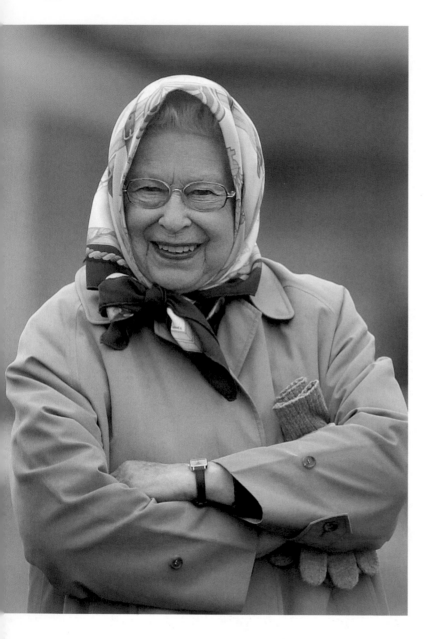

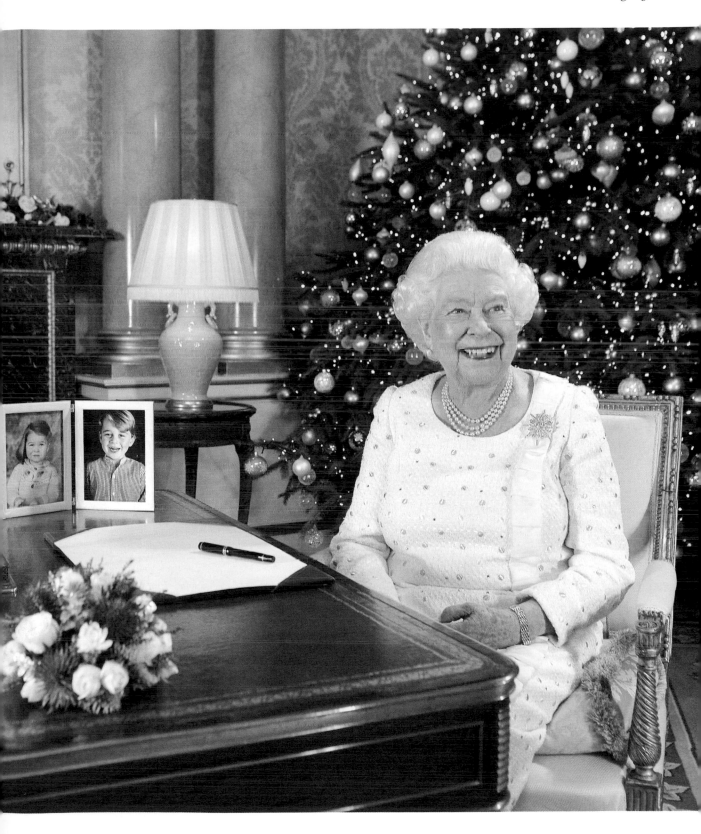

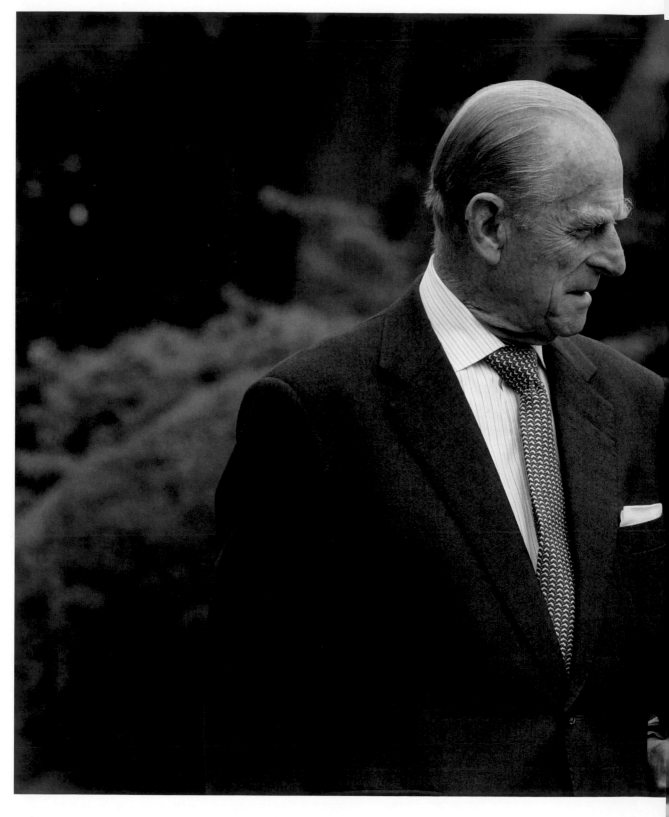

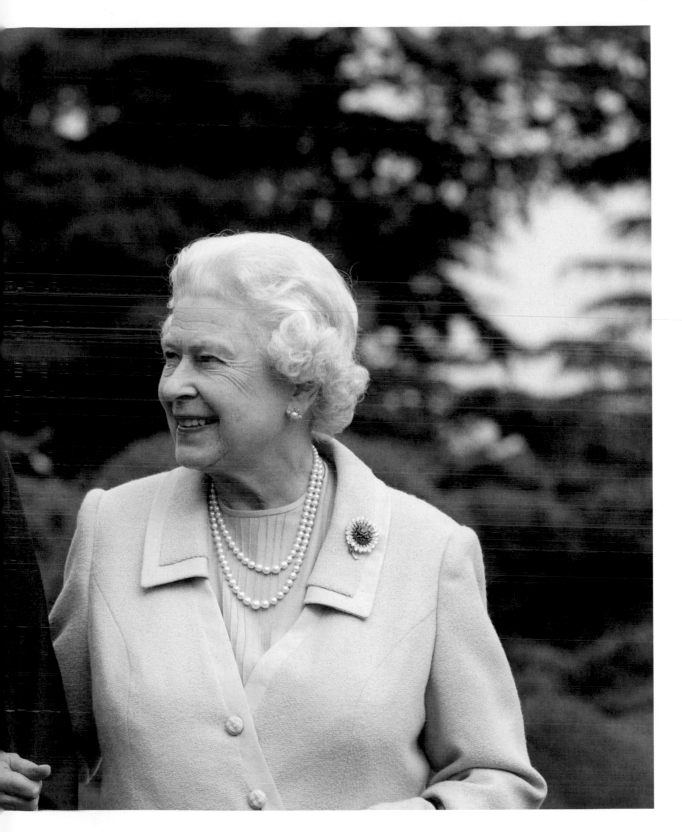

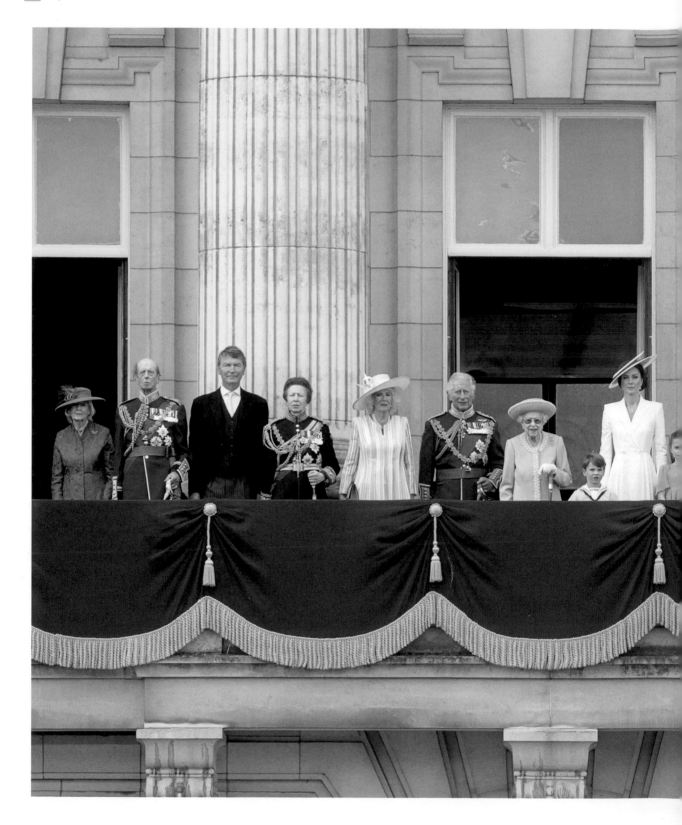

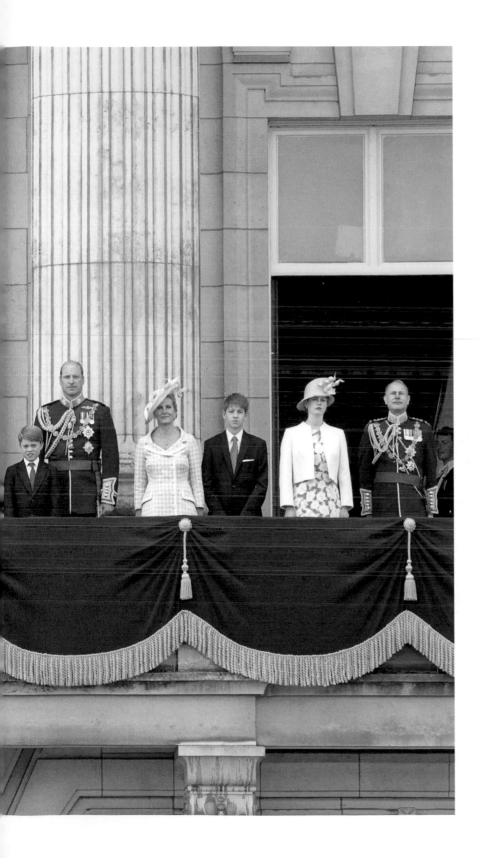

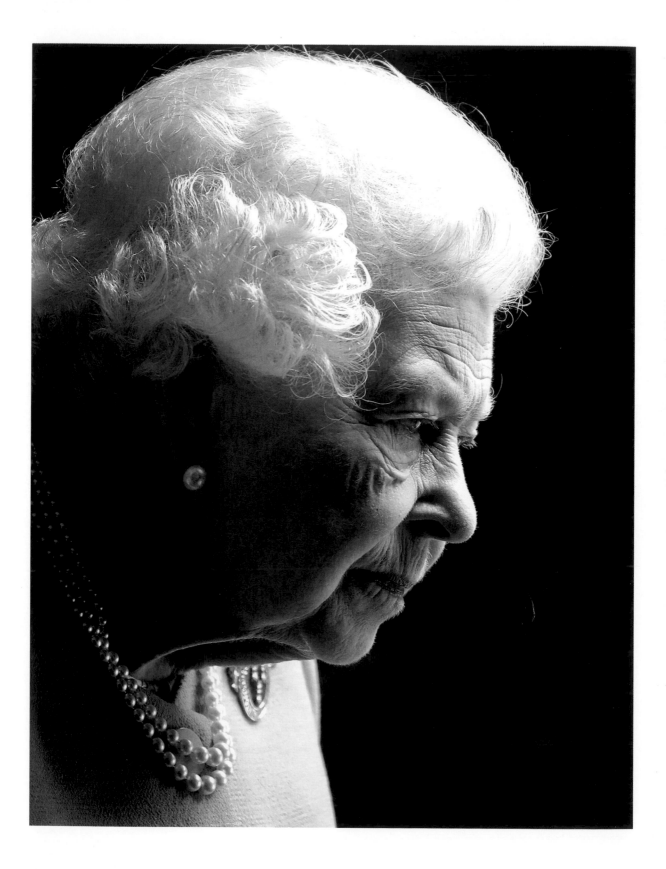